THE
FUNDAMENTALS
OF FASHION
FILMMAKING

BLOOMSBURY VISUAL ARTS
Bloomsbury Publishing Plc
50 Bedford Square, London, WC1B 3DP, UK
1385 Broadway, New York, NY 10018, USA
29 Earlsfort Terrace, Dublin 2, Ireland

BLOOMSBURY, BLOOMSBURY VISUAL ARTS and the Diana logo are
trademarks of Bloomsbury Publishing Plc

First published in Great Britain 2023

Cover image:
Actress Albe Hamiti
Director / Photographer: Monica Menez
Film: *HORS D'OEUVRE*

A catalogue record for this book is available from the British Library.

Library of Congress Cataloging-in-Publication Data
Names: Yusuf, Nilgin, author.
Title: The fundamentals of fashion filmmaking / Nilgin Yusuf.
Description: London ; New York : Bloomsbury Visual Arts, 2023. | Series: Fundamentals |
Includes bibliographical references and index.
Identifiers: LCCN 2022043177 | ISBN 9781350144286 (hardback) | ISBN 9781474242370
(paperback) | ISBN 9781474242394 (pdf) | ISBN 9781474242387 (epub)
Subjects: LCSH: Fashion cinematography. | Fashion merchandising. |
Fashion in motion pictures. | Short films.
Classification: LCC TR894.8 .Y87 2023 | DDC 778.3–dc23/eng/20221209
LC record available at https://lccn.loc.gov/2022043177

ISBN: PB: 978-1-4742-4237-0
 ePDF: 978-1-4742-4239-4
 eBook: 978-1-4742-4238-7

Typeset by Integra Software Services Pvt. Ltd.
Printed and bound in India

To find out more about our authors and books visit www.bloomsbury.com
and sign up for our newsletters.

THE
FUNDAMENTALS
OF FASHION
FILMMAKING

NILGIN YUSUF

BLOOMSBURY VISUAL ARTS
LONDON · NEW YORK · OXFORD · NEW DELHI · SYDNEY

Contents

6 Fashion Filmmaking 86

7 Getting Your Fashion Film Seen 118

8 Technology's New Frontiers and the Future of Fashion Film 136

Introduction: Understanding Fashion Film

The Fundamentals of Fashion Filmmaking grew out of a desire to give fashion film its credit and offer a cohesive, practical publication to those who wish to know, learn about, and make fashion film. A collaborative effort, it has included the generous involvement of directors, producers, programmers, commissioners, editors, academics, curators, and technologists who gave their knowledge and time freely to make this book a reality. The first title of its kind aimed at fashion film practitioners, I hope it will also provide insights for scholars, enthusiasts, and tutors; hence the exercises at the end of each chapter which are suitable for any student or reader wishing to develop their knowledge, skills, or experience in this underappreciated form of filmmaking.

An increasing number of students from all creative disciplines use film to convey their research and ideas including fashion students from backgrounds as diverse as design, business, and communication. Drawn to the medium for a variety of reasons, film is an immediate and direct way to tell stories, convey messages, or visualize dreams and is a language we all live with and which has shaped our imaginations. The widespread use of mobile technology and smartphones means the majority of people have a camera ready to capture and create moving image, while several generations of digital natives respond intuitively and fearlessly to the potential of the medium.

1.1
Phantasmagorical and magical, Ruth Hogben creates a compelling flying fashion abstraction for Gareth Pugh A/W 2009 collection.
Credits: Ruth Hogben (director), Gareth Pugh (designer). © Ruth Hogben.

Fashion film, which emerged out of the digital revolution, has grown in status to be ranked alongside its most immediate film relative, the music video. Two decades have seen fashion film take on a multiplicity of forms, yet, while fashion film has become more commonplace, it continues to elude definition. This book attempts to not only define fashion film but place it in an historical and contemporary context. The creativity and innovation of fashion filmmakers is now recognized globally through an expanding number of international film festivals while specialist platforms and the ascent of social media and digital culture have seen the form evolve and mature, attracting larger audiences and bringing greater opportunity for filmmakers.

Through eight chapters, *The Fundamentals of Fashion Filmmaking* combines theoretical, contextual, and practical information. Images can only give some indication of a moving form, so QR codes are spread throughout the text giving readers an opportunity to watch films as well as read about them. There are vast numbers of books and websites that deal comprehensively with the technical side of filmmaking, so this book should be seen as a specialist companion title to detailed technical requirements. The content, accurate at the time of going to print, has been informed by practicing filmmakers who acted as consultants, bringing their personal insights to the various themes and aspects of the discipline. However, fashion being fashion, and technology being technology, means this vibrant and dynamic area of filmmaking will continue to change and evolve. Far from a passing fad as some predicted when the form first emerged, fashion film has taken its place alongside photography, journalism, and illustration as a key form of communication for the fashion's transmedia communicator.

Gareth Pugh – S/S 2011

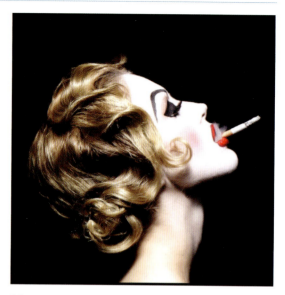

1.2
Gareth Pugh, *Joie de Vivre* (2010). Credits: Ruth Hogben (director), Gareth Pugh (designer).

What Is Fashion Film?

A continuum of photography, both related and distinct, fashion film is fashion imagery that *moves*. It might be silent, soundtracked, or spoken; nano-seconds short or feature-film long. It might follow a traditional narrative arc or be conceptually driven and experimental. Fashion film, sometimes with a beginning, middle, and end, and sometimes not, can be seen on your phone, laptop, TV, in shop windows, retail environments, and galleries, or projected onto cinema screens and architecture. In our digital, transmedia landscape, fashion film is everywhere yet definitions can be vague and contradictory.

The Still Image

In modern history, the photograph has been the traditional and dominant medium for recording fashion. Edward Steichen, Baron de Meyer, Cecil Beaton, Louise Dahl-Wolfe, Irving Penn, and Richard Avedon are some of the canonical fashion photographers, as celebrated as the designers whose work they immortalized. Alongside the buttons, buckles, and bows, these visionaries simultaneously captured the spirit of their times.

Photography freezes an image or moment into a single shot whereas film gives us a sequence of movement, as well as a great deal more. Film theorist and filmmaker Peter Wollen, author of *Signs and Meaning in the Cinema*, compares photography to ice, and film to fire: "Photography is motionless and frozen; it has the cryogenic power to preserve objects through time without decay." Photography stops time and captures its subjects like "flies in amber," notes Natalie Khan, who has written extensively on fashion film. Many fashion photographers have sought to create the impression of movement within a still frame. In some ways, this has been the ultimate challenge.

Fashion's Digital Image

In the 1990s, digital technology revolutionized fashion photography. All that was once static started to move. Digital cameras eliminated the need for processing. Film stock, on which chemically made photographs were formed, became virtually obsolete. Instead, digital photographs were produced through electronic light information formed on a sensor.

The frame's horizontal and vertical borders that once controlled the fashion image burst open. The digital image wanted to roam, hover, float. This technology allowed for infinitesimal images and a constant flow of possibility with no beginning or end. Its fluidity made less sense of the still image and ensured fashion film and moving image became a core component of fashion communication.

1.3
1960s supermodel Twiggy is captured in mid-air, on King's Road in Chelsea, London. Photo by Stan Meagher/ *Daily Express*/ Hulton Archive (via Getty Images). © Stan Meagher/Stringer.

1.4
English model Jean Shrimpton is photographed in the back of a car. Her hair blowing in the wind gives the impression of movement. Stan Meagher/ *Express* (via Getty Images).

IN FOCUS

SHOWstudio champions fashion film and moving image

Image-maker Nick Knight started his professional career as a photographer. In 2000 he founded the online portal SHOWstudio with the strapline "the home of fashion film." In his introduction to *Revolution*, the SHOWstudio retrospective at Somerset House in 2009, he explained why the medium of film was so appropriate for fashion.

> "Clothes are created to be seen in movement – any static photograph of a piece of clothing is therefore, to some degree, a compromise. Fashion film offers the hitherto impossible chance to see the garment as originally conceived, in unbridled motion."

He offers more insight into the importance of fashion film at the end of this chapter.

As well as animating fashion through a series of twenty-four frames per second, fashion film provides an experience through sound and image and, if executed proficiently, takes the viewer on a journey. As fashion moves through film, its ability to engage larger audiences through digital culture and social media is increased and is one reason film has been so enthusiastically embraced by the fashion industry.

Understanding Fashion: Definitions and Explanations

In 1831, Thomas Carlyle, a Scottish philosopher and eminent Victorian commentator, noted that "dress is always unspeakably meaningful." The idea that fashion might have meaning beyond its surface was a prescient statement that foreshadowed two further centuries of analysis, investigation, theorizing, and examination.

Since Carlyle's declaration, an extensive and sustained attempt to unlock and decode fashion has taken place by historians, sociologists, philosophers, anthropologists, psychologists, academics, and cultural commentators. Theories include the idea of fashion as a cultural barometer or mirror of society; a reflection of identity, individuality, conformity, group solidarity, cultural affirmation, or social aspiration; a means of communication; or a tool of capitalism and consumption.

Alongside fashion's theoretical history is a compelling visual heritage. Before fashion's many textbooks were drawings, etchings, illustrations, paintings, and, crucially, photography. It is primarily through imagery that most people know of and understand fashion. Fashion's photographic archive is not only a history of creative vision but a window into worlds lived at the time. Filmmakers are the most recent visual chroniclers to join this fascinating voyage, animating fashion into myriad forms. From tiny bursts of movement on mobile phones to full-length features on big screens, fashion has become a subject for four-dimensional interrogation, examination, narration, and visualization. Film can bring movement, sound, and the power of casting, scenography, and editing to our understanding and experience of fashion.

Film: An Integral Part of the Fashion Communication Industry

Film as an Expression of Fashion

Film, like fashion, has its own language, history, and conventions. Over a century old, it's a similar age to modern fashion, and the two mediums have always shared a special relationship. Fashion and clothing have always been part of film language, as costume or spectacle, a way to dress characters, or drive action. Film has also been utilized by fashion creators as a medium through which to promote design, merchandise, or activities. Way back in 1911, couturier Paul Poiret was an early adopter of the form. The first forms of fashion film were linked with advertising, art, and cinema, but it wasn't until the 1990s, with the arrival of digital technology and the internet, that fashion film became a distinctive branch of visual communication.

Fashion film is now a common element of offline hubs of commerce and consumerism. Displayed in shop windows, on billboards, or on the surfaces of buildings, visual merchandisers embrace this multi-sensorial, media-rich medium to communicate with audiences. Whether Nike, Topshop, or Selfridges, the digital moving presentation of fashion is a key part of the interactive shopping/media experience. Some contemporary cities resemble Ridley Scott's 1982 futuristic sci-fi film *Blade Runner*.

Through the fusion of narrative, movement, sound and image, brands, designers, fashion houses, bloggers, and independent filmmakers have been able to harness fashion film to entertain, inform, seduce, and provoke audiences. Beyond the physical space, it is seen online, within live and connected digital environments including social media where viewers can interact, comment on, and share fashion film. Some fashion films embed shoppable features allowing consumers to buy directly from mobile devices or computers, helping to drive online sales.

1.5
Fashion film, a global force, can reflect national and regional differences. Guan Jiang Shou in Taipei, *What it's like to be a 16-year-old in Taipei Today* (2010). Credits: Xiao-Wei Lu (director), *i-D*.

1.6
Consumerism's use of immersive moving image was foretold by former director of commercials Ridley Scott. *Blade Runner* (1982), directed by Ridley Scott. © The Ladd Company, Shaw Brothers, Warner Bros 1982. All rights reserved.

Fashion Film: A Hybrid Genre

The Pluralism of Fashion Film

Fashion film is a porous genre that constantly absorbs new influences and references. Inspired by horror (see Chris Turner's *Exorcist*-inspired film in the QR code), sci fi, or musicals, fashion film has appeared as animation, music video, Computer generated imagery (CGI) fantasy, and interactive installation comprising virtual, mixed, or augmented reality. Added to fashion film's chameleon-like qualities, it can vary in length, subject matter, and approach. With so many formats and approaches in evidence, how do we recognize a fashion film when we see one? Is there a connecting thread that unites the commercial and experimental approach?

G(o)od±(D)evil (2012), directed by Chris Turner

While fashion film is part of the commercial arena that promotes fashion goods, manufactures desire, and seduces consumers, other strands of fashion film favor a more experimental or conceptual approach. These films have more of a relationship to art and moving image and explore ideas *around* fashion such as gender, class, race, sexuality, or other themes in a broader way. These films won't necessarily fixate on garments and could, for example, be more to do with the body or notions of identity. They may be viewed in gallery spaces or non-fashion specific digital portals, which mean the audience arrive with different expectations, i.e., they are not looking to shop. The online space also plays host to many amateur fashion films made by fans, bloggers, and enthusiasts who all enrich the breadth of fashion film. In this context, fashion film can be characterized by its pluralism and historical inter-relationships with cinema, advertising, the arts, and DIY filmmaking.

IN FOCUS

Fashion film and multi-sensoriality

Fashion film now plays a key role in the fashion communication industry. A hybrid genre—which means themes or elements from two or more film genres are often blended—the multi-sensorial dimension of fashion film creates a more affecting experience for consumers. Studies into consumer behavior demonstrate that combining two or more senses create more impact on brand perception, memory, and buying behavior. Fashion marketing academics Bethan Alexander and Karina Nobbs write that "sensory branding" or branding that activates the senses "provides a distinctive and unique experiences that enhances customer emotion to engage them in a personal way." This adds brand value.

1.7
Conceived and directed by visual artist and trained designer Anna-Nicole Ziesche, *Childhood Storage* (2009) was exhibited in art galleries as well as seven fashion film festivals. © Anna-Nicole Ziesche (director).

1.8
Fashion film meets Zombie horror flick as girl gangs run riot in the suburbs. *Disturbia*, directed by Jeff Bark and styled by Robbie Spencer. © Dazed Digital 2014. All rights reserved. Screenshot from YouTube @ Dazed.

Change is a Beautiful Thing (2014), directed by Kathryn Ferguson

IN FOCUS

Examining (and debunking) some standard definitions and preconceptions of fashion film

Is a fashion film one that is made and commissioned by the fashion industry?

While much fashion film emanates from inside the industry and offers a growing field of opportunity for filmmakers, this isn't the whole story. Some excellent documentaries *about* the industry including *Unravel*, Meghna Gupta (2012), and *Machines*, Rahul Jain (2017), originate from outside the industry. Films made by artists, bloggers, enthusiasts, and fashion obsessives also contribute to a rich strand of what might be described as "outsider" fashion film.

Is fashion film purely about selling fashion?

From advertising to branded partnerships, creativity abounds within the commercial fashion film. Sometimes the selling motive is cleverly disguised with a more subtle, "soft sell" approach. But alongside promotional fashion films are those that critique, question, or expose fashion issues such as Kathryn Ferguson's film for Selfridges, *Change is a Beautiful Thing*, which examines ageing. Vloggers who opine or commentate on all aspects of fashion offer an alternative fashion film to one that is purely promotional.

Must fashion film show fashionable clothes?

In the way that clothes, and even the body, might be absent from fashion photography, this is true for fashion film. In Kathryn Ferguson's film *Horses* (2012) for the label Chloé, clothes were absent. Instead, the brand values of freedom and expression were conveyed through the glistening hide of wild horses. Award-winning *Jumper* (2014) for Jonathan Saunders presents viewers with a naked male. While many fashion films will include contemporary clothing, spotlighted narratively, conceptually, or cinematically, it is not obligatory.

> "Fashion isn't just about what people are wearing – it's also about what they are doing and thinking."
>
> Bunny Kinney, Creative Director, Nowness

Can you identify a fashion film by the credits?

Some believe you can identify a fashion film by reading the closing credits. If a strong fashion directive exists, you will often see it here. In regular short films, *Wardrobe* or *Costume* indicate who has dressed the cast. In fashion film, the role *Stylist* is more common. Individual garments might sometimes be credited by label or brand. Both conventions originate from fashion magazine editorial captions (minus prices or stockists); but this approach of identifying fashion film isn't foolproof.

1.9
Justin Anderson's award-winning film, *Jumper* (2014) is a fashion film with few clothes. Credits: Justin Anderson, featuring Pol Hermosos (director and screenplay); John Greswell and Christopher Taylor (music).

Jumper (2014), directed by Justin Anderson

Chloé Alphabet – *H/Horses* (2012), directed by Kathryn Ferguson

1.10 and 1.11

Old horses and new connect film's earliest experiments into movement with contemporary fashion filmmaking.

Top: English American photographer Eadweard Muybridge wondered if all four horses hooves came off the ground. His visual experiments in animal motion were able to answer this question and pioneered early moving image. *Animal Locomotion*, 1887. Credits: Eadweard Muybridge (photographer).

Bottom: If fashion in its purest sense is about the "spirit of our times" or can epitomize the values of a brand, then garments are not always necessary to convey a narrative. Chloé Alphabet – *H/Horses*, 2012. © Kathryn Ferguson (director).

Understanding Fashion Film

Aesthetics and attitude: defining fashion film

Two words that draw together the entire spectrum of fashion film in all its diversity and variety are *aesthetic* and *attitude*. The adjective of aesthetic means *concerned with beauty or the appreciation of beauty*. The noun relates to *a set of principles underlying the work of a particular artist or artistic movement*.

In fashion film, image is foregrounded, the illusion matters, and aesthetics are key. This attention to aesthetics makes sense of the film directors that fashion creatives are instinctively drawn to. Luminaries such as Federico Fellini, Wes Anderson, David Lynch, Roberto Rossellini, and Jean-Luc Godard have created a legacy of beautiful films with every visual element considered frame by frame, shot by shot. The elements of color grading, balance, perspective, and texture are also uppermost in the fashion filmmaker's mind. Every detail is considered from how clothes are styled, to the specifics of hair and makeup, depth of lighting, quality of sound, and balance of composition.

In all filmmaking, technical competence, editing and sound quality are all vital to the final output but the film's *aesthetic* qualities and an appreciation of how things look on screen will often define a successful fashion film. This responsibility lies in many hands including the cinematographer, producer, stylist or designer, hair, and makeup artist. Everyone works together to create something cohesive, which adds up to an attuned aesthetic awareness, one that feels right, and consciously or subconsciously, reflects the zeitgeist.

Because fashion changes constantly, aesthetics change. The aesthetic and attitude of the 1980s differ to what is desirable or aspirational today. When we look at a 1980s fashion film, we are conscious of observing past fashion. However, a preoccupation with a film's look does not mean it should be glossy or self-conscious. This can be the antithesis of fashion film and expose the director as "trying too hard." Some of Mario Sorrenti's advertising for Calvin Klein is deliberately raw and edgy

1.13
Attitude and aesthetics are combined in Calvin Klein's *Obsession* campaign film (1993) by Mario Sorrenti. All rights reserved.

1.12
Attitude is a defining factor of memorable fashion films which might also be described as a narrative or conceptual position or stance. *Katie Eary – Powerless* (2011). © Hidden Agency, Liam Gleeson (director).

1.14
Fashion as protagonist can encompass many types of filmmaking. Trans blogger Raiden Quinn looks at counterfeit designer merchandise, 2019. © Raiden Quinn.

yet beautifully captures its own slice of youth culture. While fashion film may be narratively or conceptually *about* anything, or fall into any recognized genre or format, aesthetics are always paramount.

Attitude means a way of thinking about something, a point of view, frame of mind, stance, or standpoint. The idea of attitude is not meant in the pejorative sense, as in having a difficult or troublesome attitude, but more about having a particular take on something. What is the fashion film saying? Is there an underlying message or compelling narrative? While there are potentially as many attitudes as there are filmmakers, it's helpful to consider the opposite. A fashion film with no attitude thinks nothing and has no opinion; it's the film once seen and instantly forgotten. Attitude make a fashion film watchable, memorable and, in this age of social media where dissemination is key, shareable.

IN FOCUS

Fashion film and aesthetics

The term aesthetics has its origins in the eighteenth century. German philosopher Theodor Adorno formulated a set of aesthetic criteria to assess artwork. The term, which was initially used for art and architecture, was broadened into cinema in the twentieth century, according to *Aesthetics and Film*, an online film theory journal.

Defining Fashion Film: Fashion as Protagonist

IN FOCUS

Fashion as protagonist in fashion film

The word protagonist comes from an ancient Greek word meaning player of the first part or chief actor and relates to the main actor in a story. A protagonist can also be an advocate or champion for a particular cause or idea.

In fashion films, the action, story, narrative, or concept emanate from fashion. *Fashion* is the protagonist. Whether a blogger disclosing her latest buys, a slick designer treatment, or documentary that probes fashion's ethical accountability, *fashion* is driving the action or narrative forward.

Fashion as protagonist can be many things. David Lynch's film for Givenchy, *Lady Blue Shanghai* (2010), brought his distinctive surreal and unsettling sensibility to a designer handbag that was rendered into a fearful object. A fashion film might be interested in wider themes such as sexuality, gender, performance, ethics, or equality, or present a highly focused specific perspective focusing on color, sound, shape, silhouette, or detail. While there are many views and opinions on what fashion film is and what makes a good fashion film, this idea of fashion film defined by aesthetics and attitude, and fashion as protagonist, work across a range of forms and outputs.

1.15
Film auteur David Lynch brings his dark, distinctive sensibility to a Dior handbag. *Lady Blue Shanghai* (2010), directed by David Lynch. © Christian Dior Production, 2010. All rights reserved.

IN THEIR OWN WORDS: DIANE PERNET

Founder of A Shaded View on Fashion Film (ASVOFF)

There isn't a brand big or small that isn't using the medium of film.

"We all watch films, and we all wear fashion. I never wanted ASVOFF to be a film festival just for fashion people. I wanted real film directors making films for it, not just photographers whose agents want them to make films. A model in movement at the end of a shoot does not make a film. If you look at real film directors: Wes Anderson, Mike Figgis, Kenneth Anger, David Lynch; they all know how to make a fashion film.

Fashion films shouldn't be about 'Here is a bag! Here is the shoe!' It is more about increasing the visibility or atmosphere of a brand, so that you will remember it more. I am a strong supporter of designers and have been for 25 years. I used to be one! Fashion film is a hybrid medium. It's a short film and is judged in the same way as all other short films except the fashion must look great. If the cast are wearing shit, then it's not really a fashion film.

When I started ASVOFF, I spent so much time explaining what fashion film was. Now, there isn't a brand big or small that isn't using the medium of film. And it's not about budget. If you have something to say, you can find a way to say it with little or no budget.

Technology does interest me, but I'm more interested in the result. Sometimes, I get people saying 'But, it was shot on a Red Camera!' but all I am looking at is a photo shoot, not a film. Even though it's easy, great technology alone can only make a great technician. You need an idea to make a fashion film—and great cinematography.

Clothes play a role—but not literally. It should be 'Here's a character.' Sometimes, when directors hire a stylist, they will bring in all this stuff and say 'Let's use this cute red cap' but the red cap will make the film too fashion conscious. First, there must be a discussion with the director. What's the motivation of this character? You are interpreting the character through what they wear. It could be a tiny red thread. It shouldn't be the focus."

1.16
Diane Pernet with Roissy de Palma and director William Klein at ASVOFF, 2017.

IN THEIR OWN WORDS: NICK KNIGHT

Image-maker and founder of SHOWstudio.

Fashion film has such amazing potential and is … the best way to show fashion.

"Every garment has its own narrative, so fashion film doesn't need to impose one. The best fashion photographers and directors start with the garment to create imagery that best represents and expresses a fashion designer's work. Fashion designers present their art and opinion to the world; each fashion week presents poetry, actuality, newness, innovation. It's conceptually exciting and something I seldom see, even at the world's best art fairs.

In 2000, I started SHOWstudio because I saw that fashion in motion was where the internet would and should go. Soon, SHOWstudio became an alternative, exciting platform for photographers and designers, closer to what designers wanted. It was where you could put out work without an editor saying, 'the model isn't white enough or thin enough or the images look too surreal.'

Creativity and innovation poured back into fashion image-making, and it became a completely new medium. From the start, the 'film' part was slightly deceptive; for me, 'moving image' is more accurate. If you look at any classic fashion image, like the famous shot of Twiggy jumping across the gray cyclorama in Richard Avedon's studio, a fashion film could be as small and perfect as five or six frames.

For me, it's always been about clothes in movement. Early in its trajectory, some of the large fashion houses started spending vast sums commissioning narrative led films where fashion was relegated to the side lines by big film directors who neither understand nor really cared about fashion. Good fashion photography is a scarce skill. You need an understanding of the clothes, model and designer, and fashion film should come from the same language as fashion photography. You must know what the dress means and difference between a Martin Margiela and a Helmut Lang. Really good models instinctively understand a narrative already exists in the clothes; a model like Kate Moss knows how to make clothes work in a second with a twist of her body or the line of her leg.

When Instagram first started, everyone wanted fifteen-second fashion films, so at that point the popular platform defined the media. Watching submissions for the SHOWstudio Fashion Film Award, I know if a film is any good within the first few frames, I know by the styling, attitude, refinement, grace. Whether it's an hour or a minute, all these things must work together. Fashion photography took a hundred years to really define itself, so we should remember fashion film is still in its initial stages. But it has such amazing potential and I believe it's the best way to show fashion."

1.17
SHOWstudio, the platform launched by Nick Knight in 2000, celebrates all forms of boundary-pushing fashion film. Craig Green A/W 2015. Credits: Nick Knight (director).

Summary

- Photography was the dominant form of fashion representation until the arrival of digital technology and the internet. Both elements paved the way for mainstream fashion film (although it did exist before the internet—see Chapter 2).
- Modern fashion and film are a similar age and have always been interconnected in different ways.
- Fashion film, a distinct branch of filmmaking, allows clothes to be seen in movement and provides a multi-sensory experience for the viewer.
- An integral part of the fashion communication industry, fashion film is a pluralistic and hybrid genre.
- Aesthetics and attitude are two words that define the range of fashion film output.
- In fashion film, fashion is the protagonist and drives the action.

Exercises

Understanding fashion as a hybrid genre

Fashion film is a hybrid genre, which means it can look like many things and take inspiration from other genres to communicate ideas about fashion. Watch these films and discuss fashion as protagonist. How does fashion drive the narrative, action, or concept in the following films?

- Kathryn Ferguson and Alex Turvey, *Agender*
- Lernert & Sander, *The Sound of COS*
- Jeff Bark and Robbie Spencer, *Disturbia*

What other genres are they drawing from? What do we know or learn about fashion through the film? Does a cross-genre fashion film make it more or less accessible?

Making meaning in fashion film

For Nick Knight, fashion designers create narrative that exists in the garment. For Diane Pernet, a director's narrative or story arc can bring fashion alive and make it more engaging. Compare conceptual film (many can be found at SHOWstudio) with narrative fashion films (award winners at ASVOFF) and draw up two lists comparing the different approaches. Consider the following:

- Which is more engaging and why?
- As a viewer, how do the different approaches make you feel?
- What are the strengths and challenges of each approach from the perspective of the consumer/viewer and the brand or director?

Fashion Film History

Although it was digital culture that catalyzed contemporary fashion film, various forms existed before the internet's arrival, including newsreels, cine-magazines, and commercials. These short films, where fashion played a key role, were spawned by the invention of the movie camera. With antecedents of fashion film buried in multiple genres, this chapter sets out a series of contexts and timelines where fashion has cross-fertilized with film. It's possible to plot fashion's pre-digital heritage through the lens of commerce (promotional film), art (experimental), actuality (documentary film), fiction (feature films), music, and subculture (hybrid films including music video) and in doing so, appreciate its interconnection with other forms.

2.1 and 2.2
Jun Rope are
recognized
as visually
sophisticated
pioneers of
fashion film. *Top*:
photographer
Richard Avedon
and actress
Lauren Hutton
for a Jun Rope
commercial in
a performed
forerunner of a
behind-the-scenes
film or BTS.
Bottom: daring
commercial
featuring Angelica
Huston, 1973,
directed by
Richard Avedon.
© 1973. All rights
reserved.

Broadcast, Celebrate, Sell: Promoting Fashion through Film

For over a century, film has seduced and enlightened fashion consumers.

1898–1900 A stop-motion film combined *Mystere* corsets and *Delier* hats modeled by music hall dancers, directed by Georges Meliers and projected on the side of a theater. The film is the celluloid ancestor of Burberry's Live Streaming from Piccadilly Circus in 2011.

1911 **Paul Poiret**, the father of modern couture, showed great foresight when he made a promotional film to present his designs. Screened to his clientele when he toured his collection, this was a forerunner of all designer collection films.

1920s and 1930s The **Bata** shoe company had a prodigious output when it came to making shoe commercials. Commissioning many filmmakers including Elmar Klos and Alexander Hackenschmied, modern approaches included geometric composition and innovative lighting.

1932 **Pathé News** was a key source of promoting fashion through film with newsreels that would cover key fashion news and be screened before movies at the cinema. The arrival of

Chanel's diamond *jewelry* collection at the Faubourg Saint Honore in Paris was big news in 1932.

1958–1964 **Erwin Blumenfeld's Experiments in Advertising** were outtakes, a series of pitches for TV advertising aimed at fashion and beauty clients including Helena Rubenstein, Elizabeth Arden, and L'Oréal. His techniques included experimental composition, photomontage, and solarization. Bequeathed to and remastered by SHOWstudio, they have a timeless modernity.

1967 **Basic Black** by William Claxton for designer Rudi Gernreich, featuring Peggy Moffitt, is sometimes credited as the first fashion film (a claim up for debate). The Austrian-born, American designer created avant-garde pieces including the first topless monokini.

1968 The achingly hip collection from **Ossie Clark 1968** in the Revolution nightclub, Soho, featuring Anita Pallenberg was presented to exclusive press and industry and broadcast to audiences, courtesy

Inside CHANEL (1932)

of British Pathé. Now fashion shows are routinely streamed to global audiences.

1973 The innovative Japanese brand **Jun Rope** launched in 1958 and developed a reputation for sexy, modern commercials. Shot by Richard Avedon and featuring Lauren Hutton and Angelica Huston, Avedon playfully implemented a staged behind-the-scenes (BTS) approach. BTSs are now a common trope of fashion film.

1979 Japanese brand **Parco** presented conceptual advertising by the art photographer Kazumi Kurigami to produce beautiful, sometimes baffling commercials. In 1979, he cast Hollywood actress Faye Dunaway to enigmatically eat a boiled egg. Nick Knight has carried on the beautiful models doing "normal" things legacy.

1993 What might be regarded as one of the best retrospectives on film, **Geoffrey Beene 30**, a black and white film, was directed by Tom Kalin (of *Swoon*, 1992 and *I Shot Andy Warhol,* 1996). Beene who died in 2004 had his legacy memorably preserved by Kalin's stylish orchestration of his signature lines and inspirations.

IN FOCUS

Fashion photography's film pioneers

Many of fashion photography's greats including Guy Bourdin, Richard Avedon, David Bailey, and Erwin Blumenfeld have made fashion commercials. Attractive fees aside, the short length and clear objective of these films offers a tight creative framework which can fuel inventive approaches and many of these works have retained their fresh, contemporary vision.

Brand Buy-in: Promotional Fashion Film in the Digital Age

Films made by fashion brands to sell goods, including clothing, are now ubiquitous. Commercials, advertising, and GIFs reach us through large and small digital screens from the smallest start-ups to the largest luxury brands. As fashion filmmaking diversifies and viewers become more sophisticated, brands use increasingly subtle branded content. "Below the line" advertorials may arrive undercover, bearing the editorial stamp of a publication. Paid for by a brand but creatively executed by the host publication, such bespoke commercials are a key revenue source and offer viewers entertainment as well as shopping opportunities.

The ultimate objective for all brands is consumer "buy-in" whereby a customer becomes committed to a fashion label, returning to the site and ideally making a purchase. This is unlikely to be achieved by a superficial treatment of imagery and more likely to occur when a deeper level of emotional and sensorial engagement takes place.

Fashion businesses with modest budgets use film and platforms such as TikTok or YouTube to announce their arrival, build a following, and create interest. *First Kiss* for Wren (Tatia Pilieva, 2014), a black and white short, made a significant impact. A homage to Warhol's 1963 *Kiss*, strangers were invited to kiss for the first time, live on camera. Its human connection resonated, the film went viral, and sales increased by 14,000 percent according to the label's Creative Director, Melissa Coker (*Wren*, March 24, 2014).

Luxury labels with substantial budgets can invest in more lavish production, high octane glamour, and A-list talent. **The Future is Gold** (2014) for Christian Dior was directed by music video supremo Jean-Baptiste Mondino, who has created videos for David Bowie, Björk, and Madonna. The pre-Christmas period typically presents extravagant commercials, released in the prime gift-giving season to promote perfume lines. **No. 5 the Film** for Chanel by director Baz Luhrmann (of *Moulin Rouge!*, 2001 and *The Great Gatsby*, 2013) starred Nicole Kidman and a cameo by Karl Lagerfeld and cost $33 m to make.

Other brands who have enhanced their cultural capital with notable directors include Italian knitwear brand Missoni who invited experimental cult filmmaker Kenneth Anger of *Fireworks* (1947) and *Lucifer Rising* (1972) to make a short film in 2010. That same year, Christian Dior hired David Lynch, the director whose dark and strange imagination, seen in *Eraserhead* (1977), *Blue Velvet* (1986), and *Twin Peaks* (1990–2017) was transposed onto a designer handbag for **Lady Blue Shanghai**.

While some designers turn to Hollywood's trusted directors, others see an opportunity to promote fresh filmmaking talent. Miuccia

2.3
First Kiss by Tatia Pilieva, 2014. Credits: Tatia Pilieva (director).

2.4
Screenshot, Kenneth Anger for Missoni (2010). Credits: Kenneth Anger.

Prada instigated *Women's Tales*, a series of short films to spotlight international, female filmmaking talent including *Muta* for Miu Miu (Lucrecia Martel, 2011). Kenzo, known for idiosyncratic, eye-catching designs, ensure their fashion films appeal to a visually literate generation and are social media friendly.

Electric Jungle for Kenzo Resort 2013 (Mat Maitland, 2013) reflected their signature textile designs translated into animation, color, and pattern for the screen. If a film resonates with a brand's reputation, heritage, or values, there is a greater probability that brand "buy-in" will take place.

Experiments with Fashion Film: Poetry and Abstraction

While there is a strong legacy of film being used as a tool of fashion promotion, experimental filmmaking is not primarily powered by commercial drive but rather artistic impulses. The definition of experimental or avant-garde filmmaking is one that re-evaluates cinematic conventions and explores non-narratives or alternative methods of working. It can include non-linear or conceptual approaches, unorthodox means of production, presentation, or dissemination.

Historically, many experimental shorts are linked to art movements including futurism, surrealism, Dada, and queer art, or specific artists such as Man Ray or Hans Richter. Experimental film can play in unexpected ways with time, space, and logic and within this frame, fashion has played visual, conceptual, and kinetic roles, through dress, adornment, makeup, image, the body, gender construction, performance, or more abstractly, the use of fabric, color, light, pattern, or movement.

2.5 and 2.6
Left: the compelling visual series *Beauty in Motion* directed by Erwin Blumenfeld experiments with fragmentation and distortion, 1958–64. All rights reserved. Screenshot from YouTube @Nowness. *Right*: pioneering and experimental female filmmaker Maya Deren was a key influence on David Lynch. *Meshes of the Afternoon*, 1943. Credits: Maya Deren (director), Alexander Hamid (director).

Body, Image, Time: Experimental

The desire to create abstract or non-linear films in sensory or impressionistic ways has existed since the early days of film.

1895 *The Butterfly* or *Serpentine Dance* was an early film trope that featured female performers, bodies draped in diaphanous robes, transforming into butterflies, birds, or flowers. These must have thrilled buttoned-up Victorians. Swirls of floating fabric were central to the spectacle.

1926 Man Ray worked as a *Vogue* fashion photographer and created short, experimental film work. **Emak-Bakia** was one of his best known pieces. With an eye for drama, composition, and style, his work often revealed a fascination with aesthetics, composition, and the female form.

1928 In **Ghosts Before Breakfast** Hans Richter, an avant-garde artist, used dress to represent societal convention and subvert social meanings and expectations. Here, objects take on their own life with bowler hats flying through the air while tweeded gentlemen in brogues crawl in choreographed synchronicity.

1943 **Meshes of the Afternoon** and **At Land** (1944) by Maya Deren, a Ukrainian-born American experimental filmmaker in the 1940s and 1950s, inspired David Lynch, whose work has been a considerable influence in contemporary fashion film. She often worked with her husband Alexander Hamid.

1949 **Puce Moment** by Kenneth Anger is a six-minute short, clipped from a longer unreleased film called *Puce Woman*. It depicts 1920s flapper gowns handed down by the director's grandmother. Featuring Yvonne Marquis, who takes the garments and then dances, it suggests dress as reverie.

1965 **Cut Piece** by Yoko Ono was filmed in the Yamaichi Concert Hall in Kyoto, an early performance piece by the artist. She sits alone in her best suit then invites the audience to approach her, and cut off and keep a small piece of her clothing until she is laid bare.

1966 **Daisies** by Czech New Wave filmmaker (and former fashion model) Vera Chytilová depicts two teenage girls on an adventure of destructive pranks. This surreal comedy drama of feminist revenge is shot around Prague and is a psychedelic onslaught of colored filters and fragmented editing.

Trailer for *Daisies* (1966)

1966 Verité-inspired *Chelsea Girls* by Andy Warhol and Paul Morrissey is iconic art cinema. With music by The Velvet Underground and shot in New York's Chelsea Hotel, it stars Nico and other Warhol "superstars." A forerunner to reality TV, unscripted, unedited "truth" was projected onto a split screen, two reels at a time.

1971 *Pink Narcissus* by James Bidgood shows the influence of queer cinema on fashion film with crossover themes of gender, identity, and self-presentation. This erotic film poem focuses on the daydreams of a male sex worker in a kitsch apartment.

Fashion Dreams in a Digital Age

Fashion designers, directors, and artists in contemporary fashion filmmaking have seen a growing interest in experimental approaches. Quentin Jones has drawn from Dada, an early twentieth-century European art movement that rejected rationality, logic, and reason. Ian Pons Jewell, who has been known to create films from his own dreams, has tapped into the creative potential of surrealism and the unconscious. The formats of conceptual

Diamonds (2000), Nick Knight/ Kate Moss/Sarah Morris

and video art from the 1960s and 1970s have appealed to some filmmakers while others have been drawn to the themes of experimental filmmaking including gender, identity, and self-presentation. At SHOWstudio, many films are driven by a conceptual, intellectual, or aesthetic premise.

In 2000, Nick Knight's *Diamonds* explored the aesthetics of surveillance culture in a shoot with Kate Moss. At a time of increased concern about the erosion of privacy in an increasingly "watched" culture, the viewer becomes voyeur as we observe Moss in a lift. *Sleep* (Nick Knight, 2001), a homage to Andy Warhol's 1963 art piece, was the first global, live-streamed fashion shoot. Stylists Simon

2.7
Bart Hess, *Shaved*, 2012. Screenshot from YouTube @Nowness.

Foxton, Jonathan Kaye, and Sidonie Barton dressed nine models in designer garments before they retired to their bedrooms in the Metropolitan Hotel to sleep live on webcam. Viewers logged in throughout the night to observe and participate in this fashion experiment. ***Anechoic*** (2006), a distinctive audio piece shot in the National Physical Laboratory's Anechoic Chamber, was the sound equivalent of a microscopic view of fashion that amplified the sounds of different fabrics. ***Place to Passage*** (Hussein Chalayan, 2003) blurred the boundaries between contemporary art and fashion with his multi-screen video installation. It depicted an odyssey between London and Istanbul and has been presented in galleries and art exhibitions globally. ***Dynamic Blooms*** (Nick Knight with Tell No One, 2011) combined contemporary dance, fashion, and flowers when Nick Knight and Alister Mackie transformed designer-clad model Monika Jagaciak into breathtaking flora.

Wonderwood (Brothers Quay, 2010) was the antithesis of glamorous perfume advertising. This conceptual commercial for Comme des Garçons fragrance by leading stop-motion animators Stephen and Timothy Quay featured puppets, diffused light, and an evocative soundtrack. ***Shaved*** (Bart Hess, 2012) conceived by the animator, photographer, and designer presented a swimmer covered head to toe in shaving foam who then shaves himself in a hypnotic performance. ***Paint Test No.1*** (Quentin Jones, 2012) was a cheeky wink to Dada. In it, the filmmaker, animator, and

2.8
Quentin Jones went back to basics for a low-fi classic that combined her own body and a bucket of black paint in *Paint Test No.1* (2012), for Nowness. Credits: Quentin Jones (director), Alex Franco (photography).

illustrator paints her naked self with a bucket of black paint. ***Suspension of Disbelief*** for Vionnet (Tim Walker, 2013), inspired by Tim Walker's story *Far Far from Land*, was featured in the experimental section of the Aesthetica Short Film Festival in 2013. It features the model Kirsten McMenamy floating in a human-sized fish tank and washing up on a rocky beach. ***Before & After*** (Polina Zaitseva, 2019), winner of SHOWstudio's 2019 Best Beauty Award, combined thought-provoking close-ups of lipsticks with scalpels and forceps with a rousing Edvard Grieg soundtrack. ***Hidden*** (DBLG, 2019), a triptych video installation created by DBLG fused Vincent Lapp's debut fashion collection, music, and visual art, immersed viewers in colored light and surround sound, and won SHOWstudio's Fashion Film Award. ***Torus*** (Nick Knight and Fredrik Tjærandsen, 2020) spotlighted the wearable bubbles of this designer's graduation collection and explored ideas of infinity, connectedness, and isolation. Experimental film allows directors to be daring and viewers to dream.

> "There are those films that use the camera to *reproduce*; and those that employ the resources of cinematography to *create*."
>
> Robert Bresson, *Notes on the Cinematographer*, 1975

Torus (2020), directed by Fredrik Tjærandsen and Nick Knight

Documenting Fashion on Film: Capturing "The Real"

Factual content forms the basis of documentary, and all documentary offers a version of the truth. But how facts are found, organized, and selected will define the final work. Objective reality is perceived by the filmmaker but presented subjectively; there is always an alternative view. In the last few decades, the fashion industry has become both the subject and producer of documentary, which has come to constitute a key strand of fashion filmmaking.

From legacy documentary that aims to assess and evaluate fashion industry icons to examinations of subculture or probing exposés that reveal hidden, often unpalatable truths about this superficially glossy world, the digital revolution has led to a renaissance of documentary filmmaking, with regular contributions appearing at film festivals and mainstream cinemas.

2.9
Long before it was fashionable for designers to "self-immortalize" through documentary, the father of British documentary-making Humphrey Jennings turned his camera on the creative process and output of Norman Hartnell, Queen Elizabeth II's dressmaker. *Making Fashion* (1938). Credits: Humphrey Jennings, BFI.

Capturing Reality: Documenting Fashion and Style

Documentary has long aimed to illuminate that which is usually hidden in the fashion world.

1938 In **Making Fashion**, Humphrey Jennings, one of British documentary's founding fathers (also known for *London can Take it!* (1940) and *Listen to Britain* (1942)) turned his camera onto Queen Elizabeth II's dressmaker, Norman Hartnell, for the first designer documentary.

1947 **Fashion Means Business** (USA) captured a booming fashion industry after the austerity of the war years. Featuring Hardy Amies, Brooke Cadwallader, and Jacques Fath, this was the first-time viewers caught a glimpse of Christian Dior's New Look.

1956 In **The Loire Valley Clog Maker** (*Le Sabotier du Val de Loire*) Jacques Demy tells the story of an artisanal clog maker, who crafts every detail with care. Made in the French village, Loire-Atlantique, La Chapelle-Basse-Mer, this is arguably the first 'process' film, which is now a favored approach with luxury brands.

1968 **The Queen** (USA), directed by Frank Simon, features New York's drag scene in the 1967 All-American Camp Beauty Contest. Re-released by Netflix in 2020, it predates *Paris is Burning* (Jeannie Livingstone, 1990) by over two decades, and was made when cross-dressing was treated as a criminal offence.

1975 **Grey Gardens**, by Albert and David Maysles (USA), focuses on two reclusive relatives of Jackie Kennedy Onassis: Edie Bouvier Beale (fifty-six) and her mother Edith (eighty-two) who inhabit a crumbling, twenty-eight-room, Long Island estate with cats and raccoons. This film has inspired many fashion designers and stylists.

1977 When Vivienne Westwood and Malcolm Maclaren were mining fetish wear as a key component of the punk look and spirit, **Dressing for Pleasure** (UK) (John Sampson) shone a fascinating light on the authentic fetish scene including a cameo by Jordan, a key figure in early British punk.

1989 The lyrical and poetic documentary **Notebooks on Cities and Clothes** by German director Wim Wenders (*Wings of Desire*, 1987; *Paris Texas*, 1984) spotlights the work and creative endeavor behind the collections of conceptual designer, Yohji Yamamoto and is one of the more reflective designer documentaries.

Trailer for *Grey Gardens* (1975)

2.10
Poster for *The Queen* (1967), directed by Frank Simon. It was re-released by Netflix in 2020. Image Art/Contributor (via Getty Images).

1992 In the domestic British documentary **British Graffiti,** Valeri Vaughn (BFI) talks to rockabilly aficionados about their lifestyle, devotion to rockabilly, and how they would like to live in the 1950s. The title riffs on *American Graffiti*, a hit 1980s film set in 1950s America.

1995 One of the big screen's best designer documentaries, **Unzipped**, by Douglas Keeve, featured Keeve's then partner, Isaac Mizrahi. Screened in cinemas in 1995, this authentic, absorbing, and witty portrayal of the designer's process and captures the emotional demands of creating a collection.

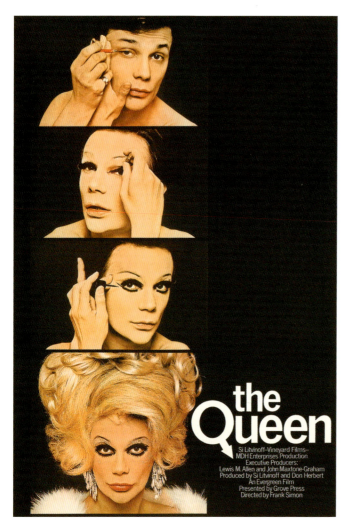

Post-Digital Slices of Fashion Life

One of the key questions of all documentaries regards access. How are filmmakers able to gain access to such exclusive domains (such as *Vogue*) or remote subjects including leading designers? By being granted access, what restrictions and limitations are placed on the filmmaker? Who decides on the final cut? Who controls the story? When living designers co-produce such films, the filmmaker's scope and freedom may be curtailed and there may be a conflict of interest as designers and their marketing/PR teams seek to protect their image. The reality is that what makes great drama may not be so great for the brand. Also, documentary *style* and documentary *substance* do not always coalesce.

Icons of the fashion industry, both alive and dead, have provided inspirational fare for documentary-makers in the last two decades. *The September Issue* (R. J. Cutler, 2009) takes us behind the scenes of American *Vogue*, as the formidable editor Anna Wintour presides over a record 840 pages. Revealing passions and personalities, it's an insight into the usually locked doors of fashion's armor-plated tower. *Bill Cunningham New York* (Richard Press, 2010) captures reclusive veteran *New York Times* photographer Bill

Cunningham in an intimate portrait before his death in 2016 and puts his huge contribution to street photography on the map. *Diana Vreeland: The Eye Has to Travel* (Lisa Immordino Vreeland, 2011) uses Vreeland's distinctive voice alongside skillful editing to pay homage to the life and times of former editor of Harper's Bazaar. *Iris* (Albert Maysles, 2014) is a verité portrait of centurion plus Iris Apfel, long-time interior designer and style icon. Many designers have welcomed filmmakers into their kingdoms, keen to preserve their legacy, including Armani and Karl Lagerfeld. *Valentino – The Last Emperor* (Matt Tyrnauer, 2009) follows the Italian designer as he prepares for his final show after announcing his retirement in 2007.

In documentary, the editing, selection, cutting, and sequencing of visuals and action defines the narrative. Many of the documentaries made about living fashion designers amount to mythologizing works which serve to maintain and protect the branded halo around the subject. When documentaries are made by fashion outsiders or undercover, greater insights or revelations are more likely. Several notable films have examined fashion's poor record in ethics and sustainability, asking uncomfortable questions or presenting challenging realities beneath fashion's glossy image. *China Blue* (Micha X Peled, 2005), shot secretly, examines the harsh conditions of denim manufacturing in the Southern city of Shaxi where workers are paid as little as 6 cents an hour for shifts as long as twenty hours. *The True Cost* (Andrew Morgan, 2015), an examination of global fashion manufacturing, reveals the human and environmental

2.11
The erotic pleasure of fetish wear is celebrated in *Dressing for Pleasure*, a 1977 documentary directed by John Sampson, released at a time when punk was absorbing fetish wear into its lexicon of transgressive style. Image from the book *Dressing for Pleasure* by Jonny Trunk (FUEL Publishing, 2010).

cost. Underage models were the focus in *Girl Model* (David Redmon and Ashley Sabin, 2011), a documentary shot between Siberia and Tokyo.

Subcultures have also provided fertile territory for filmmakers and some excellent work gives an insight into the individuals within these groups. *Fresh Dressed* (Sacha Jenkins, 2015) presents the history of hip hop and urban fashion from its roots in cotton plantations through to corporate America. It draws together the relationships between gang culture and graffiti and features legendary boutique owner Dapper Dan. This was the winner of the Grand Jury Documentary Prize at the Sundance Festival in 2015 and includes archive footage and interviews with Kanye West, Pharrell Williams, and Sean Puffy Combs.

Fashion on the Big Screen: Narrative and Storytelling

Cinema has always given us films *about* fashion. An industry full of larger-than-life characters and daily off-screen dramas lends itself to cinematic treatment. Alongside films that create stories inspired *by* the fashion world are movies that capture the cultural mood of their times or zeitgeist, be this with a theme, approach, or aesthetic that in turn may inspire fashion.

2.12
British actress Audrey Hepburn's character Jo Stockton was inspired by Suzy Parker, the supermodel of her day. Parker appears in a cameo in the "Think Pink!" scene in *Funny Face* (1957). Mondadori Portfolio/Contributor (via Getty Images).

Films of the Moment

The "it" films of any generation embody the values, desires, aspirations, and dreams of the moment.

2.13
Screenshot of *Jubilee* featuring Jordan, directed by Derek Jarman (1978).

1957 *Funny Face* (USA) (Stanley Donen with Audrey Hepburn (USA) starred Audrey Hepburn as a fashion model and was inspired by Diana Vreeland's editorship of *Harper's Bazaar*. It featured costumes by Givenchy and Fred Astaire, and the photographer character was inspired by Richard Avedon.

1960 *Breathless* (*A Bout de Soufflé*) (France) (Jean-Luc Godard with Jean Seberg) is a key film in the French New Wave (*Nouvelle Vague*) movement of filmmaking that captured a youthful, fresh approach of *actuality* or life "as it happened." Shot on handheld cameras, it reflected the speed and aspirations of the time.

1966 *Who Are You, Polly Magoo?* (*Qui êtes-vous, Polly Magoo?*) (France) by William Klein is a black and white, art house satire reflecting the cruel and compelling world of fashion modeling.

1966 *Blow Up* (Michelangelo Antonioni with David Hemmings and Jane Birkin) is an art house murder mystery which features a fashion photographer who witnesses a murder. Filmed during the swinging sixties, the main character is believed to be inspired by David Bailey.

1972 *The Bitter Tears of Petra von Kant* (Germany) (Rainer Werner Fassbinder) focuses on a gay female fashion designer, and stars

Trailer for *Prêt-à-Porter* (1994)

Margit Carstensen and Hannah Schygulla. Directed by one of Germany's most prolific directors, the elegant costumes have inspired collections by Prada.

1975 *Belle de Jour* (Luis Buñuel with Catherine Deneuve) features a bored, bourgeois stay-at-home spouse who becomes a sex worker by night for thrills. Catherine Deneuve would go on to be a close friend of Yves Saint Laurent and the film has inspired many fashion collections.

1977 *Jubilee* (UK) (Derek Jarman with Jordan, The Slits, and Lindsay Kemp) is the film embodiment of punk which provided a counter cultural and subversive jubilee in the year Queen Elizabeth II marked her own silver jubilee. A classic of its time, Jarman cast Tilda Swinton as Elizabeth I.

1978 *Eyes of Laura Mars* (USA) (Irvin Kershner with Faye Dunaway) is a supernatural thriller about a fashion photographer who can see into the future. It stars Faye Dunaway and combines 1970s languid glamour with menace.

1989 A powerful indictment of racism in New York in the 1980s, *Do the Right Thing* (USA) (Spike Lee) has a rousing soundtrack, captures a slice of New York's street style, and stars Rosie Perez in a memorable role.

1994 *Prêt-à-Porter* (USA) (Robert Altman with multiple fashion cameos) was shot live at the international collections with a whole host of fashion industry cameos. It was criticized as one of his lesser works but its reputation has grown over time.

2.14
The tortured Sapphic relationship of a fashion designer is offset by the memorable costumes and wigs of costume creator Maja Lemcke in *The Bitter Tears of Petra Von Kant*, directed by Rainer Werner Fassbinder in 1972. German actresses Margit Carstensen and Eva Mattes are seen here on the set of the film. Sunset Boulevard/Contributor (via Getty Images).

Post-Millennial Fashion on the Big Screen

In the Mood for Love (Wong Kar-Wai, 2000) was described by *Vogue* as "the ultimate fashion romance." Period-accurate depictions of fashion and textile trends in 1960s Hong Kong inspired the collections of Roberto Cavalli, Erdem, and Derek Lam. William Chang, dual costume and production designer, and director of photography Chris Dove created a film of dreamlike beauty about forbidden love, which became a

modern classic. *A Single Man* (Tom Ford, 2009) was based on Christopher Isherwood's 1964 novel of the same name, and was designer Tom Ford's directorial debut. His aesthetic sense is evident in every shot and scene, and the film has been described by some as looking like an advertorial for *Wallpaper** magazine; Professor George Falconer will go down as the chicest professor ever depicted on screen.

The comedy *The Devil Wears Prada* (David Frankel, 2006) with Meryl Streep as Miranda Priestly, the fierce editor of an American fashion magazine, and Anne Hathaway as the new intern, was based on a *New York Times* bestseller by Lauren Weisberger. The author, Anna Wintour's former assistant, is believed to have drawn much inspiration from her old boss for the main character. *Sex and the City* (Michael Patrick King, 2008) was based on the drama series of four female friends in New York (Carrie, Samantha, Charlotte, and Miranda). Starring Jessica Parker as fictional fashion writer Carrie Bradshaw, it was styled by Patricia Field who through Carrie Bradshaw's character introduced the world to Manolo Blahnik shoes, saddle bags, and personalized necklaces. *Absolutely Fabulous* (Mandie Fletcher, 2016), based on the British TV comedy series, depicts the absurd world of fashion PR with Jennifer Saunders as Edina Monsoon, a fashion PR, and Joanna Lumley as her alcoholic best friend, Patsy Stone.

With lives often full of drama, fashion designers make fascinating subjects for films. *Coco Before Chanel* (Anne Fontaine, 2009) depicts the designer's early life. She hated the uniforms she was forced to wear in the orphanage so much that she ended up giving women their very own. Another enigma captured on film after his death was Yves Saint Laurent in *Saint Laurent* (Bertrand Bonello, 2014). Painfully shy, Saint Laurent's life was plagued by mental health issues and periodic dependence on drugs and alcohol. *Phantom Thread* (Paul Thomas Anderson, 2017), Daniel Day Lewis's last role before retiring, was inspired by the lesser known, troubled, genius designer Charles James. *Rage* (Sally Potter, 2009), by the director of the Oscar-nominated *Orlando*, is a satirical mystery located at a New York fashion show, when a runway accident turns into a murder investigation. Starring model Lily Cole, Jude Law in drag, and Judi Dench as a fashion critic, it comments on the internet's age of compulsive confession. Horror meets comedy when a haunted dress torments various owners in Peter Strickland's *In Fabric* (2018). Set in the busy sale season of a department store, this garment is imbued with the power to disrupt lives and create havoc.

IN FOCUS

Fashion's favorite directors

Fashion creatives often admire film directors with a heightened aesthetic and visual sense: the Italian neo-realism films of Roberto Rossellini influenced Dolce & Gabbana; Karl Lagerfeld adored the baroque splendor of Federico Fellini; while Yves Saint Laurent was fascinated by Luis Buñuel who introduced him to the beauty of Catherine Deneuve, who would become his long-time muse. Other visually iconic directors whose influences can be seen on catwalks, styling shoots, and fashion films include Jean-Luc Godard, Alfred Hitchcock, Stanley Kubrick, Dario Argento, David Lynch, Wong Kar-Wai, Jane Campion, Zhang Yimou, and Wes Anderson.

Hybridizing Fashion: Subculture, Music, and Film

2.15
A shot from *The Hat Videos* directed by Isaac Julien in 1987, pictured here, for Bernstock & Spiers was used in Isaac Julien's art film, *This is not an AIDS advertisement.* © Isaac Julien.

2.16
Behind the scenes of Bodymap's film, *Bodymappism* (1985) with illustrated backdrop. © Stevie Stewart.

The 1980s were a heyday for fashion film. In these pre-internet years, there was an appetite for putting fashion into movement and on video. Fashion designers teamed up with film directors to experiment with the short video form or made their own. *Tatler* stylist, then fashion's *enfant terrible,* Michael Roberts, directed a re-telling of a *Midsummer Night's Dream* for knitwear brand, Joseph. Also in this decade, photographer Cindy Palmano made a video for Georgina Godley's *House of Beauty & Culture*, while fashion designers Antony Price, Bella Freud, and Pam Hogg experimented with film and moving image as an alternative or complementary mode of fashion communication.

It wasn't unusual for fashion editors to be commissioned by record labels to style artists and performers, a practice that continues today. Alongside his day job at *Blitz*, Iain R. Webb styled bands including the Pet Shop Boys, and John Maybury directed iconic music videos including Sinead O'Connor's *Nothing Compares 2 U* and Neneh Cherry's *Buffalo Stance,* styled by Judy Blame. Quintessentially stylish, they remain visually arresting three decades later.

Film Fusion: Style, Music, and Subculture

The roots of fashion film were laid many years before the internet arrived through the cultural collaborations of the 1980s.

1985 *Slave to the Rhythm* featured Grace Jones and was directed by her then partner, Jean-Paul Goude. He cut and sliced images and graphics of the performer to startling effect, creating a surreal, visually punchy, and highly stylized video that was bold and exciting.

1986 *Punk Rock Bodymap,* directed by Judy Montgomery, featured catwalk footage of Bodymap's Half World collection. Intercut with cool kids outside London's Flamingo Club and model Barry Kamen taking flight as Icarus. The music was by Nadjma, an Iraqi synth-pop vocalist from 'Rapture in Bagdad' and reworked by Adrian Sherwood.

1986 *Hail the New Puritan*, a 16 mm mockumentary by Charles Atlas, featured Michael Clark and music by Mark E Smith and The Fall. A fictionalized portrait of the enfant terrible of British dance, this day-in-the-life portrait follows his preparation for a performance of The New Puritans.

1986 *Addicted to Love* was shot by fashion photographer Terence Donovan and styled by British *Vogue* fashion editor Elizabeth Tilberus (the future editor of the US *Harper's Bazaar*). The lip-syncing supermodels wore clinging Azzedine Alaia and pretended to play guitar in this cheesy classic of its time.

1987 The hat designs of Paul Bernstock and Thelma Spiers formed the basis of two short videos by visual artist Isaac Julien entitled *The Hat Videos* for Bernstock & Spiers for S/S 1987. These are not available to view online although one of them reappears as part of *This is Not an AIDS advertisement* by Isaac Julien.

1988 *Buffalo Stance* by Neneh Cherry was styled by Judy Blame and filmed by John Maybury. Blame, an influential stylist, helped create an iconic and powerful image for the performer which combined feminism and fierce sexuality.

1989– *Millennium* and *Afrodizia* **were
1990 two films** by John Maybury for Rifat Özbek's A/W 1989/1990 and S/S 1990 collections. The latter featured the performance artist Leigh Bowery as a gold Buddha.

Neneh Cherry, *Buffalo Stance* (1988)

2.17
John Maybury's
film for Rifat
Özbek S/S 1990
collection fused
club culture,
film, and fashion
and was the
primary medium
through which
the collection
was displayed.
Afrodizia (1988).
© John Maybury
(director).

1990 Sinead O Connor's music video
Nothing Compares 2U was shot by
John Maybury. In cool black and
white, it was stylishly "unstyled,"
featuring the performer's shaved
head, black leather jacket,
washed-out jeans, and shades,
and has stood the test of time.

2000 *Accelerator* was Pam Hogg's first
feature film featuring 1960s It Girl,
Anita Pallenberg alongside Bobbie
Gillespie of Primal Scream and
Patti Palladin.

"The video short is beginning
to take over from the traditional
catwalk show. The design
duo Richmond & Conejo
showed a film at the back
of their catwalk show that
was reminiscent of Le Chien
Andalou (which also opened
David Bowie's Thin White
Duke show.) Catwalk footage
was layered with a model and
graphics proclaiming: Destroy,
Disorientate, Disorder, which
was the slogan and ethos of the
design double act. There was
also a little film by Bic Owen
for the clubwear designer,
Pam Hogg which was a Stevie
Hughes/Bill King fashion
spread come to life."

Iain R. Webb, *Blitz* magazine editorial, 1986

IN FOCUS

MTV's influence on the emergence of 1980s fashion film

One of the reasons British fashion designers discovered the power of video in the 1980s was the arrival of MTV (short for Music TV). This 24-hour music channel launched in the US in 1981 and arrived in the UK in 1987 and effectively created a new home and purpose for the music/fashion/film dynamic. While music, fashion, and style have a longstanding relationship (think of the unforgettable looks of Little Richard, Elvis, The Beatles, Sex Pistols, and David Bowie), this new era of music video meant music and style became more entwined. A valuable tool in the drive for music sales, key fashion and music crossovers can be found in the videos and images of Roxy Music, Pet Shop Boys, Madonna, Björk, and Prince.

IN FOCUS

1980s fashion film pioneer: John Maybury

John Maybury became a key figure in fashion filmmaking during the 1980s and became a mainstream director of successful features including *Love is the Devil* (1998) about artist Lucien Freud. In a significant departure from the traditional catwalk presentation, fashion designer Rifat Özbek (British Designer of the Year 1988, 1992) commissioned two Maybury films: *Millennium* (1989), inspired by Özbek's space age collection, and *Afrodizia* (1990), a twenty-minute digital production focusing on his club-inspired collection. It received mixed reviews from press who "felt frustrated because they were expecting a live show," believes Maybury.

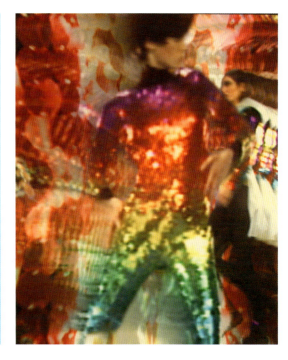

2.18
A multi-colored sequinned outfit from Rifat Özbek's S/S 1990 collection. *Afrodizia* (1988) lso featured Leigh Bowery. © John Maybury (director).

IN THEIR OWN WORDS: JOHN MAYBURY

A fashion film should take viewers on a journey to another place.

"Fashion is an emotional, moving, beautiful thing. There is a precision in fashion that in movement takes on a poetry. When we see fashion on the red carpet, using flash, it becomes fast and crude. My heart lies with experimental cinema which provides a more interesting context. I love a close-up; the human face is the most interesting landscape. Detail shots of clothes have a similar effect and can show a quality that is mind-blowing. I'm constantly astonished by the craftsmanship of the fashion designer. Film allows an intimacy with the clothes.

There is a distinction between the conceptual fashion film and one where designers are actively involved in the process. Fashion films should respond to the concept of a collection; garments have a narrative of their own substance. How a model moves and translates the collection into movement is fascinating. In 1983, I was given a video camera and in 1984, I filmed all the catwalk shows on video. Before that in 1980, I was involved in an Antony Price show with Marie Helvin and Jerry Hall. They wore motorcycle jackets and crash helmets. I shot tin foil dresses and corsetry on Super 8 in a theater. Fashion film could and should be its own thing because fashion is a visual language.

Moving image is a dynamic language. Both Rifat Özbek and Alexander McQueen wanted to break out of catwalk restraints. Rifat felt they were a tired formula over which a designer had limited control. He wanted to do something modern, to pull the collection into a visual context that would imbue an atmosphere and take the viewer on a journey. Compared to the restraints I have faced working within the music industry, Rifat was a dream. I was allowed to go bonkers, but the clothes were always respected.

Millennium cost 25,000 pounds and was 25-minutes long. It was a non-narrative piece show to the sounds of Pink Floyd and Acid House. It featured a rotating Leigh Bowery dressed as a gold Buddha alongside models Helena Christensen, Yasmin le Bon, and Lesley Winer but really it was all about the clothes which, as a director, was liberating. The clothes were inspired by the cosmic and space age with multi-colored giant sequins. We showed the film in a blacked-out room with fairy lights. While some of the press went wild for it—this was the future!—some fashionistas who turned up expecting to see a show were frustrated by it.

Afrodizia was entirely digital. The feel was more tribal, modern, and electronic. It bought together couture sportswear and featured Lorraine Pascale and Naomi Campbell as models; the It Girls of the moment. Catwalk shows could be chaos—pandemonium but with this, there was no knife edge of a catwalk show where everything could go wrong. With a film, the designer was in control. These films were non-narrative; each film has passages and the backgrounds were made from details of the clothes. Inspired by Kubrick's 2001: *A Space Odyssey*, you saw the models walking through these stylescapes."

Video makes the whole presentation more exacting. It allows you to show the full figure and the detail but in an exciting context. It doesn't distract the viewer from the clothes but draws them in. Rifat was able to put together every outfit with accessories and control exactly how every outfit looked. Rifat adored the films although they had mixed reviews. The Bowery film was shown at nightclub Taboo and in a few film festivals where it caused a stir in the experimental section. Fashion people didn't care for it much because they felt they were missing the live experience of a show. A fashion film should take viewers on a journey to another place.

IN THEIR OWN WORDS: ISAAC JULIEN CBE

These films form a visual archive ... of rare and original collaborations.

"As an art student at Saint Martin's School of Art (now CSM), in the 1980s Isaac Julien CBE was making films for his fashion friends Paul Bernstock and Thelma Spiers, who would become the millinery duo *Bernstock & Spiers*. These films were presented in a showroom and at Mr. Chow Restaurant in Knightsbridge, then also a nightclub.

My relationship to Bernstock & Spiers was like that of John Maybury and David Holah of Bodymap. There was a whole school of thought—a Middlesex Polytechnic posse of design—that was about experimental film, fashion, music, performance all entwined. Iain R. Web, then fashion editor of *Blitz*, was art directing; Thelma Spiers was the stylist; Nina Kellgren was the director of cinematographer. I would edit the film to a soundtrack, usually perfected as a disco track mixed in advance for the catwalk, which sounded closer in style to being at a disco club like Taboo in London which mixed between catwalk and discothèque melodies with some classical overtures to Bach.

Visually, the video art techniques I deployed, like video color solarization and slowing down of the image, reflected an in-depth study of portraiture focusing on the model's face and queering the gaze. There were both classical and more contemporary dance motifs in the work. At the time, I was looking at the role of the model in Italian Renaissance portraiture and studying black and white photographs of George Platt Lynes.

The first film in the series had an ambience of visual interiority and was more self-reflexive. The second emulated the aesthetics of the catwalk as 'fashion genre.' The sonic design element utilized DJing, which a lot of young artists were appropriating at the time. There was a symbiotic identity between being a DJ, designer, and clubber—making art or making films was de rigueur, a hallmark of both eighties artists and fashion designers. The first film was made at the height of eighties video art where the scratching methods of DJing and rap were appropriated into video art.

In response to the AIDS pandemic, I made a film entitled *This is not an AIDS Advertisement* (1987) that utilized footage from the two Bernstock & Spiers films in the second half.

It was a video art advert for queer desire against the moralism being espoused by the dominant media at the time. Audiences are still demanding to see *This is not an AIDS Advertisement* thirty years later.

The films epitomize the style of video art and fashion subculture before the rise of today's fashion commodification—and something in the shadow of punk rock and the early years of the AIDS pandemic. You would go to clubs and how you dressed was not seen as separate to the work you produced; performance and self-fashioning were as important as the art you made. If you went to a club, you were likely to bump into Peter Doig, Pet Shops Boys, John Galliano, Derek Jarman, Leigh Bowery, John Maybury, Bernstock & Spiers, to name but a few.

Then, there was a fluidity in relation to fashion, film, and photography. The art and fashion worlds had not yet been demarcated and hardened into market, branding as they are today. These films form a visual archive of the beginnings of these rare and original collaborations where ideas between art and fashion were expressed in opposition within spaces and realms of subculture's which we may take for granted today."

This is Not an AIDS Advertisement (1987), by Isaac Julien

2.19
Visual artist and director Isaac Julien on the set of *Looking for Langston* (1989). All footage courtesy of the artist, Isaac Julien, and Victoria Miro, London.

Summary

- Although the internet and digitization catalyzed fashion film, the form existed in a pre-digital age.
- Historically, fashion film can in found in commercials, newsreels, and broadcast media, as well as in experimental film, documentary-making, music video, and feature films.
- By looking at pre-internet fashion films, it's possible to appreciate the form's connection with other strands of media, the arts, and culture.
- The arrival of MTV to the UK and consequent rise of music video can be linked to the wave of fashion film in the 1980s. Only some of this has been digitized and can be found online.

Exercises

Explore different approaches to documentary-making

Documentary is a non-fictional approach to filmmaking that can fall into many sub-categories from poetic (evokes a mood or feeling rather than proving a point through linear narrative structure), observational (presenting "real life" as it unfolds with no voiceover, interviews, or soundtrack), participatory (a collaborative production that engages subjects in the storytelling process), or expository (sets up a specific point of view or argument). Choose one of the documentaries from the earlier lists. What type of documentary is it and how does it engage the viewer?

Consider the fashion documentary-maker's perspective. Are they on the inside looking out or the outside looking in?

Look at a documentary by a fashion insider and one by a fashion outsider. (You can establish this by assessing their earlier work and how connected they are to the fashion industry). Compare and contrast questions of access, control, funding, and the filmmaker's agency. What is the relationship between the filmmaker and the subject? What aren't we seeing? What has been edited out?

3

The Contemporary Landscape

"The internet …
became the native
platform for fashion
film, enabling the genre
to reach an audience
and for filmmakers
to experiment with
artistic, technological
values."

Marie Schuller, filmmaker

The early years of the twenty-first century saw the fashion communication landscape shift in unimaginable ways. While the analogue world laid the foundation for fashion film, digital culture allowed it to flourish. The internet, inclusive, immediate, and global, supported a variety of media formats and bought unchartered opportunities to the fashion industry and audiences. Through new portals, platforms, and streaming services, online fashion culture soon spanned retail to publishing, curation to fandom.

Inextricably linked with this, mobile technology became increasingly sophisticated, resulting in the everyday pocket computers we now know as smartphones. These combined advances made it possible for every brand, from multi-conglomerates to small businesses and leftfield bloggers, to have their own editorial platform or voice. A new democracy of communication meant all were able to channel relevant content directly to audiences. In this great transmedia mélange, film and moving image came to play a vital role.

3.1
Social media and a growing awareness of social issues including white privilege has meant traditional publications have had to readdress their content and audiences. #representationmatters Vogue.de. © Ekua King for *Vogue* Germany. Credits: Alexandra Bondi de Antoni and Tereza Mundilová (creative director), and Poliana Baumgarten (DoP). © Judith Pöverlein, PR Manager *Vogue* Germany.

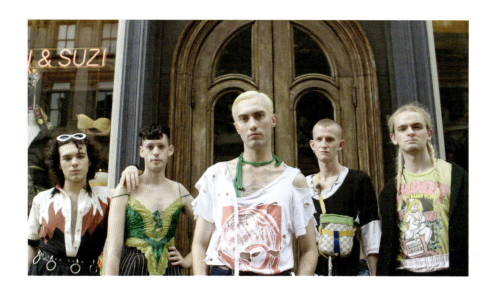

3.2
An *i-D* documentary that focuses on the Loverboy founder, Charles Jeffrey, and his closest collaborators as they create an installation for Dover Street Market. *Loverboy Takes NY*, 2016. Tom Ivin (director), Declan Higgins (producer). Images from *i-D*.

3.3
Mobile phone culture became a central part of communication through which everyday lives were mediated. Here, young women in Tokyo, Japan take selfies to celebrate Coming of Age Day when they turn twenty years old. January 13, 2003. Photo by Junko Kimura/ Getty Images.

3.4
Early black and white BTS screenshot (2005) featuring supermodel Linda Evangelista and fashion photographer Peter Lindbergh. Credits: *Moving Fashion* (2005), Peter Lindbergh.

Linda Evangelista behind the scenes on a Peter Lindbergh shoot (2005)

IN FOCUS

Technology takes us behind the scenes

With its tagline "the home of fashion film," SHOWstudio was the first portal to recognize the potential of digital culture and the internet to change the production and consumption of fashion image-making. Founder Nick Knight sought to make fashion more transparent, to *show* viewers inside the studio, hence the name. Opportunities to witness previously hidden aspects of the industry including the live practice of designers, stylists, makeup artists, and photographers, through film and streaming, offered fresh content for audiences and made a previously fortressed world more accessible.

Imperfect Beauty: *The Making of Contemporary Fashion Photography* (2000), an exhibition curated by Charlotte Cotton for the Victoria & Albert Museum, focused on the collaborative, unseen labor involved in fashion image-making. This desire to go beyond the surface, stimulated and facilitated by new technologies, spawned its own sub-genre of fashion film with its own acronym. Behind the scenes, or BTS, focused on the "making" process of fashion shoots or design products. This format become popular with brands to cultivate deeper engagement with viewers. For fashion followers, the opening of this once elite world meant greater access to communities, markets, information, entertainment, news, imagery, and inspiration.

Growing Status and Visibility for Fashion Film

Fashion film's second decade of the new millennium kicked off with great fanfare as multiple stars of the movie-making world were hired by fashion houses to create films for their brands. As noted in Chapter 2, 2010 saw Kenneth Anger lured out of obscurity by Missoni and David Lynch enlisted by Christian Dior. Jean-Pierre Jeunet (*Delicatessen*, 1991; *Amelie*, 2001) directed for Chanel in 2012; Wes Anderson (*Moonrise Kingdom*, 2012) directed for Prada 2015; and Baz Luhrmann (*Moulin Rouge!*, 2001; *The Great Gatsby*, 2013) created a lavish short for Erdem's H&M collaboration in 2017. While paying for the vision of an A-list director ensures press attention for fashion brands, this investment also indicates the increased importance of fashion film.

3.5
SHOWstudio made the idea of seeing behind the scenes a core tenet of the platform philosophy, hence the name SHOWstudio. The creative genius of Alexander McQueen is captured in *Transformer; The Bridegroom Stripped Bare* (2002). Credits: Nick Knight (photographer), Alexander McQueen (designer).

Jean-Pierre Jeunet directed for Chanel in 2012

ERDEM X H&M, *The Secret Life of Flowers* directed by Baz Luhrmann (2017)

IN FOCUS

Curating fashion film

In 2009, SHOWstudio was the subject of a ten-year retrospective, Revolution, at Somerset House and in 2012, fashion film was the subject of a major, globally touring exhibition from the British Council who commissioned filmmaker Kathryn Ferguson to curate *Dressing the Screen*: *The Rise of Fashion Film*. Comprising exhibitions, talks, and workshops in ten different cities across the world including Beijing, Singapore, and Moscow, Harriet Seabourne wrote in the online introduction that the show reflected "a departure from aesthetically driven look book style of the past towards films driven by narrative and concepts shaped by new technologies."

Social Media and Fashion Film

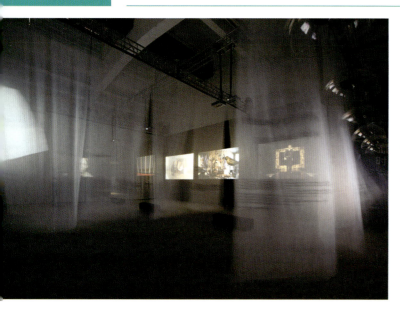

3.6
Exploring fashion film beyond the prosaic catalog and look book approach, The British Council funded Dressing the Screen, a touring exhibition, seen here in Beijing, 2012. Credits: The exhibition space at the UCCA Gallery in Beijing's 798 Art District, designed by British architectural firm Serie, Architects. Photograph by Seri.

Digitization and connectivity compelled fashion's formerly closed world to open its doors and invite fans and consumers inside. Brands developed social media profiles across a range of platforms to communicate directly with customers and facilitate two-way conversation. It was now possible for audiences to enter into dialogue with brands rather than simply having fashion dictated from on high. At the vanguard of this were a new generation of fashion bloggers who, with their impressive followings, became influential opinion formers. Billy Boy, Tommy Tom, and Scott Schulman of *FaceHunter* appeared on the front row of the Dolce & Gabbana catwalk show in 2011, posting live from the catwalks. Some print journalists were irked by this disruption to the traditional hierarchy and although this was a one-off season, it made a bold statement about shifting power in a morphing landscape.

Successful bloggers could work independently and capitalize on opportunities for affiliate advertising or brand partnerships. The use of film by fashion bloggers and vloggers (video bloggers) bought new voices and approaches to mainstream media. At their most influential, they could call fashion brands to account, potentially shaping views of young audiences in the way that traditional print doyennes once did with their readerships.

For filmmakers and film providers, social media channels such as YouTube, Facebook, Instagram, Twitter, and TikTok became open channels for the instant transmission of fashion film and short videos to audiences. In return, followers could like, comment on, and share films which could potentially go viral. In 2018, TikTok, social media video, was the most downloaded app of the year. Featuring stickers,

Further evidence of fashion film's heightened status was the growth in specialist festivals. For several years, Diane Pernet's annual event A Shaded View on Fashion Film (ASOVFF), which launched in 2008, was a solitary trailblazer but this was soon joined by fashion film festivals on every continent. From La Jolla in Los Angeles to Bokeh in South Africa, the form was being celebrated in Istanbul, New York, Berlin, Milan, and many more world capitals.

At these events, complete with awards, trophies, networking opportunities, and parties, filmmakers, enthusiasts, and industry congregated to spotlight and celebrate the best fashion films. As well as specialist festivals, already established short film festivals such as the London Short Film Festival and Aesthetica Short Film Festival began to include fashion film strands alongside established categories such as Thriller and Animation.

Fashion Film and Online Editorial

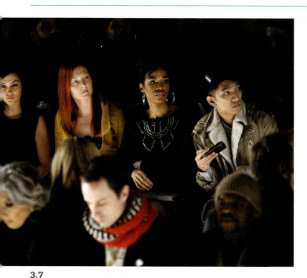

3.7
Influencers were invited to fashion shows and brought new voices and views to their audiences. DJ Leigh Lezark, model Maggie Rizer, singer Michelle Williams, and blogger Bryan Boy attended Mercedes Benz fashion week and the BCBG MaxAzria Fall 2010 Fashion Show, 2010. Credits: Jason Kempin/Getty Images for IMG.

Since the early digital days when SHOWstudio shone a solitary light on fashion film, there is now a significant online culture of fashion film. From specialist platforms, such as *Specialten* magazine and Nowness, to glossy high-end titles like *Harpers*, *Glamour*, and *Vogue,* youth titles, including *Vice* and *Dazed* magazine, to industry titles, such as *Business of Fashion*, these spaces offer a rich, engaging experience to today's transmedia fashion consumers.

From an editor's perspective, there are many advantages to online moving image editorials. In news publications, for instance, editors can respond instantly across multiple channels and produce films to reflect immediate interests or current agendas. In terms of brand partnerships, films can incorporate click-through merchandise for a more immediate shopping experience. It is possible to combine films with complementary follow-through data or relevant articles to encourage a conversation around subjects using chat boxes or forums. This media mix sets up a different power relationship between producers and consumers and means fashion viewers are no longer passive receivers of top-down edicts, once the standard practice of fashion print media in the pre-internet era. Social media allows editors to examine data (through Google Analytics) and understand where their viewers come from and what content they have engaged with the most.

filters, and augmented reality, followers could share short, fun videos. Fledgling stylists, influencers, and fashion enthusiasts have flocked to TikTok to create cute, funny, and accessible content. Ryan White, Features Editor of *i-D*, believes the move to vertical videos has "democratized its creation and allowed for user-submitted iPhone footage to be added to the mix. As we see on Instagram and TikTok, the most engaging videos are no longer solely the ones shot by traditional means."

Social media offers digital spaces where films can be launched. *Vimeo* can create significant leverage for filmmakers especially if chosen for their Staff Picks. Alongside opportunities for promotion, filmmakers can also meet other like-minded creatives. Geography is no longer a barrier and digital networking takes place across cities and countries. Social media's strengthening relationship with fashion is illustrated by YouTube's dedicated fashion and beauty channel led by Derek Charles Blasberg, where Marc Jacobs and Naomi Campbell have their own programs.

"Looking at data is important, but you must always pair it with ideas and gut feeling. With editorial, data alone is never enough."

Alexandra Bondi de Antoni, Vogue.de

Björk, *The Gate* (2017), directed by Andrew Thomas Huang

A case study in multi-platform storytelling

"Storytelling is about creating, dissecting, and analyzing the content then amplifying it across platforms, not just distribution. For instance, we have various categories at Nowness such as Define Beauty and In Residence (about architecture) So, the film and story must be relevant to the platform's audience and target specific interests that foster dialogue beyond snackable content. In the Björk collaboration with Gucci and Dazed Media, Gucci made the costumes, we premiered the video on Nowness and there was also a cover for *Dazed* magazine starring Björk. The print version was one thing and the launch, another. We did Facebook Live with the video director, Andrew Thomas Huang, Björk and Jefferson Hack."

Ahmad Swaid, Head of Content at Dazed and Nowness (2016–2019)

The Fashion Industry and Instagram

While several social media channels have come and gone, with some gaining popularity for a period until superseded by something more relevant, Instagram has held its position as the fashion industry's social media channel of choice, although in the future this may change. As a visual platform, it is globally accessible and hosts an international community of visual practitioners who can communicate with images rather than words. For online publishers and filmmakers, Instagram brings many opportunities including Instagram TV, which allows for longform content, a recent area of creative and social entertainment. Ahmad Swaid, former Head of Content at Dazed and Nowness, believes social media channels like Instagram now compete for viewers against channels such as Netflix and Amazon Prime. He believes that "the trend for binge watching whole boxsets proves attention spans are growing, which means we can make longer films that people are more likely to watch."

"The video needs to be visually striking, have a good arc and be thinking about the platform it will live on. What comes first with any medium, whether print or stills, is the story."

Ahmad Swaid, Head of Content at Dazed and Nowness (2016–2019)

For publications with an older readership, social media provides an inroad to younger demographics. *Vogue* Germany, established in 1979 and Vogue.de, the digital platform, launched in 2000 with the aim of reaching new audiences and telling stories in diverse ways. Video forms a key part of the strategy and content spans backstage stories, films that develop out of cover stories or shoots, branded content, and video produced purely for social media and YouTube. Executive Editor of Vogue.

A case study
in socially responsive online editorial: Vogue.de

"A project I'm proud of is #representationmatters where we talked about racism in the German media landscape. We shot one video, produced lots of texts and had talent share their experiences over social platforms. Overall, we reached 30 million people. The project shows how digitally, you can work across different platforms to transmit an important message. We try to inspire, open eyes, make you laugh but also fall in love with beautiful images. We also want to educate and convey bigger messages."

Alexandra Bondi de Antoni

de Alexandra Bondi de Antoni sees Instagram Stories as an important platform for video-based stories such as takeovers by influencers or celebrities or real-time coverage of relevant occasions. She explains: "compared to the fashion film content, these videos are quicker and shot mostly on a mobile phone. Even though they seem unscripted, lots of planning goes in. *Vogue* Germany has become younger, more accessible, and more politically, socially engaged. Even though fashion and beauty will always be our core subjects, we need to talk about different and relevant topics."

"Growing our video presence allows us to reach more people without diluting the core message; fashion relates to every video we make. From meeting our favorite designers to spotlighting local and global youth culture trends, we want to know the team behind the brand as much as the kids who replicate their style."

Ryan White, Features Editor, *i-D*

"The whole 'is catwalk dead?' conversation was a boring discussion. Photographers didn't kill painting and filmmakers won't kill catwalk."

Ruth Hogben, filmmaker

3.8
The abstracted
vision of Ruth
Hogben combined
with Gareth
Pugh's S/S 2011
collection in a
spectacular digital
presentation.
*Gareth Pugh – S/S
2011 Film* (2011).
Credits: Ruth
Hogben (director).

Fashion Film on the Catwalk

Film as an alternative or complementary mode of presenting designer collections is not new and has been in evidence throughout the twentieth century (from Paul Poiret to Rudi Gernreich and Rifat Özbek; see Chapter 2) But Gareth Pugh's ground-breaking collaboration with Ruth Hogben legitimized and elevated the status of fashion film for the catwalk. Hogben, former assistant to Nick Knight, made a futuristic film to be screened on Pugh's catwalk in place of a live collection in S/S 2011. No matter what seat the audience sat in, front row or back, all could observe the garment clearly, from all angles. In fact, the audience saw more than would have been possible on a traditional catwalk with its limitations of space and audience perspective. Suzy Menkes wrote in the *New York Times*: "In its bravura, its beauty and its possibility of going viral to hundreds of millions of people via SHOWstudio and over the Internet, this grand slam in the virtual world poses a question that is increasingly being asked by both designers and executives: Is a fashion show really necessary."

Gareth Pugh has continued to experiment with the expansive catwalk experience. For his S/S 2015 collection, he worked with artist-filmmaker Andrew Thomas Huang to create an immersive experience. An LED screen triptych combined with a live choreographed performance designed to connect the audience emotionally with the creative process of making a collection. Philip Schütte, Creative Director of Random Studio, who work with Raf Simons on moving image productions for the catwalk, see their filmmaking as an "extension of the designer. We see visual communication as a digital fabric, an extension of actual

fabric on the runway." In S/S 2016, Tom Ford, a designer who has directed feature films (*A Single Man*, 2009; *Nocturnal Animals*, 2016) launched his S/S 2016 collection as a fashion film, directed by Nick Knight and starring Lady Gaga.

"We believe catwalk is a conversation and a chance to understand something more than you can see. Every collection is a statement or hypotheses of where things are going."

Philip Schütte, Creative Director, Random Studio

Fashion Film in Retail

Although initially slow to realize the potential of technology's global connectivity, businesses started to adapt more enthusiastically in the second decade of the new millennium. Early fashion films could be dull and unimaginative, akin to moving catalogs, but the digital revolution combined with the rise of e- and m-commerce changed customer expectations.

It became customary for moving image and short films to be embedded within brand websites and content became more sophisticated and innovative. In the terrestrial, pre-internet world, print or TV advertising was clearly delineated but in a wraparound, mobile culture of "e-tail," branded video content could be more discreet, and was sometimes impossible to distinguish from editorial.

As the sector expanded, the quantity of digital content grew. For creative agencies, publishing platforms, e- and m-commerce, it became important to deliver memorable rather than background films. Being able to present clothing or merchandise in movement, in the context of a narrative or an arresting visual sequence was more likely to capture the attention of viewers, and even more so if there is an emotional resonance.

Production agencies such as White Lodge, Badger & Wolf, and The Mill continue to provide a steady supply of films and creative content to brands, labels, and businesses. These creative hubs commission film directors and other creatives to generate many of the films we see in shop windows, within stores, or online. Advertisers and producers realize the more engaging their content, the longer consumers will stay on websites. Brands have come to recognize a campaign film represents better value for money than a traditional print campaign and can go further, across more channels, thus reaching more people.

Fashion films, with their visual punch and immediate accessibility, are not only to be found through the screens and portals of online spaces but in the bricks and mortar of physical environments, in shop windows and within store environments. These screens, known as DOOH (short for Digital Out of Home Screens) are specifically for instore, long-life, digital advertising displays. And increasingly within retail, the purpose of these is not only to sell product to consumers but to create an experience, turning stores into destinations which give something memorable and distinctive compared to the detached ease of online shopping.

Noir – Dice Kayek (2013) directed by Marie Schuller

3.11
Marco Miehling for the Art Block at Selfridges images (2019).
The film accompanied a sculpture. © Andrew Meredith 2020.

3.12
She, He, Me, co-directed by Kathryn Ferguson and Alex Turvey,
celebrated the diversity of non-binary gender through dance
and helped launch *Agenda*, a unisex department at Selfridges
in 2015. Alongside being presented in the store window to
attract passing trade, the film had significant traction online.
Selfridge's image. © Andrew Meredith 2020.

"We've used film to talk about sustainability,
diversity, gender, and much more. We hope
customers come to us to buy a lipstick but
leave with a little more; maybe a new idea,
shot of inspiration or the feeling they've
had an experience that transcends shop-
ping. Film has often been the most effective
medium for Selfridges to explore the idea of
retail activism."

Sarah McCullough, Director of Creative Direction at
Selfridges, 2017–2020

"Part of the visual and physical dialogue
between brands and their customers,
film supports the idea of 'buying into' the
brand and lifestyle."

Demetra Kolakis, Course Leader in Fashion Visual
Merchandising and Branding at the London College
of Fashion, UAL

IN FOCUS

Social media shapes fashion film formats

Liam S. Gleeson, Director and Founder of Hidden Agency

Brands want a twelve-month "always on" conversation with their consumers.

"Social media has been massively important and some of our campaigns are made specifically for this purpose. These films don't exist outside of social media. They can be as short as five seconds long, purely for a quick laugh or to grab attention; a type of digital guerrilla advertising.

It's important for filmmakers working on social media to analyze the demographics of audiences, depending on the brand. I often think of a brand as a coffee table magazine.

You need an intriguing front cover to draw people in and then it needs to be filled with amazing content, so big campaigns act as the front cover and social media as the magazine insides.

Luxury and streetwear brands will invariably have different approaches. It's not just about one or two big campaigns a year anymore. Brands want a twelve-month 'always on' conversation with their consumers and to present something new every five or six weeks. You'll do different shoots, and these will be carved up for social media use. So, it's more strategic to think long term and across channels. If used responsibly, social media can be an invaluable platform for aspiring creatives."

Lee Roach A/W 2012, directed by Liam Gleeson

3.13
Pre-empting Instagram Stories and TikTok, this campaign for Liam Hodges was made specifically for Instagram and consisted of nine films, each ten seconds long. Liam Hodges. © Hidden Agency. Credits: Liam S. Gleeson (director).

3.14
Liam Gleeson conceived and completed this film in twenty-four hours for menswear designer Lee Roach in 2012. © Hidden Agency. Credits: Liam S. Gleeson (director).

Fashion Film and Music Video

There is a compelling crossover between fashion film and music video. Both are short forms; both operate within commercial industries, and both might be promoting a creative enterprise. Furthermore, a fashion film might have a music track as opposed to traditional dialogue while a music video might have drafted in the talents of a stylist, to help visually articulate a band or performer's image. So, it's not surprising that sometimes the boundary between fashion film and music video can on the surface appear blurred; although this can usually be determined by who has commissioned the film.

IN FOCUS

The role of music in fashion film

"Music can immediately set a mood, bring a location alive, conjure up an era, or sense of nostalgia. Music can provide context, setting, and authenticity. In terms of film, music is a way to set the tone, ethos, and brand values often buying into the credibility and appeal of a fan base."

"Online content suits the pace and lifestyle marketing of fashion brands who favor online advertising, which is better value for money than traditional TV advertising. This market has opened new opportunities for music and fashion collaboration in the short form fashion film."

Lynden Campbell, Managing Director of HotHouse Music Ltd and former Head of Synchronisation in the Domino Recording and Publishing Company, has licensed music for many fashion films including Ben Sherman, Ellie Saab, Dior Homme, Louis Vuitton shoes, Christian Dior, Selfridges, YSL, Paul Smith, and All Saints.

3.15
Fashion film and music video have some common ground with many filmmakers commonly working across both areas. LPX music video shot on 16 mm featuring Opening Ceremony Top. Tremble by LPX, 2017. Credits: Mafalda Millies (director), Frank Larson (DoP).

IN THEIR OWN WORDS: KATIE BARON

Author of *Fashion + Music: Fashion Creatives Shaping Pop Music*

In the best pop videos, style, attitude, and story coalesce.

"The starting point of music video is nearly always the story because the underlying narrative of the song or track tend to be the bedrock from which the rest of the creativity unfolds. Fashion film has a more abstract palette of references and creating mood might be enough. Alexander McQueen, part of a pioneering fashion film movement in the noughties, was a rare designer who understood how to create an entire universe of epic and alien proportions, while Gareth Pugh's short film collaborations with Ruth Hogben, who went to work with Lady Gaga, are testament to the power of seeing a visionary fashion designer's work in the full flight of conceptual motion.

Several music videos are seminal for their fusion of music and style, conflating music video and fashion film. 'Frozen' by Madonna, directed by Chris Cunningham (1998) is like a mini film. Set in the Californian desert, Madonna wears Jean-Paul Gaultier's Tribute to Frida Kahlo collection, a gothic homage to the iconic Mexican painter and then transforms first into a panther, then a bird. Before that 'Like a Prayer' (1989), which dealt with controversial themes at the time of Catholicism, sexuality, and desire, and Neneh Cherry's 'Manchild,' shot by Jean-Baptiste Mondino and styled by the legendary Judy Blame, are brilliant examples of autobiographical storytelling, elevated by their signature mix of high and low, mash-up fashion.

Grace Jones's music videos with Jean-Paul Goude and most of what Björk has produced are brilliant. In the best pop videos, style, attitude, and story coalesce. Styling is always an essential part of the music video; the key to unlocking mood and identity. Music videos are important because they are often the gateway to the live gig, where bands really make their money."

Madonna, "Hung Up" (2005), directed by Johan Renck, styled by Arianne Phillips

IN FOCUS

Where music meets style; ten fashion divas of the digital age

Kylie Minogue, "Can't Get You Out of My Head" (2001), directed by Dawn Shadworth, styled by William Baker

Missy Elliott, "Get Ur Freak On" (2001), directed by Dave Meyers

Madonna, "Hung Up" (2005), directed by Johan Renck, styled by Arianne Phillips

Amy Winehouse, "Back to Black" (2006), directed by Phil Griffin, styled by Naomi Parry

Rihanna, "Rude Boy" (2007), video by Melina Matsoukas

Beyonce, "Diva" (2008), the performer wears Thierry Mugler couture pieces

Lady Gaga, "Bad Romance" (2009), directed by Francis Lawrence, art direction by Charles Infante

Bjork, "Mutual Core" (2012), directed by Andrew Thomas Huang, costume design by Michael van der Ham

MIA, "Bad Girls" (2012), directed by Romaine Gavras, costume by Hannah Edwards

FKA Twiggs, "Cellophane" (2019), directed by Andrew Thomas Huang, styled by Matthew Josephs

Amy Winehouse, "Back to Black" (2006), directed by Phil Griffin, styled by Naomi Parry

Lady Gaga, "Bad Romance" (2009), directed by Francis Lawrence, art direction by Charles Infante

IN THEIR OWN WORDS: IAN PONS JEWELL

Music video and fashion filmmaker

My films try to embrace the mystery in the world; to scratch the surface and see what's underneath.

"Fashion film has much in common with music videos in terms of process, more so than commercials in many cases. The director will be given some free rein, often writing the creative treatment based upon the brand or collection. Similarly, with a music video, the music will be sent to the director who formulates an idea. I listen to the music, close my eyes, and allow it to conjure imagery in my mind. Usually, it will be an entire video, a story that plays out in my mind that I put this to paper. Other times, it might be an image or mood, I then develop further into the final script. But it always comes from the music; it's an almost synaesthesia-like process.

With works I've done for Sevdaliza, Paolo Nutini, and others, the video has come almost entirely from a few listens. The changes in tone and beat will spark a scene change or narrative development. Other times an idea is formed that isn't whole and the listening process builds the story. I sometimes describe it as if the idea is a solid that melts perfectly over the form of the music, becoming one with its shape.

My films try to embrace the mystery in the world; to scratch the surface and see what's underneath. They are dreams on the screen and like dreams, a film is a space where you write your own logic. You suspend disbelief watching films as you do within a dream. Most people are cut off from the dreams we all experience every night. One reason I love David Lynch is that he brought surrealism to mainstream audiences. Despite us all having had 'weird' dreams, surrealist imagery or ideas are still seen as not being commercially viable for the most part."

In Limbo:
Landshapes
(2013), directed by
Ian Pons Jewell

3.16
Ian Pons Jewell,
who lived in
South America
for a while, was
inspired by the
spirituality and
rich cultural
heritage of
Bolivia. Music
video *In Limbo:*
Landshapes
(2013). Credits:
Ian Pons Jewell
(director), Doug
Walshe (DoP).

Summary

- The contemporary communication landscape sees fashion film appearing in multiple contexts.
- These include retail, online, both editorial and e-commerce, social media, catwalk, and the music industry.

- Different contexts bring with them different audiences with their own expectations, which is reflected in the content.

Exercises

Plot the digital journey of a fashion film

Find a fashion film online that appeals to you. When was it launched or where did it start? What is the film's status now? (How many views?) What was the key amplifying moment (when might it have been shared by key influencers or picked up by the media)? Did the film come from inside or outside the fashion industry?

Interrogate the appeal of the behind-the-scenes fashion film

Behind-the-scenes (BTS) films became a sub-genre of fashion filmmaking in the early 2000s and remain a popular approach. The opportunity to look behind the fashion image, to see how fashion magic is created, has wide appeal. Look at BTS films by designers and

brands. What are the advantages in promoting this type of content? If it's not selling products, what do you think the objectives are? Does your impression or opinion of the brand change after seeing these films?

Make your own treatment using music as inspiration

Find a song on YouTube that doesn't have an "official" video. Follow the lead of Ian Pons Jewell and listen to it closely, hearing the story, feeling the mood, and allowing visuals to unfold in your own head. Listen for the beat or mood changes, then sketch out what you see onto a rough storyboard. First, imagine you have a limitless budget—then do it again with no budget—and aim to pare down your original idea to its core. What have you made, a music video or a fashion film?

4

Trends in Fashion Film

Since its early, post-digital appearances, fashion film has significantly evolved. No longer an "add-on" to editorial shoots, it's a distinct and separate form of fashion image-making that commands its own budget and creative team. While the moving "look book" (fashion model moves in a frame) has specific functions, such as imparting garment information, the medium of film offers far greater potential to fashion communicators.

Prada – *Castello Cavalcanti* (2013), directed by Wes Anderson

4.1
A mini-classic from the Prada stable. *Castello Cavalcanti*, a short film written and directed by Wes Anderson.

Miu Miu *Women's Tales* #6, *Le Donne della Vucciria* (2013), directed by Hiam Abbass

4.2
Prada-clad puppets in Miu Miu. *Women's Tales* #6, *Le Donne della Vucciria* (2013), directed by Hiam Abbass.

4.3
Fashion film now merits its own production and creative teams and is no longer a subsidiary of fashion photography. In the refined aesthetic of Monica Menez, color and composition are carefully orchestrated. *Hors D'oeuvre* (2012). © Monica Menez. Credits: Monica Menez (director), Albe Hamiti (model).

The Long and the Short

In the last twenty years, fashion film directors have responded to innovative technologies becoming more adept, articulate, and ambitious and often placing greater importance on narrative to draw more visually sophisticated audiences for whom film forms part of everyday digital life. As narrative exerts more influence in fashion-related film, we see the form breaking out of its classic two-minute treatment. On the one hand, tiny visual sequences, second-long GIFs, and TIFs inhabit social media to catch the eye of the swipe savvy. On the other hand, fashion films are becoming longer, more involved, and immersive.

These two opposing directions, the short and long, reflect the dichotomy of current viewing habits: we have social media content being assessed in a nano-second, yet concurrently and perhaps *because* of the lightness and speed of social media, there is a need for more meaningful viewing, characterized in the wider world by the serial bingeing of box sets.

Creating dramatic tension: case study of The Lift

In the award-winning fashion film, *The Lift*, for Danish footwear brand Bianco, director Daniel Kragh-Jacobsen has created five minutes (once this would have been considered long) of beautifully crafted dramatic tension. Centered around an encounter between two strangers in a lift, it's a skillful piece of storytelling, well-plotted and paced. No viewer wants to fast forward. Instead, they hold their breath to see what happens next. Even though commissioned by a fashion brand, *The Lift* creates an emotional connection and empathy for the characters portrayed.

Bianco – *The Lift* (2019), directed by Daniel Kragh-Jacobsen

4.4
Two people who fall in love in a lift without the other ever knowing is the compelling and deceptively simple narrative in Bianco's *The Lift* (2019) directed by Daniel Kragh-Jacobsen. © New Land 2019. All rights reserved.

Fashion and Social Responsibility

A growing social awareness is being reflected within brands that are experiencing a cultural sea change. The reputation of fashion no longer rests purely on image or quality of design, but equally on values and ethics. In recent years, some brands and individuals have had their reputation (read business, sales, or profits) damaged by the exposure of poor or unsustainable practices, a lack of inclusivity, and in the case of some individuals, sexism, or sexually predatory behavior. The accessibility of digital information and social media means negative information spreads quickly, so many brands aim to be visibly responsible, transparent, and accountable.

Film plays a key role in the promotion of socially acceptable messages to inform and reassure consumers of a brand's social awareness and ethically responsible approaches. From a predominantly white world, we're seeing a greater plurality of representation in fashion media. Movements such as #extinctionrebellion, #Metoo, and #BlackLivesMatter are far-reaching and consciousness-raising and are being reflected in some, but by no means all, fashion campaigns and marketing.

The desire for more socially inclusive representation percolates across markets from youth culture publications like *i-D* and *Dazed* magazine through to luxury publishing such as *Vogue*. Hopefully, this marks positive, progressive, and permanent change. While fashion film becomes socially attuned and more variable in terms of format, other stylistic or thematic trends are also influencing fashion film.

4.5
Beauty I See You Everywhere—the second of four films commissioned by Selfridges for The Beauty Project creates an alternative beauty map of the UK and was a response to fashion's standard and London-centric ideals. © Kathryn Ferguson. Credits: Kathryn Ferguson (director).

Narrative and Storytelling

While narrative and storytelling are a cornerstone of traditional filmmaking, fashion filmmakers have only recently come to it with greater conviction. It may seem odd to include such a fundamental tenet of filmmaking but to appreciate this development, we must remember where the post-digital fashion film started—with a model swaying in a wheat field or walking along, being no one, going nowhere. This basic approach to fashion film, which stems from a dated approach to fashion photography, is at best dull but at its worst, instantly forgettable.

Fashion film now competes with multiple distractions, be these in an online or physical space, so the need to hook viewers and retain their attention is imperative. The danger of boring viewers with a "so what?" film means many narrative approaches are being adopted. From the linear to the conceptual and multi-layered, on a storytelling spectrum they are connected with the viewer's pressing question, *what happens next?* In all cases, something has been effectively "set up" by the director which persuades the viewer to keep watching until the end.

At its most basic, fashion narrative can be defined by action that takes place beyond the passive display of garments. Benn Northover directed *Either Way* for the Spanish luxury brand Loewe (S/S 2020), art directed by the Creative Agency M/M in Paris and featuring Jodie Comer of *Killing Eve* fame. The actress

IN FOCUS

Fashion film innovator: Miuccia Prada

Miuccia Prada's *Women's Tales* champions global female film directors and uses a diverse range of talent which in the past has included Lynne Ramsey (*Brigitte*, 2019) and Lucrecia Martel (*Muta*, 2011). Narratively powerfully and aesthetically strong, the *Prada* films are often mini exemplars of the form with full ensemble casts, impressive sets, and beautifully dressed performers. In these "big, small" films, the clothes are rarely the first thing a viewer notices. *Le Donne Delle Vucciria* (Hiram Abbass, 2013), starring Lubna Azabai, is set in a puppet-makers workshop which begins to fill with music, stirring the Prada-clad villagers below into dancing. However, storytelling through fashion film is not dependent on complexity or large budgets. It is entirely possible to produce a quite simple idea on a minuscule or non-existent budget and execute it well.

Loewe – *Either Way* (2020), directed by Benn Northover

appears in her dressing room, repeating the word *Loewe* with a myriad of emotive inflections and gestures from anger and passion to incomprehension. As viewers, we witness a successful actress, playfully sharing her craft (as well as being taught how to pronounce the brand name). Filmmaker Benn Northover explains: "I had a character-based narrative in mind but let the filming process and character Jodie and I discovered on set influence the arc of the piece."

4.6
Film director,
Benn Northover
and actress Jodie
Comer worked
collaboratively
to evolve the
storyline for
the Loewe S/S
2020 film *Either
Way*, directed by
Benn Northover.
Credits: Benn
Northover
(director).

A fantastically porous medium, fashion film can cross-fertilize with other genres to create visually compelling responses to its subject. Fashion film's post-modern ability to transmute and inhabit other genres has seen inspiration drawn from zombie films, 1970s horror movies, 1930s surrealism, and 1960s sci fi. While this desire for storytelling has exerted a powerful influence over many fashion filmmakers, it's worth noting there are notable exceptions who challenge this approach. Both Nick Knight and John Maybury feel fashion narrative is something that belongs to the fashion *designer* and that the story is imbued in the garments they create. For these stalwarts of fashion image-making, the superimposition of another narrative simply distracts from the fashion. However, many other filmmakers feel differently and aim to bring their work to an audience, beyond fashion fans.

Spanning Slapstick to Highbrow: From Comedy to Art

4.7

Film still from *Ruthless* directed by Alexander Ingham Brooke for JW Anderson men's S/S 2014 collection, commissioned by *Interview Magazine*. The inspiration for the dramatic lighting was drawn from fifteenth-century paintings by artists such as Caravaggio.

One has only to conjure the image of frosty, front-row faces to see from where fashion's reputation for having no humor stems. But in fashion film, an unfriendly face, even a beautiful one, who simply pouts or looks down their elegant nose, is unlikely to hold viewer's attention. This may be one reason we're seeing an interest in pastiche, irony, satire, and spoof as inspirations for screen fashion stories. The goal for many brands is to create an emotional connection with customers and humor is one way to achieve this. If the cool fashion stare has the effect of distancing viewers, then making a joke or creating a funny situation will do the opposite and create a sense of warmth towards the film, ergo the brand.

Fashion having fun has been demonstrated by the video campaigns of Lanvin. In S/S 2010, the models danced and in the A/W 2012 meta-fashion film, featuring Raquel Zimmerman and Karen Elson, two male models danced to Pitbull's *I Know You Want Me* while designer Albert Elbaz played a cameo role. Skyping his team on the set of the womenswear shoot by Steven Meisel, he declares his approval: "Love! Love! J'Adore!" More recently, Isaac Lock's mockumentary/behind the scenes film, part of the *Fashion Disciples* series at Nowness (2018), parodied a conceptual fashion shoot which was being "partnered – not sponsored" by a skin brand. It's deadpan delivery pokes fun at the "art or advertising?" conundrum in fashion image-making, with an absurdist take on fashion's bubble of non-reality.

> "Humor is one of most important ingredients. It needs to be embedded in the story and have elements of surprise."

Monica Menez, fashion film director

While some fashion films draw on comic elements, others look to art. Whether for the weight of its cultural capital or the arresting visual references, fashion film shaped by artistic inspiration or approach feels less throwaway and offers more reflective space for the viewer. Alexander Ingham Brooke's film *Ruthless* for JW Anderson was visually inspired by fifteenth-century paintings by Caravaggio with their chiaroscuro lighting effects and dramatic contrasts.

Visual artist Anna-Nicole Ziesche made her first film, *Infinite Repetition*, for an MA in Fashion Design (2000) and also directed *Childhood Storage* (2009) and *Before a Fashion* (2014). Although trained as a fashion designer, she started making films to create definitions around her practice. She explains, "terms such as cross-disciplinary, transdisciplinary or hybrid were not key words then. I was aware of being situated somewhere between fashion and art – and would purposely stress I was a fashion designer making films."

PRADA presents "A THERAPY" (2012), directed by Roman Polanski

Isaac Lock, *Fashion Disciples* (2018), Nowness

Fashion Film (2013), directed by Matthew Frost

The Sound of COS (2014), directed by Lernert & Sander

IN THEIR OWN WORDS: LERNERT & SANDER

Fashion film is like when two worlds collide.

"Amsterdam-based artist filmmakers Lernert & Sander began collaborating in 2007, and have built a reputation for high conceptual art films and a keen fashion aesthetic. Fashion film clients have included Cos, Hermes, Phillip Lim, Viktor and Rolf, and Selfridges.

Fashion and art are a good combination. They stick well together although fashion isn't as truthful or focused as art. Brands need content every six months. Through them, it is possible to creatively dramatize a designer's DNA. Fashion films hurt our eyes when they are meaningless. In the beginning, you would see these films of a model on a rotating platform with a wind machine blowing. A film has twenty-four frames per second and fashion photographers who have moved into film have sometimes struggled with this concept. Why would you have a model lean against a wall with a wind machine if you have twenty-four extra frames?

If we make a film with fashion, there is the possibility to move around the garment. 360 degrees and twenty-four frames allow you to do this. We also try to inject some humor into our film and fashion is opening up to this. For COS, we shot with a camera inside a hula hoop and created a circular space for the brand. We had two camera crews but didn't want to see them. It takes twenty-four times more effort—it's not just a thing on a camera.

Fashion film is like when two worlds collide. In fashion, by the time you are bought in as filmmakers, the collection is already three months old. Filmmakers should be there at the very beginning when the collection is being put together.

People say to us 'I love your style' and we reply 'style is having no style.' It's all about the idea. We keep it black, white, or gray with no hocus pocus. We want to eliminate the noise; we want to focus on the idea. Our inspirations include the art photography of Roy Anderson who shoots everything in white and gray. We like films, musicals, and magazines but our biggest inspiration is each other. Sometimes, we will meet for a walk or a coffee and that is inspiration enough. We are friends—not just cold surnames."

4.8
Lernert & Sander wittily foregrounded the importance of the hand, which uses a finger puppet as the model, and the menswear brand, Brioni. *Wallpaper**. Credits: Lernert & Sander (directors), commissioned by *Wallpaper**.

Machine Versus the Hand

Although originally produced in the analogue world, it was digital culture that allowed fashion film to flourish. Technology changes constantly (much like fashion) and constant waves of innovation have spanned new camera technologies and modes of communication including applications, platforms, social media, and streaming services. All have offered fresh approaches to fashion film.

IN FOCUS

Technology drives fashion film

From films that use surveillance technology to the Diesel campaign with Nicola Formichetti shot entirely on iPhones, Nick Knight embraces modern technologies with vision and enthusiasm. He has worked with iPhones, virtual reality (VR), CGI, and artificial intelligence (AI) to create innovative responses to fashion's moving image. Elsewhere, Prada's experiments with VR and a growing playfulness with the possibilities of digital animation and avatars are all examples of fashion film's future possibilities. Visually, they often offer an alternative experience and the viewer might find themselves, as in the case of Anna Radchenko's *Kokosmos*, cast into a sci-fi or futuristic fantasy world.

In contrast to the slick, technology-led film, there is a counter movement that foregrounds a sense of the handmade and draws us into a more intimate experience. This illustrative, painterly, or animated approach is less interested in the crisp registration of

digital imagery. Films shot on VHS or hand-held Super 8, highlight a pre-digital age and create a more human experience for the viewer who is reminded of the hand in the filmmaking process. (Ironically, many digital apps now imitate or recreate analogue photography effects.) For *To Die by Your Side* in 2011, Spike Jonze teamed up with Olympia Le-Tan to create a stop-motion short which offered a charming alternative to expected fashion fare. Shot in the famous book shop, Shakespeare & Company, it featured the characters of their storybook, *Clutches*.

4.9
Future Body (2015) features 3D printed fashion artifacts with live action and green screen filming composited with an animated CGI environment for a digital aesthetic. Alice Hurel wears dress by Dioralop and shoes by Iris van Herpen for United Nude. Credits: Nirma Madhoo.

4.10
Diesel campaign (2013) styled by Nicola Formichetti and shot by Nick Knight entirely on an iPhone. Credits: Nick Knight.

IN FOCUS

Low-fi playfulness: Quentin Jones

Paint Test No.1 by Quentin Jones for Chanel draws more from performance art and features the filmmaker using her naked body as a canvas. Instead, Jones "dresses" or paints herself with black paint from a bucket in a visual illustration that comments on fashion's quest for individuality and identity. Jones explains:

> "*Paint Test No.1* was made from between 10,000 and 15,000 still images. Because the film would be digested online, I wanted to retain the tactile nature of the process. People were excited by seeing paint move and paper rip as opposed to slick graphics. It pushed fashion film into a more low-tech, low-fi direction. The great thing with stop motion is you can stop on any one of the images to paint over it or add a cut-out. When I began to work more commercially, I started to work with a photographer and camera operator who combined stop motion and video footage layered up in the studio."

> "People were excited by seeing paint move and paper rip as opposed to slick graphics."

Quentin Jones, filmmaker

Paint Test No.1 (2012), directed by Quentin Jones

4.11
Quentin Jones went to basics for a low-fi classic that combined her own body and a bucket of black paint. In *Paint Test No.1* (2012), directed by Quentin Jones for Nowness. Credits: Quentin Jones (director), Alex Franco (photography).

Choreography and Meaningful Movement

When photography was the dominant form of fashion communication, models had to simply look attractive and pose. With film, more was demanded of performers. Even the simplest fashion film without dialogue or acting, a model needed to move according to the director's instructions. Without this ability, the result would be an unconvincing wooden performance and undermine the film's credibility. One solution to this has been to cast dancers. Dance has increasingly merged with fashion film to create something, that on the surface resembles music video and taps into our perceptions of entertainment. The growing popularity of prime-time dance shows have also exerted an influence. From *Strictly Come Dancing*, the BBC's celebrity dance off, to the Academy Award-winning feature film *LaLa Land* (2016) by Damien Chazelle with Ryan Gosling and Emma Stone, it has become a well-visited approach. Ahmad Swaid, former Head of Digital Content at Dazed and Nowness, notes that "Lots of people like dance. In 2016, we premiered a dance film starring Lil Buck at La Fondation Louis Vuitton. It went viral with 20 million views."

For the fashion filmmaker, incorporating dance offers many advantages. It can subsume the narrative themes into the movement of the body and choreography, display clothes in four dimensions, and create visually compelling shapes within the frame. Stella McCartney's children's collection for 2018 was modeled by child flamenco dancers. *Mine* by Tell No One, an interactive, fully shoppable fashion film, features four female and one male dancer in a gymnasium, whose clothes vanish while dancing. The viewer hears little huffs and the sound of a xylophone as the models magically leap into their clothes.

Mine by Tell No One (2014) introduced choreography and interactivity in this mold-breaking film.

4.12
Filmed at La Fondation Louis Vuitton in Paris, London-based director Andrew Margetson followed Memphis-born jookin' dancer Lil Buck who twisted and turned past masterpieces by Picasso and Matisse. Directed by Andrew Margetson, 2016. Credits: Andrew Margetson (director).

Documentary and "The Real"

The director of *Kids* (1995) and *Gummo* (1997) Harmony Korine delivered a seminal fashion film when he collaborated with designer Proenza Schouler in 2010 to make *Act da Fool*, a film about youth and subcultures, relationships, and identity. Featuring a Tennessee gang, the gritty documentary style feels like a raw slice of life with compelling characters, dialogue, and narrative. Railing against poverty, racial discrimination, and lack of mobility, the lead character declares: "this town stinks … everyone is just passing through." With its challenging polemic and engaging characters, *Act da Fool* was a powerful production which set a new benchmark for what fashion film could be.

There are many notable examples of fashion films that look more like documentary shorts. Kathryn Ferguson's *Change is a Beautiful Thing,* shot for the Selfridges Beauty Project (2014) cast women over seventy to reflect on the meaning of age and beauty (see QR code on p. 8). At *i-D* magazine, contemporary documentary-making focuses on youth and global street culture and is part of the editorial DNA.

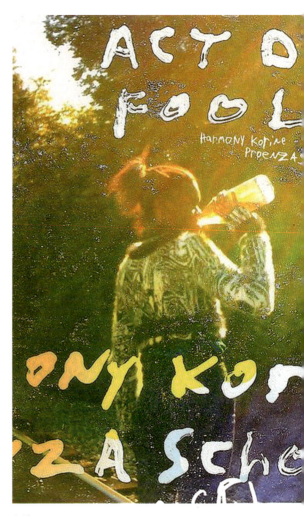

4.13
Act Da Fool (2010) by Harmony Korine was a breakthrough fashion film. Created for Proenza Schouler, it's a gritty documentary that documented the lives of American teenagers. Credits: Harmony Korine, Jean-Baptiste Mondino.

IN THEIR OWN WORDS: DECLAN HIGGINS

Executive Producer, *i-D*

We visit places and communities most fashion magazines wouldn't go to in order to produce visually striking documentaries.

"When I was younger, fashion seemed an impenetrable world. You had to be cool to sit at the coolest table. Documentary offers an insight and invite to a wider audience. For most people, a Chanel dress is unattainable yet 30–40 million people follow Chanel on Instagram. The fashion circus is basically three hundred people but millions of people are interested in it; documentary acts as a bridge to let in a much wider interest.

At *i-D*, I hope to shine a spotlight on something viewers wouldn't otherwise see and that our documentaries might inspire viewers to learn and do something themselves. We visit places and communities most fashion magazines wouldn't go, including Kiev, Johannesburg, Seoul, Taipei, São Paulo, LA, Arizona, Tijuana, and to Native American communities in San Diego. These visually striking documentaries are windows into everyday life and say something about how people look and feel about culture. *i-D* is short for ideas and identity and this connects all our documentaries.

In 2015, we had over 10 million views in the first week of a documentary about a tattooing in South Korea where it's illegal. To this day, it has around quarter of a million views a week. We work a lot with Instagram. When we did our documentary in the favelas of São Paulo, we received a message from the young people in our film to say it had changed their lives; Adidas had been in touch so it had affected their lives for good. As our social lives grow through social media platforms, documentary offers a real-life story. Brands can push things with budgets in a way we can't. The integrity of the documentary is in the story that's being told."

4.14
Subculture and identity are two key strands within *i-D*'s documentary strand. *Women Test the Internet's Scariest Beauty Products* (2018). Credits: Tom Ivin (director).

IN THEIR OWN WORDS: ALEX TURVEY

Filmmaker

In the beginning, some of my films were rejected for being "too cinematic."

"As a storyteller, my focus has always been to engage with projects that bring me closer to working in narrative. I was seeking a way out of music video direction which I found to be quite exploitative and was looking for a more sustainable commercial route that might help me fund the film ideas I had. Around this time, I began to see briefs for branded content.

In the beginning, some of my films were rejected by some of the magazine editors for being 'too cinematic.' I had unknowingly stepped out of fashion's tropes which was then all about surface and a lack of narrative. But going against the grain strengthened my identity and I got a lot of press from it. I was put forward for a Levi's campaign and from there it snowballed.

I appreciate craft and innovative design regardless of the medium and was not overly interested in fashion. Many of these projects were for high-street fashion brands looking for a graphic treatment and at that time my music videos were known for a stylized cinematic look, a product of my formal education in graphic design. These projects had slightly better budgets than music videos and shorter run times. They offered the opportunity to sharpen my aesthetic tools without the meddling of managers, artists, and record labels.

Costume is hugely important in supporting a story, and I used these opportunities to create cinematic moments. Some of them felt void of story but I always aimed to enrich the work with tone and feeling. I think this is best displayed in my film for River Island and Georgia Hardinge. I managed to shoehorn an alien mother birth scene into an advert for a high street brand which made me chuckle."

River Island Design Forum X GH 02 (2103), directed by Alex Turvey

4.15
River Island Design Forum X GH 02 by director Alex Turvey (2013) had inspirations spanning the surrealism and science fiction. © Alexander Turvey.

Summary

- Trends influence the sorts of fashion films being made, shaping their content, production, and/or dissemination.
- Fashion films are becoming both shorter and longer than the traditional 2.5 minutes, depending on context, purpose, and audience.

- Film can play a key role in promoting socially responsible messages to audiences and consumers.
- Some trends influencing contemporary fashion filmmaking include satire, art, technologies (new and old), choreography, and documentary.

Exercises

One, two, three: spot a trend in fashion filmmaking

This chapter outlines some trends defining contemporary fashion filmmaking. Can you spot a recurring idea or theme three times? If so, this constitutes a trend.

The connecting thread might be a general theme, narrative structure, type of production or technical approach, use of a particular model, look, set, or location. Consider if the trend is being adopted by a certain market or targeted at a specific audience? Where is this trend is in its lifecycle? Established, emerging, or waning?

Capture emotion and experiment with an iPhone

Nick Knight shot an entire Diesel campaign, styled by Nicola Formichetti, on an iPhone in November 2013. Outside of fashion, Sean Baker, Michel Gondy, Stephen Soderbergh, and Claude Lelouche have made feature films on iPhones. Hollywood director Claude Lelouche says "the importance is the emotion you capture and that's easier to capture with an iPhone than with anything else." Time-lapse, slow motion and night scenes can all be achieved with an iPhone and the app FiLMiC Pro makes it possible to adjust exposure and focus separately. Use a smartphone to capture emotion and consider how this might inspire a film story or concept.

Reconciling style and substance: explore politics and fashion film

Isosceles, a film screened on Nowness in 2018 by Amy Gwatkin, is a feminist film production shot with an all-female team that explores and challenges the male gaze. Kathryn Ferguson (*Change is a Beautiful Thing*, 2014 and *Incredible Machines*, 2016) has not been afraid to tackle issues of under-representation and fashion's traditionally narrow view. Watch these films and consider how the political framing shapes your view of the brand. What are the advantages and disadvantages of mixing politics and fashion film?

Isosceles (2018), directed by Amy Gwatkin on Nowness

5

So, You Want to Make a Fashion Film?

An industry that employs billions of people globally and fuels economies, fashion is a sector that is highly alluring. For many, the word fashion is reduced to visual shorthand; impression-istic images of the latest catwalk looks, dramatic designer creations, or impossibly good-looking models. But beyond these snapshots is a far richer and involving subject. The greater a filmmaker's understanding of the subject, the more there is to draw from when making a film.

As outlined in the opening chapter, fashion has multiple meanings. It is communication, identity, a social badge, a way to protest or conform. Fashion is both a marker of the indi-vidual and mirror of our collective desires, values, needs, and wants. If you would like to read more about fashion there is a Further Reading section at the back of the book. There are many cultural and creative lenses through which to explore and capture fashion but anyone wishing to translate their interest into a film, be this a personal project or professional commission, will need to consider practical elements such as their own proficiency, resources, available collaborators, and budget. Elements such as the proposed audience, context, and should be nailed before production starts.

But before any of that begins, what's needed is an idea.

5.1
The Journey (2014) by Monica Menez received best Art Direction award at ASVOFF 7. Credits: Monica Menez (director),
Laura Ponte @ Uno Models (model).

Subject Knowledge and Ideas

Where do ideas for films come from? Like any creative output, the answer is anywhere and everywhere. Each director has their own approach but what's important in the initial stages, and then consistently while developing a practice, is to establish a method of recording ideas, prompts, or thoughts. For a receptive filmmaker, every book, link, tune, memorable conversation, color, pattern, shape, juxtaposition, and visual relationship can inspire and fuel new work.

From the observation of memorable characters, a situation in the street, music, art, food, architecture, global politics, activism, or literature, creative stimulus can come at any time. Director Benn Northover believes it's important to stay open because ideas for fashion film won't necessarily come from fashion. "Inspiration comes from the most unexpected places. It's important to feed your creative imagination and process with things that strengthen your ideas." Award-winning filmmaker Monica Menez looks to music, spaces, or photography. "I imagine what could go along with the music or how the people in the pictures could act. I am also interested in interpersonal relationships like the interaction between men and women. All my films also contain elements of fetish."

Image-making tools and visual effects that facilitate new viewing experiences, feelings, and images can be another source of filmmaking ideas. The technology—hardware, software, and cameras—of the filmmaking process can offer diverse ways into fashion filmmaking. The photographic practice of testing—practice-based inquiries into light and shadow, color, distortion, refraction, experimenting with 360-degree cameras or virtual reality—are an entirely relevant form of research. Exploring these areas can prove productive and potentially drive the trajectory and look of a film, although a narrative or concept will still be required.

"I was creating unexpected juxtapositions like a photograph with something hand drawn over the top or would paint over collages. When I started clicking through the photographs, I realized the paintings in motion were amazing."

Quentin Jones, Filmmaker

5.2
Former editor of SHOWstudio, Penny Martin's pinboard reveals some of the key themes and stories worked on in 2008. Credits: Penny Martin (photographer).

How to Capture and Catalog Ideas

As important as finding ideas is how to capture these into one accessible place. An analogue mindset might prefer compiling look books, scrap books, or notebooks but these should be organized as cohesively as possible. For instance, the front of a notebook could be for random jottings, the back for organizing these into more cogent ideas.

For some, basic sketching is a first step. As a visual record of observations, an abstract representation that provides key elements—shape, scale, lines, color, and spaces around an object—will do; a masterpiece isn't necessary. Mobile phones offer the most intuitive way to record information or inspiration. If this is your preferred method, give the process more consideration. Start to consciously frame and compose shots using all the tools available and experiment with perspective and composition.

The use of a mobile phone for gathering ideas can bring a host of additional benefits to visual research. Google Maps can document where and when images are taken, but filmmakers should aim to author and edit a personal image archive in a way that makes sense. Geo-tagging dates and locating photographs geographically is a useful function for location scouting. Camera-setting information such as the ISO (sensitivity to light) and exposure settings, registered with every photograph, can inform storyboards and future location work. How findings are organized for more intuitive, future searches will start to shape the personal production process of a filmmaker.

From Inspiration to Research

Initial inspiration will need to be deepened with greater research. This may take one or multiple forms: written, visual, verbal, or online. It may involve trawling through archives, interviewing individuals, reading books, or exploring vintage periodicals to glean inspiration and build some visual, conceptual, or narrative foundations for the film. Tropes and devices used by other film genres such as advertising, horror, science fiction, and romance have the potential to be imported into a fashion film framework. Establishing which research methods work for the subject, filmmaker, and film is key, so allow time to find relevant connections or inspirational catalysts. This stage is important to avoid producing a superficial moving image treatment.

Marc Jacobs – *Notes on Three* (2019), directed by Benn Northover

5.3
Benn Northover believes viewers of films are more likely to remember human emotion and how a film makes them feel. Behind the scenes of the Runway Fall 2019, the Marc Jacobs campaign starring Marc Jacobs and Christy Turlington. *Notes on Three* (2019), directed by Benn Northover. © Benn Northover 2019. All rights reserved.

Who Is the Audience?

The film may be a private project only ever to be seen by a select few. There's also the opportunity to share a film on a personal platform or send it to specific individuals, be these friends, collaborators, or prospective employers. A commercial production is likely to be shared with the client's followers. Whatever scale the project, it's important to conduct market research and know the audience.

With any commission, it's vital to understand the target market, brand values, and visual output of the client's competition. An established brand may have existing material gathered through the PR or marketing department which can be requested. Even a new designer with no PR support should have an idea of their proposed customer. This essential information enables the filmmaker to select the most appropriate models, location, music, etc. If past films exist, these should be viewed with a close eye as they will give a sense of the brand's evolution and visual heritage. Does the client wish to build on this past or depart from it? Which earlier films were considered successful and why? How was this measured or ascertained? Is the client going for the same market and feel or hoping to attract a new customer base?

If commissioned by a client, parameters should have been established: a clear brief, deadline, and, ideally, an appropriate and workable budget. The commissioner should understand the film's objective, purpose, and audience, and how long the film should be and which platforms it will be disseminated across. However, if this is not forthcoming or clear, the filmmaker should draw out these specifications with a meeting and questions. To deliver a

confident film, clarity is vital. Benn Northover admits, "sometimes the brief can be pretty sparse, so I look for clues into more expanded ideas. I have had a lot of creative freedom working with Marc Jacobs and Loewe where there's a shared love of cinema and art. When there's that trust and enthusiasm, a lot is possible."

Getting to know the collection—or product—is at the heart of any commercial or product-based fashion film. This will inform the direction and scope of research. Filmmakers should ideally interact with the pieces physically rather than just simply view them as screen-based images. Feeling fabrics, examining the workmanship and details, even listening to how they sound can potentially inspire filmmaking possibilities. This close interaction with product might inspire the idea of close-ups, half shots, or full lengths. Some of the pieces might suggest a sequence in slow motion or building some pre-recorded Foley sound to amplify the shimmy of beads or rustle of silk (as seen in Anechoic; follow QR code on this page). An awareness of the inspiration behind collections can trigger a creative chain of thought to suggest unusual locations, model choices, or narratives.

While product is central to commercial fashion film, character and narrative are also important. Because films are likely to be seen more widely than print campaigns, there are many opportunities for creative risk taking. The well-worn trope of a model staring into a camera while simply wearing something brings nothing new to the form.

Even a personal, non-commercial film still requires some form of market research. The exploration of film portals and platforms that display new talent, will reveal which themes have currency and traction. Nowness, Dazed, *i-D, Vice,* and SHOWstudio all showcase fashion films although these editorial spaces are not primarily concerned with selling garments, collections, or brands. Although

Anechoic, concept by Penny Martin and Paul Hetherington, creative direction by Nick Knight and Paul Hetherington (2006), SHOWstudio

What Is the Message or Story?

As an industry and business, fashion is about selling desire and more product, be this the cool of Calvin Klein or elegance of Givenchy. *Buy Me* is the sub-text of most commercial fashion films which seductively peddle desire, beauty, lust, envy, and pride. Fashion is also glamour and escapism, one of the ways we collectively dream and construct alternative identities.

However, it would be a mistake to think all fashion films must be promotional or celebratory. Film is a medium through which to explore, challenge, and critique aspects of fashion. Many of the most memorable fashion films do something *more* than create engaging moving images. They deliver a compelling narrative or message that elevates the form beyond the aesthetic.

"Great films always have something new about them. They either show us something we've never seen before, or something we know but in a new way. The newness is rejuvenating—of the language of cinema, and of ourselves."

Mark Cousins, filmmaker and author

5.4
Spotlighting new talent with Meet the Digital Provocateurs, part of The New Order season in Selfridge's shop window. © Andrew Meredith. Credits: Photograph by Andrew Meredith.

Beauty I See You Everywhere (2014), directed by Kathryn Ferguson

brand partnerships and advertising are prominent, they are committed to creative talent and diverse voices. The wider fashion community regularly check these platforms and editors actively seek original, unseen quality work.

The proposed channel and audience will shape the parameters of what's considered suitable or appropriate. If the films directed at a youth market (under eighteen), there are limits on the type of permissible content. Sexual content or scenes likely to cause distress or anxiety may require a trigger warning. There may be gender considerations to weigh up. Is the film being presented on a website largely viewed by men, women, or a non-binary audience? Selecting models the audience can identify with, relate to, or be drawn by is key to producing an effective and cohesive fashion film. As well as considering the potential age and gender of a film's audience, geographical and cultural context also count. Material considered suitable for some world audiences may be deemed offensive by some countries. To summarize, where does the film fit in terms of markets, platforms, and audiences? Context informs content.

5.5
The film *Zombies* (2019), by Congolese-Belgian director and musician Baloji, offered a critique on the stupefying effects of mobile technology and the self-imposed isolation it can bring. Directed by Baloji.

ZOMBIES (2019), directed by Baloji

5.6
The impossible ideals of the beauty industry were challenged with style and wit in Jasmine de Silva's graduation film, *How to Build Your Human*. Credits: Jasmine de Silva (photographer and director), Natasha Gravia-Lund (model), Judit Florenciano (hair stylist), Maryna Beskorovayna (makeup artist).

How to Build Your Human (2018), directed by Jasmine de Silva

IN FOCUS

Style *and* substance

Kathryn Ferguson's *Beauty Project* for Selfridges offers strong examples of films that combine style with substance while drawing attention to under-represented themes such as aging and regional style. Jasmine De Silva's first film, *How to Build Your Human*, explored the pressure women feel to live up to impossible beauty ideals. Helen Woltering, formerly Creative Lead at Refinery 29, Berlin believes that:

"Films need a strong narrative and concept to keep people engaged. A strong narrative needs a similarly strong aesthetic. This means studying the client's visual language and suggesting new visual elements and direction to craft a stand out film. Do you want to make an impact; drive social change; raise awareness; inform or educate? The film's intention, normally part of the brand's Key Performance Indicators can form the basis of a strong campaign. The more versatile and multi-faceted the interests and talents of the creative director/team, the richer the film will be."

5.7
Beauty I See You Everywhere (2014), the second of four films commissioned by Selfridges for The Beauty Project examined regional beauty and challenged London-centric norms. © Kathryn Ferguson. Credits: Kathryn Ferguson (director).

To excite the psyche
Just using "likes"

What Is the Film's Purpose and Context?

Fashion does not exist in a vacuum and nor should fashion film. The context in which film is presented and consumed must be considered because this shapes the editorial direction. What is the point of the film and why is it being made? Is it to create interest around something specific? To sell product or celebrate an event? Is it to agitate or provoke the audience? Invite them into the brand? Confront tough questions or create awareness of something previously ignored? Perhaps, it's simply an opportunity to experiment and try an innovative approach? Personal projects should go back to basics. What does the fashion mean in this film? What is its value and why does it matter? Is there a statement to be made or question to leave the audience with? A fashion activist who makes films may wish to highlight the industries' use of low paid workers or examine issues of ethnicity, gender, or sexual stereotypes.

A commissioned film may have an obvious commercial imperative driving the production such as framing or selling a specific brand or product. Or there may be an objective such as sending more traffic into an online selling space. Depending on the intention and proposed audience, fashion films can have multiple purposes.

The physical context of where films will be presented should also be considered. Is it for a fashion show, exhibition, the internet, a festival, website, fashion blog, online publication, gallery, YouTube, Vimeo, or Instagram? Is it a cross-disciplinary piece, which combines fashion with dance, music, performance, theater, circus, science, or other forms of digital technology, and will this have particular screening contexts?

If the film is to be screened in a physical space such as a shop window, or within the layout of a store, potentially as a retail installation, this will present site-specific challenges including the control of sound. Depending on the environment and viewer interaction, how viewers will access sound will need to be thought through. Will there be potential noise seepage that interferes with a viewer's experience? Will the sound of the film need to be controlled and contained (which would potentially require listening devices such as headphones)?

A film to be viewed on a mobile device, or through a social media site such as Instagram, may drive specifically how the film is produced. For instance, for social media, one film may be split into twelve distinct parts, with each section or installment to be screened every month of the year. In this case, the director needs to build this into the planning stage. How can something visually compelling be created to encourage viewers to look out for the next one? Is the film connected to the selling of product or click and buy technology? If so, the garment will need to be presented clearly, from a range of perspectives. All such eventualities must be built into the planning and shooting schedule.

5.8
Meghna Gupta's documentary *Unravel* (2012) focused on an Indian recycling plant and presented the unpalatable truths of Western fashion consumption. Credits: Meghna Gupta (director).

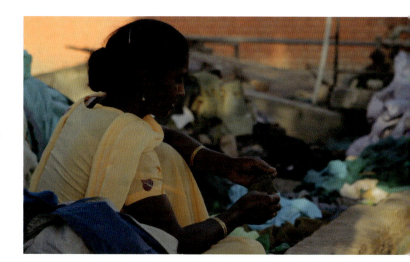

What's the Approach?

Approach relates to a filmmaker's authorship or directorial stamp. An independent film-maker with a specific agenda or collaborative brainstormer who likes to talk ideas through with key members of the team and collectively evolve a concept will have quite different approaches to filmmaking. Is there a political or philosophical imperative driving the film? Will a core belief or set of values govern the decision making and final output? If for instance, the film is about feminism in relation to fashion, sustainability, or cultural identity, how this will be translated into the production of the film? Should it be an all-female production crew? Should the cultural identity explored on screen be reflected off screen in the making of this work?

There are also more straightforward questions. Will the film be a narrative work or more conceptually driven? Will the viewer be transported, entertained, seduced, titillated, thrilled, challenged, unnerved, or startled? Aesthetically, how will the film look? Natural or staged? Authentic or theatrical? Will the location speak to—or contrast with—the narra-tive or concept? Will it be shot in a studio or on location? Will the cast be selected through street casting or model/acting agencies?

What's the Budget?

The budget should cover the cost of crew, locations, lighting hire, and post-production. A small budget may require that some elements are forfeited or team members work for credit only. A tiny or non-existent budget can lead to more innovative, strategic solutions. If the film is intended for gallery or exhibition purposes, and the filmmaker is well organized in advance of production, it may be possible to apply for arts funding depending on what resources are available. For a more detailed understanding of how a budget might be organized, see the diagrams at the end of Chapter 6.

IN THEIR OWN WORDS: KATHRYN FERGUSON

Film director

Both fashion and film have their own potency through which you can speak to people.

"Fashion films should have a purpose and a point and not just be about people posturing in expensive clothing. At its core, fashion is about identity, and I need to engage emotionally with the subject matter to create a film I'm proud of. I do not like the gratuitous over-sexualization of women. I find it boring. I'm amazed that anyone might still find it exciting. It does not feel bold or new because that kind of imagery is everywhere: on the high street, advertising real estate, even cleaning products. It's surely time for a new narrative?

Over the years that I've been working as a filmmaker with fashion, I've seen things shift with directors from other genres coming in from advertising, music video, and experimental filmmaking. All use their skills as a new way to show fashion living and breathing through new narratives and ways of storytelling. It's exciting to see how people interpret fashion who aren't traditionally working within the industry.

Two-dimensional fashion films, those that play to pre-conceptions, really irk me. Film needs to be smarter and more responsible. The lack of diversity and size is worrying but still goes on. This questioning of everything is part of the creative process. We need to ask who is being left out? Who should we include? Who do we welcome?

Most people will respond to who they can identify with. I'm excited by real people as opposed to models or actors. People have such incredible stories to tell. It's great to have real people involved in the creative process. Documenting has become core to what I do. I originally wanted to be a journalist but, as someone who is dyslexic, I find writing laborious and would have found it challenging as a career.

I realized at a certain point that I needed to work harder at what I was saying. If I was going to use this sacred medium, I needed to work on what I had to say. Both fashion and film have their own potency through which you can speak to people. And it might be something not traditionally associated with fashion film. I wanted to speak about female-centered issues. I wanted no more silent, passive women. I wanted to represent strong people, real people, who they and what they need to say. They bring more personality to a film. I've worked with very few models since I started working like this."

5.9
Incredible Machines (2016) by Selfridges HOT AIR Presents. © Kathryn Ferguson. Credits: Kathryn Ferguson (director), Wayne McGregor (choreography).

Incredible Machines (2016), directed by Kathryn Ferguson

Barbara Casasola: Menswear for Women (2014) by Marie Schuller comprised sixteen looping films and was inspired by the Nouvelle Vague movement. A collaboration with SHOWstudio and muse Jamie Bochert, the clothes were intended to look almost incidental.

IN THEIR OWN WORDS: MARIE SCHULLER

Film director

I started working with narrative and dialogue and made use of the elements that make film unique and different to photography.

"In terms of my own practice, my early work was heavily shaped by my mentor at the time, Nick Knight. I worked with Nick for five years after film school, and his studio-driven, graphic, technically avant-garde style heavily influenced my own work at the time. I started working with novel uses of lighting, projections, and moving lights. I applied heavy post-production, manipulating the source image into new visual languages, crafting very abstract and surreal imagery.

Back then I was a much better editor than I was a director and my films benefited from that—my work was heavily cut, using editing as a stylistic driving force, and I explored every single trick in the FCP7 effect library. I approached film from the editing backwards, hiding the fact that I wasn't a very good director. Instead of going into a shoot with a sense of structure or narrative in mind, I very much had a 'fix it in post' mentality and was only concerned with capturing visually beautiful and exciting stuff on the day.

Once I left SHOWstudio and Nick's mentorship, I started exploring my own practice and found my own style. It took years, and close to a hundred films, to gain a conceptual understanding of what I like and believe in, and how I might communicate this with the medium of film. Back in the days I had a technique I named 'accidental editing,' where I took a clip and chopped it up at random. I would then rearrange the bits to create a choppy edit that would jump back and forth and inject dynamic and energy into the edit.

When I started thinking more intensely about the structure and cinematic flow of my own films, I had to seriously adjust my approach to editing. I made a rule for myself to never cut unless the cut was needed. How does this film benefit from this cut? Do I need to cut, or am I only doing it to hide the fact that my material doesn't have the energy or hold the interest of its audience without a choppy edit?

This new approach initially led to a chain of boring films, but then forced me to become a better director and seriously address my sense of storytelling. I moved away from heavy post-production and became rawer and more intimate in my work. I started working with narrative and dialogue and made use of the elements that make film unique and different to photography. I questioned every decision: Is this idea original? Do my casting choices represent the world as I see it? Does this make sense? What am I trying to say? Most of what I am trying to do still fails, but with every film I do I continue to become a better director."

5.10
An iconic lipstick, Givenchy Le Rouge, given the film star treatment by Marie Schuller (director) in 2016.

Summary

- Whatever type of fashion film is being developed, research into the subject and market are required.
- Context informs content; filmmakers should understand where the film fits in terms of platforms, and audiences.

- Depending on the intention and proposed audience, fashion film can have multiple purposes.
- Alongside aesthetic elements, the film's story or message should also be considered.

Exercises

Harvest inspiration

Start an observation book or an online file to gather notes through text, image, audio, or video; anything interesting or notable. Take time to observe your environment, people, and things to create surprising connections, relationships, or patterns. A filmmaker's unique way of seeing helps develop a style and voice that in turn can prompt ways to collect, organize, curate, and share research.

Deconstruct a fashion film

Find a fashion film that connects with its chosen audience. Is it possible to interrogate this work from a production perspective? How long is it? How many shots are there? How many in the cast and on the production team? Is it on location or in a studio? Has it been sponsored? How many seconds or minutes of script are there, if any? How many changes of outfit? Is there music? Is this credited? Does the music add to the viewer experience or distract from it? The intention here is to develop the instincts and awareness of a producer rather a consumer.

Conceptual approaches to fashion

Looking closely at the clothing or collection that will be the subject of a fashion film can inspire a more conceptual approach. The inspiration behind a collection or its aesthetic attributes and qualities such as colors, silhouette, or detail can be reflected in filming approaches or art direction. Is it possible to extend the core fashion idea into casting, location, or music?

Fashion Filmmaking

Filmmaking breaks down into distinct stages: from researching the project through to shooting, editing, and distribution, referred to as pre-production, production, and post-production. Pre-production encompasses all the work and processes before shooting starts. The more thorough this is, the more likely a smoother shoot. Like much creative practice, filmmaking requires a considered, common sense approach alongside positivity, resilience, experimentation, and flexibility. Establishing a working structure and being organized are not only key to physically creating a fashion film but will unlock valuable mental space for creative thinking. It's worth remembering that creativity is not only confined to the ideas stage but emerges throughout the process with resourceful problem solving when dealing with unexpected changes or challenges.

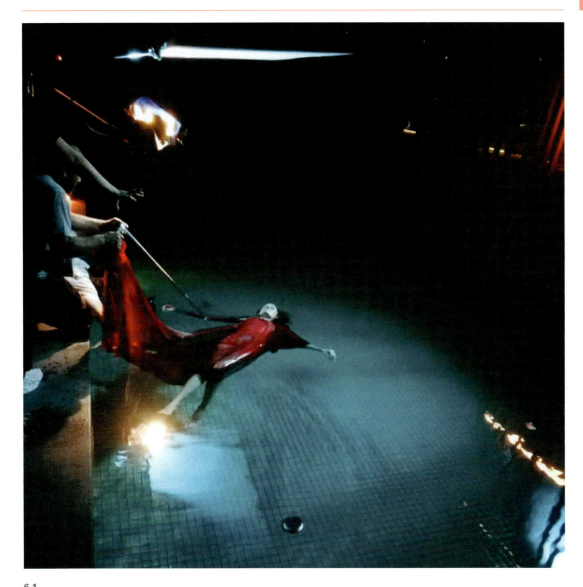

6.1
BTS image of *Hotel MFW* (2019) directed by the Milan-based Creativity Factory The Blink Fish for Camera della Moda. Credits: Giacomo Boeri and Matteo Grimaldi (director), Stefano Usberghi (DoP).

6.2
Lernert & Sander
draw attention to
the construction
of filmmaking
with a performed
presentation of
sound creation
in *Sound of COS*
(2014). Credits:
Lernert & Sander
(director), Lernert
& Sander X Jop
van Bennekom
& Gert Jonkers
(Creative
Direction). ©
Studio Lernert &
Sander. All rights
reserved.

*Welcome to
Milan* (2019),
directed by
Giacomo Boeri
and Matteo
Grimaldi (@
theblinkfish)

IN FOCUS

Research made easy

Apps and automated workflows such as Pinterest, Pocket, and Instapaper can convert sudden moments of inspiration into a personal archive. Whether to support a more cohesive sharing of ideas publicly or facilitate individual searches and records, tagging research, also known as media management, is as vital as tagging video files. Filmmakers should regularly take time to arrange photos into albums and utilize smart searches to classify material, e.g., by color or location. If sketching or taking notes on paper, work should be digitized using a scanning app or by taking a photograph. Text-based research, whether printed or online, should be captured and stored, preferably as files, not merely as browser bookmarks. Files

should not be left on computer desktops. Apps also allow a synching of material across devices for easy access wherever a filmmaker is. Once research is complete, filmmakers can share and start the journey of creating a tangible output potentially using Instagram, Twitter, Facebook, or Pinterest. Software like IFTTT (If This Then That) can combine social networks and cloud storage to create unique workflows for sharing across platforms in one tap. The tagging of an item such as #streetcast in Evernote can trigger a host of other activity—sending the photo to Instagram or Pinterest, tweeting a link, or posting an image to Tumblr in one tap. This curation of the world starts to define and order creative practice.

Creating a Pitch

The pitch plays a crucial role and should inspire and inform in as few words as possible. Initial image research will also play a key role in this document. Its purpose is to make the film concept accessible and appealing to multiple stakeholders, e.g., collaborators, crew, clients, and sponsors. Clear and succinct synopsis writing is essential and should be led by strong visuals that can inform progress and ideas development. The pitch should distill the essence of the film into an accessible summary and consist of a short, punchy narrative that both entices the reader and sells the production. This document is likely to be the first contact with your project for most people and first impressions count. It should demonstrate a filmmaker's understanding of a specific market, audience, brand, or theme, so it needs to be conveyed verbally with ease. A copy should always be readily available (in a back pocket or on a phone) in case of any serendipitous encounters (otherwise, a potential collaborator, client, or investor may have lost interest by the time a Wi-Fi connection is found).

As this is a synopsis for a film, include video or film references and think of the pitch as something like a moving mood board. Some commissioning editors of film prefer to *see* an idea rather than *read* it. They wish to understand the concept and vision, so short and impactful works best. The format should be organized into one that is client relevant, be they a designer, brand, website, or production house.

Although PDF is a standard format, filmmakers should ensure that editable, offline version are available on a mobile device using Microsoft Word or Google Documents, so quick adjustments can be made before emailing. In industry, Google Drive is most commonly used and supports the production of spreadsheets and share documents so teams can access changes from production into post-production phases. A schedule that includes team holidays or absences should be mapped out, so these can be worked around if necessary.

Planning the Production

While most fashion films start with great ambitions—visual, narrative, or conceptual—the process of production planning is when grand plans are scaled to budget and realistic, achievable goals. Production managers would normally see to this but if it's a very small team, this reality-check will fall to the director.

Casting

Model, acting, or talent agencies have searchable websites, headshots, and measurements but come at variable and significant costs. If a project has no budget for models, some agencies are willing to help with 'new faces'—models or actors who require images to support their fledgling career aspirations. However, professional models and actors are just one route. Street casting, or the use of non-professional models, can offer refreshing alternatives and bring a distinctive authenticity to fashion film.

These individuals might literally be discovered on the street or through social media, such as Instagram. If casting under eighteens, a parent's permission is necessary and any non-professional individual requires careful and considerate preparation, release forms, and a contract that outlines the agreement, terms, and conditions. Both street casting and the use of professional models can each bring their own issues around reliability, professionalism, and legalities. If there is no fee, a credit should always be included for the performer/model.

6.3
Hotel MFW (2019) directed by the Milan-based Creativity Factory The Blink Fish for Camera della Moda. Credits: Giacomo Boeri and Matteo Grimaldi (director), Stefano Usberghi (DoP).

IN FOCUS

Kathryn Ferguson's tips for street casting

- What will your chosen subject bring to the project? It's not like casting a model where you are just going for a particular look. Filmmakers should meet with, interview, and listen to potential candidates. Three or four key questions will steer the conversation and filmmakers should meet as many individuals as they can.
- It's important to have strong characters— as though casting for a drama. People who bring their own insights and personality to a project can be exhilarating.
- Even if subjects have been street cast, a model release form is essential.
- If there is no budget to pay performers or models, aim to cover transport and lunch.
- Ensure subjects are comfortable, physically and emotionally. Filmmakers should talk through the entire process, explain what will happen, and offer reassurance. Create a safe and nurturing space and explain if they aren't happy about anything, they can speak to the director. While it's the producer's job to keep the cast fed, watered, warm, and to organize transport, the director should look out for the emotional well-being of their performers and ensure they don't feel vulnerable in this situation.
- All subjects must be fully and correctly credited in the project.

A great deal of casting now happens on Instagram. Here, it's possible to see an individual within their own curated lifestyle context and find further contact details, either a website or agent. While some filmmakers are drawn to a specific look, others will note the numbers of followers an individual has. Pooling social media followings within a production team can create traction for a film. Influencers have cultural and economic currency that speaks in the marketplace hence their popularity with brands. But before committing to anyone through social media, a meeting, either online or in person, should be arranged, following all necessary safety precautions. Someone may have the right look, but how do they move? Can they act? What are they like on camera? Testing is key here. Language barriers can affect production, especially in a film with dialogue. If the film is for a brand, the chosen subject should chime appropriately with the brand values so checking in with the commissioner before committing to a model is advised. Helen Woltering believes that "the cast have to be relevant to the target group in order to create an emotional bond."

"If you can see the beauty in someone, then other people will too."

Kathryn Ferguson, filmmaker

Storyboarding and/or Scripting

Storyboarding is an essential part of the filmmaking process. It helps realize work, encourage collaboration, and needn't be an artistic masterpiece. It helps to visualize the required shots, step by step, for client and crew. Once, images would be spray mounted onto foamboard but now a shared digital space is more likely. It's worth noting that too rigidly controlled storyboards may not leave room for "happy accidents" during the shoot. Producer and director Drue Bisley, who has worked for Ruth Hogben and Mario Testino, favors a more creative approach: "Having to put down so much of the story can limit the potential magic of the medium. But if you leave spaces, they will have to be filled in." How the conceptual thread or narrative arc of the film is visualized will shape the emotional and sensory journey of the viewer. If there is any dialogue, a writer may be required to deliver a script to draw out the storyline and/or characters. In big-budget films, storyboard artists are specifically hired but a first timer can find many supportive resources online to guide and support the process. Key questions to consider are: How can a narrative concept translate into a visual storyboard? What should be included? Should collaborators be sought to achieve this? How will the storyboard inform production decisions and allow the director to reflect on these choices? Alongside the storyboard, a shot list and shooting schedule are required. **A shot list** breaks down every scene shot by shot and is the camera's eye version of the film. This will inform scheduling and equipment choices.

A shooting schedule allows shots to be prioritized and organized into a non-sequential timetable. This maximizes shooting time and makes explicit potentially non-essential scenes. The longer a film takes, the more money and resources it absorbs. When removing scenes, the cohesion and logic of scene sequencing must be considered (unless it's an experimental or non-linear film). If a film is to be shot at multiple locations, travel and sustenance times must be factored into the schedule to allow cast and crew to refuel.

6.4
#representationmatters, Vogue.de. © Bennie Julian Gay for *Vogue* Germany. Credits: Alexandra Bondi de Antoni and Tereza Mundilová (creative directors), Poliana Baumgarten (DoP), Aminata Belli (model).

6.5
Storyboard of *The Journey* (2014). © Monica Menez. Credits:
Monica Menez (director), Sasa Zivkovic (storyboard).

6.6
Art direction and designer plans for *Detour* (2017). © Anna
Radchenko (director), Lisa Jahovic and Helen Sirp (art direction
and set design), Edgar Dubrovskiy (DoP).

6.7
The sketches are interpreted into shots. The set designers
created the giant hair ball from a yoga ball wrapped in artificial
hair and constructed on set a day before the shoot. *Detour*
(2017). © Anna Radchenko (director), Lisa Jahovic and Helen
Sirp (art direction and set design), Edgar Dubrovskiy (DoP).

Locating the Right World: Where Will the Film Be Shot?

A studio is the simplest, most straightforward solution to shooting and has the advantages of ease, convenience, staff, and resources to support a filmmakers' needs. These vary in scale and price but if a studio is too expensive or is not suitable, a location may be sought. As well as considering the ambience, aesthetics, and narrative relevance of locations, practicalities around budget, accessibility, and how far the team will need to travel will all need to be weighed up.

Like all areas of production, a designated member of the crew to source locations and handle the associated responsibilities is the most efficient route and will cut down the time-consuming work of hunting locations from scratch. A good location director and/or manager will oversee all location goals, just as a casting director or experienced production manager would with cast and crew. But if hire fees are steep and budgets tight, this responsibility may fall to the director or first assistant director (AD).

The value of a recce (short for reconnaissance mission) cannot be underestimated. A room discovered online may be smaller than envisioned and be neither practical nor feasible. The initial recce—to understand the dimensions and limitations of a space—should be followed up by a technical recce with the cinematographer, camera operator, producer, location manager, and first AD. At this stage, it will be possible to establish where the shots will take place. The gaffer who deals with electrics can plan exactly where the lights will be positioned. The location of the base area where

the makeup artist, hairdresser, and stylist can set up can also be decided.

If shooting takes place in a crowded public space and a member of the public walks into shot, their permission may be sought to be shown on the film (if it's not edited out). The producer should have release forms ready to go, or extras could be organized in advance for background scenes.

6.8
Warrior with a Crown (2018), directed by the Milan-based Creativity Factory The Blink Fish. Credits: JMP, and Francesco Cuizza (director).

6.9
Left: Spaces and concepts are mapped out in the pre-production planning for *Detour* (2017). *Right*: Being able to see the spatial possibilities and narrative potential in everyday spaces—such as car parks—is part of the filmmaker's skill. © Anna Radchenko (director), Lisa Jahovic and Helen Sirp (art direction and set design), Edgar Dubrovskiy (DoP).

6.10
Detour (2017). © Anna Radchenko (director), Lisa Jahovic and Helen Sirp (art direction and set design), Edgar Dubrovskiy (DoP).

Consider the impact of the season: a beautifully lush forest in a search result may not be so inviting in February and create a very different backdrop and narrative. It's the job of the producer and first AD to check the weather ahead of the shooting day, although it's important to work with the weather and be prepared for all eventualities. The time of day and quality of light may also impact on the shooting schedule.

Travel time to, from, and between locations, access to electricity, a warm or cool covered area, and (without wishing to alarm) the nearest hospital should all be identified. Whether a filmmaker has a week or two months to complete a film will influence the suitability and distance of a location. Film director Ivana Bobic, who has created films for Mulberry and Stella McCartney, believes that "a location can give context of time and place and set up an atmosphere. You weigh up different things: the climate, textures, shapes, architecture, and how this relates to the clothes you are shooting. Is the collection English and classical, exotic, or modern? If you are shooting for a brand, the landscape should relate to the subject and their lifestyle. The location can be part of the storytelling. Patterns or textures can be overloaded or juxtaposed. Clothes can be framed with the background, but for commercial work, the clothes must really pop in the frame."

6.11
BTS image from *Abjective* (2017) by Marie-Therese Hildenbrandt. Credits: Marie-Therese Hildenbrandt (director), Felix Vratny (photographer).

IN FOCUS

Making the right camera moves by Edgar Dubrovskiy

"Apart from the camera movements achievable on any **tripod head** (pan and tilt, moving left/right, up/down) there other options for your camera movement. The next level up would be a **slider**, which easily attaches to the tripod (slightly longer options might require extra support on the sides to prevent the tripod from tipping). A slider will give you basic left right and back/forwards movement. A **small jib** would be the next step, which allows for the camera to change its height during a shot, or produce a high-ish top-down shot (for a setup looking down at the table surface, for example.) For a smoother handheld, on a budget, look at **Easy-Rig**, a vest that distributes the camera weight across the body. If you have money for a grip, you can add a full-blown **dolly**, giving you an option for much longer tracking shots, 'dollying' left and right as well as the option of going back and forwards. A more complex dolly will also give the option of going up and down as much as the dolly's construction allow.

Another option that is probably cheaper and easier to use in smaller spaces is a **gimbal**. A camera gimbal helps to smooth the operating, making up-the-stairs and in-the-woods shots possible. It removes any visible bumps—a good operator is a must for the best results. The same goes for the **Steadicam** or something like the Trinity from Arri. These also help get complex moves without laying track and flying cranes. A gimbal doesn't always have to be used in rough terrains or car-riding shots but can also be used for some specialist work. I've shot a music video (*Selene* by Metaxas) in a warehouse using a gimbal. The space was too tight for a Steadicam, so a gimbal was the only way to achieve the director's vision; a one-shot dance music video.

Going into bigger grip departments (grips in UK look after the camera movement and placement, be it a simple tripod or big crane and specialist units, a **telescopic crane** (or techno crane) allows for more complex moves with its telescopic 'arm.' This means you can go up/down/in/out and left/right simultaneously. A movement in all directions without long tracks means the cinematographer can fly above a swimming pool or do complex moves above the sand or forest terrain, where laying tracks would be impossible or extremely time-consuming and expensive. Another heavy-duty piece of gear is the **MoCo Unit**, a motion control piece. Once the camera is rigged, you can repeat the movement multiple times, allowing you to overlay shots in the post-production to produce a layered effect (for example to have the same person twice in the frame, or to combine stunts into one shot by shooting them in two separate passes."

6.12
Makeup artist
Nina Parks
attends to model
Vera Van Erp
on the set of
Looks (2017) by
Wolfgang Joops,
a TV commercial.
BTS image from
Looks, directed by
Ivana Bobic.

Hair and Makeup

Hair and makeup goes with the territory of filmmaking but has greater emphasis in fashion film. Hair and makeup should dovetail with the styling and be part of creating the whole look. The makeup is a key part of the brief and spans the natural and fresh faced to the highly dramatic or theatrical. Makeup artist Yulia Yurchenko, who has worked on films for many commercial brands, believes there are key differences between working on photographic editorial and film: "The shooting process in film is more complex than a photoshoot. As a makeup artist, I need to find a balance between keeping models flawless, with as few touch-ups as possible to maintain the shooting flow. You don't want to rely on post-production in film, it's not the same as a retouch in Photoshop; it takes longer and is more expensive." International hairstylist Sam McKnight agrees: "video takes longer to shoot than stills. It's not just about reeling off a few snaps. There isn't the luxury of time to develop a spontaneous idea on the shot day, and although the doing bit is the same, continuity is key and most films are planned to a T."

Lighting can also have a huge impact on the look of the model and the type of makeup that is applied. Yurchenko continues:

> You need to be aware of what's happening with lighting and last-minute changes that might happen. Once, I was asked to do canary yellow eye makeup and at the very last moment the lighting was changed to a red wash which effectively obliterated the yellow eyeshadow. Now I always triple-check the lighting before the shoot and check the makeup look directly on set. Combining makeup techniques with light provides

6.13
BTS image
from *Kokosmos*
(2019). © Anna
Radchenko
(director), Roman
Yudin (DoP).

endless variations for creating a character. Also, the color grade is a big part of the finished film's look (it can end up diffused, or more saturated than on the shoot day, for example), so I tend to look for any hints of the planned color grade in the treatments I receive.

6.14
Crystal Clean. The painstaking face and body makeup took eight hours to apply for this film that makes a comment about unrealistic beauty ideals. Credits: Jasmine de Silva (photographer and director), Natasha Gravia-Lund (model), Natasha Lawes (makeup artist), Judit Florenciano (hair stylist), Sian O' Donnell (stylist), Amy Exton (set design).

The Big Day

Whether it's a DIY job, low-budget film, or big-budget commercial, the shoot isn't just about the director's vision. Although this is crucial, equally important is the preparation, timing, communication, and delegation of responsibilities. Creatively, it's possible to shoot well anywhere, even in a bedroom or corridor. This may limit the scope of possibility, but even with little or no budget, a strong concept or story can come alive, if well thought through and planned in advance. Creativity is not limited to the "idea" but translates into the entire production, especially if there are few resources. Persuading others to collaborate for no fee requires creativity and diplomacy, as

does finding spaces that do not charge expensive location fees.

Every shoot is different and will present its own challenges. Some can be planned for and others may constitute "learning surprises." A teenager's bedroom may have authenticity and naturalism but, practically, there may be issues with space and light. A studio will have everything required but will charge for everything—including every bottle of water. Deciding where to shoot will involve research, as will deciding who to work with in the team and who to have in front of the camera. Ideally, a director will work with a producer to organize this, but a new director may need to shoulder this responsibility.

IN FOCUS

Choosing the right equipment

There is a broad scope of technical equipment available. This varies enormously in price and changes constantly but budget, experience, and suitability will ultimately drive this decision. It may be the only camera available is the director's mobile phone. Hiring equipment is also an option. The director of photography should be trusted here. Chances are they were selected based on the look of their work and will invariably have a favorite camera to work with. The choice of camera impacts significantly on the film's art direction and can create a low-fi, gritty look or a super slick, glossy image, and everything in between. Communicating the desired look to the AD is essential to effective collaboration, as is discussing how this might be achieved within the existing project constraints.

Styling: Dressing the Cast

Full-time stylists may work for department stores, magazines, and individuals but many more work on a freelance basis and can be found through social media or industry directories such as *Fashion Monitor*. Stylists play a vital role in fashion film production. The more directly linked to the fashion industry, then the greater the role of stylist to the overall vision of the film. They are responsible for selecting and obtaining garments by liaising with PRs or brands who lend clothes in exchange for credits. They will be on set throughout the shoot to help dress models or cast and ensure everything works effectively for the camera. Afterwards, the stylist is responsible for sending everything back and for delivering the correct credits.

Besides having an excellent fashion knowledge and being tuned into current trends, stylists should be aware of how clothing will enhance narrative and character choices.

If the fashion film is a low- or no-budget production, filmmakers should seek trainee stylists or students who hope to build a portfolio. A talented stylist with a flair for stylishly orchestrating garments can construct interesting looks from many places—from charity shops to hardware stores—and may even have their own dressing-up box. Renowned stylist Caroline Baker was known for creating original imagery from military clothing and could do amazing things with paper, string, and pegs.

Film is the result of many hands, so the director should be conscious of no single creative talent taking over or dominating the vision, unless this is expressly desired, for example, if the film aims to spotlight the creative talents of

a makeup artist or hairdresser, but the director should guide this. Perhaps certain colors of garments need to harmonize with the set. Perhaps, it's a personal style film that's been street cast, in which case, "models own" will suffice and subjects can self-style.

Accountability: Completing the Paperwork

If completing paperwork sounds like a mundane activity, rest assured the paperwork associated with fashion filmmaking can be fun but there are some essential formalities. Any film production needs to be watertight. This is particularly important as film content is increasingly shared across multiple platforms and formats. In addition to any employment contracts, there may be forms to be completed as post-production begins. Although each production is different, some common paperwork includes artist release forms, location permissions, risk assessments, and NDAs (non-disclosure agreements).

Permission forms may be required for the production team and cast. Model/ actor/contributor release forms should be completed and signed before any filming commences. These give permission to use, reuse, and edit material shot with the subject. These are common documents for actors and models but non-professionals (street cast models, for instance) will need help to understand this process. NDAs may need to be signed if working with a big brand or fashion house with embargoes about when content can be released. The call sheet will reinforce this and there are often "no social media" signs in many studios to prevent media leakage.

Location permits are required when shooting in exterior locations. These are more likely to be found through the local authority but can also be obtained from private landlords. A London Westminster Council permit, for instance, does not cover filming on the South Bank—so filmmakers should always check locally. Equally, interior locations can be covered by the permits of private owners *or* a general authority (for instance, filming on the London Underground requires permission from Transport for London). Although filming location work without the right permission does happen, it exposes the filmmaker to liability issues, both in terms of safety and the legal liability for footage used. Therefore, public liability insurance should be sought. University students may find they are covered through their courses but will need to access the appropriate document.

6.16
Marie Schuller teamed up with London designer Craig Green in this film that explored workwear. *Workwear: These Women* (2016). Credits: Marie Schuller (director).

Rafandi – River Island Design Forum, Matthew Miller (2018), directed by Liam S. Gleeson

Dice Kayek – *WHITE* (2014), directed by Marie Schuller

Post-production: where the magic happens

Once shooting is over, post-production starts. Besides this being where all the astonishing, magical, and mind-boggling effects are created—from models flying through the air or walking on water, silhouettes dissolving and colors popping on the screen—it also includes the more prosaic elements of media management and setting up workflows. Collating, organizing and sharing rushes (which are the unedited, raw footage of filmmaking), editing, working with color grading, audio, effects, music, graphics, and finally mastering and uploading the finished film are what make the fun stuff achievable. In many ways, this part of the filmmaking process is both the most technical and potentially most rewarding. However, as the deadline looms, there is the risk of time-consuming errors.

Post-Production Workflows

The post-production schedule is key. A commissioned film should have feedback time from the client factored into the deadline for completion. Big brands may require the eyes of an entire management hierarchy on a film *before* the final edit. What might be the end of the project for the director may need to be three months *before* the release date to accommodate all these invested eyes on the project. If working with a celebrity, they too may have the right to see the work first. Even with a personal project, in the spirit of collaboration, feedback sessions with key team members should be built into the schedule. But parameters should be set for the amount of feasible and practical feedback within a timeframe.

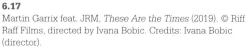

6.17
Martin Garrix feat. JRM, *These Are the Times* (2019). © Riff Raff Films, directed by Ivana Bobic. Credits: Ivana Bobic (director).

6.18
Dice Kayek –*WHITE* (2014), directed by Marie Schuller. Credits: Marie Schuller (director).

Editing the Film

Working within commissioned guidelines means understanding where to make cuts seamlessly and how the material might be manipulated and re-arranged to create the best pace or tension. This is the craft of editing. Deciding what can be lost should be one of the first decisions in post-production. At this stage, it's also important to consider how the film will be consumed. The edited length, structure, and composition will vary, depending on where it's being viewed—whether, for instance, content will end up on Instagram or YouTube. For a cinema screen, where everyone is seated, focused, and looking forward, captive and concentrating, a slower edit would work. If the film is for a mobile device, then a short, faster edit might be more suitable for a viewer on the move.

Working with Music

Music sets the mood but this must be carefully selected with an ear for sound and in the context of the screen images it will score. Permissions will need to be sought—which can take time—and processes adhered to if you wish to license music from a music label or provider, and costs will vary depending on what your film is being used for. There are also many free music archives and libraries such as Creative Commons, Premium Beat, or Jamendo which offer stock, royalty-free music at affordable prices without the need to pay further fees, and students may be able to access these at favorable rates.

IN FOCUS

Working with audio and music

No matter how well art directed or stylish a film, bad audio or a poorly chosen soundtrack has the potential to kill it. Well-chosen audio, on the other hand, will animate and elevate the film but this requires research and planning. For fashion filmmaker Quentin Jones, "music needs to be fun, catchy, entertaining and engaging. It also needs to punctuate the film and move with the visuals. The tempo needs to have enough points of interest and build to some kind of crescendo. It also needs to have immediate impact." The Marc Jacobs S/S 2020 film *Conversations* was an audio-visual collaboration by Benn Northover with his brother Jack Northover, a film composer. "Fashion films should be scored with the same care as when approaching a narrative or documentary film; the music is of great importance for the overall feeling of the film. The film was heavily influenced by the notion of overheard stories and conversations." For Ivana Bobic, music and sound are part of the storytelling. The *SS 2015 Dance Film* for Mulberry used the track Dance by the band ESG, which presented a real attitude and said something about the brand. "For Whistles, we would craft our own sequences through sound design, sometimes with an editor or separate sound designer. With this approach, you can draw in subliminal effects. Music can tell you about the character, mood of the collection or time it was set. If the fashion references are the 1970s, then music can also set a tone and give the film a context. The right sound can push a brand to a new place. As many films have no dialogue, it's possible to say something through the lyrics; they can become the voice of the narrative."

Mulberry – *SS15 Dance Film* (2015), directed by Ivana Bobic

Finding your own musical talent, locally or online, perhaps someone unsigned looking for opportunities and credits, may be a way forward. No matter how friendly this arrangement, a contract should still be signed as their circumstances may change (they may sell their rights to a record label and publishing company). Just because they might not have a record label or publishing company, this doesn't remove the need for a formal agreement, and they can still request a fee. However, using a track from a licensed or well-known artist requires a different process entirely.

IN THEIR OWN WORDS: LYNDEN CAMPBELL

Music supervisor

You're not simply able to apply someone else's music to your film without ensuring legal permission is in place.

"Although music has never been easier to access online, you must be mindful of not accidentally stealing music. Just like other forms of intellectual property that cover the film being made, music is a property defined by laws of every country. You're not simply able to apply someone else's music to your film without ensuring legal permission is in place. The administration of permissions is called licensing and like any commercial transaction this is processed in return for a fee. This will always require consent from both the performer *and* music composer or their legal representative.

Where an artist has sold rights to a record label or a writer has sold rights to a publisher, you first need to approach the legal or licensing teams of the relevant record label and publishing company. This may or may not be the same point of contact. You can find information online (AIM Association of Independent Music), through music collection society websites (in the UK this is PRS Performing Rights Society or PPL Phonographic Performance Limited). A music supervisor could assist you with this process for a fee.

Every piece of music protected by copyright must be cleared before usage which requires a signature on a contract and in most cases, a fee. A persuasive email with a treatment, storyboard, or rough edit attached may help start a conversation. Information supplied by filmmakers enables rights holders to understand the proposed use of the music and allow time for relevant contacts to respond. Filmmakers will need to know which tracks they wish to license and the term and scope of its use across which media and territory. This process might not happen quickly so allow extra time. Silence from a music provider does not constitute acceptance.

Platforms like Instagram, YouTube, and Facebook have an automated whitelisting process (whereby the film will be removed if you don't have the right permission to use the music). This only applies to user-generated usage and will not apply if you are promoting a product or service which will require a license. Even a cover version of somebody else's song, may still be copyrighted. A license agreement will protect filmmakers against any liability should that artist or songwriter be liable for a third-party claim. Whatever approach is decided, ensure the music rights cover the production for the range of outputs and territories in which the film will be screened. Whenever signing contracts, legal advice from an experienced music lawyer is a good idea."

Sync Audio and Foley Sound

Music is just one solution to the sound of fashion film; there are other approaches too. Working with dialogue, picture-synced audio, the use of atmospheric or multi-layered sound-scales—and even silence—all offer sonic opportunities. Sound can work as a powerful narrative tool enhancing not only what the viewer sees but leading a viewer's feelings and emotions. Foley sound such as footsteps running through a tunnel can be added in post-production. Sometimes it's necessary to re-record sound in order to mimic real sync sounds and other times atmospheric sound is needed.

IN FOCUS

Credits and intellectual property

An accurate, up-to-date list of credits should be maintained throughout, right up until the completion of post-production. Credits will likely be one of the last tasks performed by either the editor, post-house, or motions graphic artists (or whoever is assigned the role). Filmmakers are responsible for accurately crediting their crew with special thanks to supporters, sponsors, and commissioners, some of which may require logo placement. With fashion film, companies, designers, or brands that have lent clothes for free might have done so in exchange for a credit. When posting a film online or exhibiting at a festival, ensure all credits are included and accurate. This is a key part of the post-production process and final edit lockdown.

Poetry, branding, visual likeness, photography, quotes, guest appearances, and locations (work not original to the filmmaker) will also require permissions. According to the World Intellectual Property Organization, these "creations of the mind" might include "literary and artistic works, designs and symbols, names and images used in commerce." So, song lyrics, extracts of poetry, or the use of brands in anything that is more than incidental will require the owner's permission. The filmmaker is responsible for the clearance of all external material, and may be required by a festival to produce necessary documentation at any time. Always obtain a physically signed agreement to ensure any contribution from outside the films core crew is signed off. This ensures a filmmaker's rights and enshrines the agreement of the contributor.

In terms of any intellectual property (use of poetry, songs, music, photography, etc.), it would be wise to send the contributor an early edit of the film during post-production for approval to illustrate the use of their work within the film. This good practice draws contributors in and includes them in the production (rather than being regarded as mere suppliers). On higher-end productions, fees and licenses will need to be negotiated. The filmmaker's priority is to ensure the agreement covers public exhibition of their work. Any breach of the agreement could result in legal action, incurring additional costs and damaging a filmmaker's reputation.

IN THEIR OWN WORDS: SALLY COOPER

Editor

You do not, at any point, want to lose the viewer's attention.

"Editing is definitely where the magic happens. It's the first time the story, which so far has only been on paper (script, treatment, storyboard), comes to life. You can manipulate the viewer into feeling something, bringing together the elements everybody has worked so hard to create. The edit room is where the skills of writers, creatives, sound recordists, Directors of Photography (DoP), not to forget the organizational skills of the of producers and first and foremost the director, are combined to create a storyline that will entice viewers to laugh, cry, worry, or sit on the sofa with a cushion over their face with sheer terror.

We work closely with the people finishing the project: sound engineers, sound designers, or composers, who can change the feel of a piece with the addition of music and sound effects as well as VFX artists and colorists. Everyone is essential in making the project the best it can be before it goes on screen to be enjoyed by the viewer and the possibilities are endless.

Your gut answers all the questions about where to make the cut. The big ones are 'Is this engaging to look at?' and 'Is it getting boring?' You do not, at any point, want to lose the viewer's attention. However, sometimes it's good to let a scene play out longer in a take which allows you to read the emotion in some-one's face. Sometimes an empty room can be a really powerful image depending on the context. Basically, if it assists the storyline and makes you feel something you're good to let it play out. A good editor is able to cut any style: fast-paced and eclectic, slow and romantic, or factual and full of reality. In general, the best edits are the ones you don't feel."

British Fashion Council LCM, directed by Matt Lambert

6.19
This film for Men's Fashion Week directed by Matt Lambert was shot on so many different cameras, it proved a challenging but ultimately rewarding task for Sally Cooper. *Best of British Menswear* (2013). Matt Lambert (director), Sally Cooper (editor) Edit Company, Cut + Run.

Working with Color

Color grading can make an enormous difference to the final professional look of a film, bringing parity across scenes and at best will help achieve a distinctive visual style. The colorist will not only work with the director and AD to alter color, contrast, hue, and saturation but will have the creative tools to enhance the film's feeling, atmosphere, and emotion.

IN THEIR OWN WORDS: FAITH MILLIN

Colorist

It's the colorist's job to interpret, translate, and achieve the client's original vision.

"Color grading for film and video is a digital process that manipulates the image for a desired outcome. This can include not just color, contrast, hue, saturation, overall exposure, white balance, matching different cameras, etc., but more detailed and creative manipulation where 'looks' can be created to enhance a feeling or atmosphere within a scene, manipulate the time of day, isolate skin tones, skies, clothes, shaping, etc. Every fashion film project is different as directors constantly push the boundaries of what makes a fashion film.

With fashion film, the grade can be more creative in terms of look. Directors and DoPs are often open to fresh ideas and trying new techniques and looks. There's less desire to give the film a 'real' or 'natural' look, although this is sometimes required. In high-end fashion work, a director or client might request specific skin work or product detail. I'm sometimes provided with campaign images where the color and stills has been set by the stills retoucher—and approved by the director and client. In this instance, I will be asked to match the campaign still images, so they work when shown alongside each other. The software I use is DaVinci Resolve.

The way I work is very collaborative. The best projects I've been involved with are when the director, director of photography, art director, producer, post supervisor, editor, and VFX team all work together on both a creative and technical level. When collaboration is working well, people are more likely to offer up innovative ideas and solutions creating a stronger result and more enjoyable process.

The most challenging part is reading between the lines with a first-time client to work out exactly what they hope to achieve visually, technically, emotionally, and narratively with the film and thinking about how to achieve this in the grade. As the working relationship develops with a director or DoP, you fall into a rhythm as you learn the intricacies of their individual aesthetic and visual end goal.

It's the colorist's job to interpret, translate, and achieve the client's original vision (usually stored somewhere deep in their minds!). Before we get into the session, I like to discuss visual references, talk about their film, as well as discussing the creative and technical aspects with the DoP."

Woman on the Verge (2018), directed by Mafalda Millies

6.20
Shot on 16 mm, *Saloni* was inspired by the look and feel of 1960s James Bond movies. The footage was made to look saturated, lush, and slightly disorientating. "We achieved this through the film's natural grain, the occasional use of a glimmer lens, hot lighting and the color grade." F/W 2019 campaign. © Mafalda Millies (director), Carolina Aguirre (editor), Tom Mangham @ The Mill (colorist).

IN THEIR OWN WORDS: MONICA MENEZ

Director

A single impulse can evolve into an entire story for a film.

"Sometimes I see a location that inspires me to create a story around a place, sometimes it's a piece of music or fashion that fires my imagination. Other times, I already have a story in my head so start to build the setting and an entire concept around it. After the initial idea is born, I think about the main colors I want to use predominantly—which is often the basis of the mood boards I create afterwards. These boards usually consist of three to five mostly pastel colors.

A single impulse can evolve into an entire story for a film. While searching for music, I came across a short tango piece. When I listened to it, I almost immediately had this scene in my head in which a woman is moving her legs to the music. This is basically how the 'ham scene' from *Hors d'oeuvre* was born, where you see a woman who hangs herself, but then starts to move her legs to the music's rhythm. I built the entire film around that single idea.

Another example is *Odditory*. I had a storage room in an old school building and one day discovered a lecture hall there that impressed me deeply. I took some photos and created a mood board. Gradually, I developed a color concept and simultaneously did some music research, although the music eventually used was specially composed."

6.21
BTS image from *Hors d'oeuvre* (2012). © Monica Menez. Credits: Monica Menez (director),
Paul Robert Klinar (DoP).

ODDITORY (2013),
directed by
Monica Menez

Hors d'oeuvre
(2012), directed by
Monica Menez

IN THEIR OWN WORDS: EDGAR DUBROVSKIY

Cinematographer

I translate the director's visual thoughts into the language of cameras and lighting.

"The cinematographer is the link between the director's brain and what you see on screen. I translate the director's visual thoughts into the language of cameras and lighting. Very few directors can do this for themselves. They come up with the original idea and during the shoot focus on getting the best performance from the performers. My job is to cinematically capture the idea in the best possible way.

Every director has a different approach but the job always starts with a long talk which might last from a couple of hours to an entire day. During this conversation, which is semi-psycho-analytic, I will ask lots of questions about what the director's trying to achieve and why they want to shoot it in a particular way. We'll discuss the message and story. On the day of shoot, we both want to walk on set and have a completely mutual understanding of what will be achieved. The conversation is as much about establishing your working relationship as the film itself.

It's important for the director and cinematographer to share the same ethical values and points of view. We'll look at other work that might be relevant but It's important not to look at work too similar or you might end up copying it. I prefer to go to the location and see what we can use there. Then I ask the director to send me a playlist of music, either what they were listening to when coming up with the project or the sort of music we might hear in the film.

Then we share images and discuss colors, tones, palettes. I will often go back to the director once I have their visual references to understand specifically what they are seeing in a particular image. Is there a detail or are they drawn to its overall feel? It's like a ping pong of ideas.

As well as two-dimensional inspirations, such as photography, I enjoy walking into spaces and seeing how they're naturally lit. I ask myself why I'm drawn to the lighting and observe how surfaces reflect or glance light then consider how I might recreate this on set. Having a good eye means you notice things but crucially, can recreate them. I'm very inspired by live performances, the unique sorts of lighting in theater or dance. The space is your canvas and then it's your job to sculpt the light. We live in over-lit spaces; the office and gallery are both brightly lit but it's contrast that makes lighting interesting. I also work with and manage a team: the focus puller (1st AC) is chief camera assistant and the grip looks after the camera movement (dolly, tripod, jib, cranes, etc.).

I find that younger cinematographers will rely on Pinterest, Instagram, and other easily accessible 'image banks' so we have lots of similar images being reworked. What is the point of being a McQueen imitator? I'll always try and push directors to think deeper, find their own voice and point of view. The director/cinematographer relationship is very important and listening is key. Directors can be out of touch with the day-to-day boring reality (I mean this it in the best way). But the cinematographer has to be more grounded in the reality of trying to achieve the vision technically: cameras, length of dollies, etc. I can dream as much as I want, but in the end, I must deliver it on screen. Some ideas have to be simplified or adapted to the realities of the budget. But directors shouldn't stop dreaming. It's always possible to scale down later in pre-production."

6.22
Edgar and filmmaker, Anna Radchenko on the set of *Detour* (2017). © Anna Radchenko (director), Lisa Jahovic and Helen Sirp (art direction and set design), Edgar Dubrovskiy (DoP).

IN THEIR OWN WORDS: MARK CONNELL

Production designer

You will ask questions like "Can we build these walls of glitter?" and "How might we create the illusion of raining scissors?"

"I would describe myself as a film architect. Production design requires you to be creative, productive, and technical because your responsibility is to design the space, set up the scale, and define the look of the film environment. You're likely to be one of the first people the director will contact—because they need to understand what is feasible—and you're likely to be on set the longest. You might be asked to create an entire word, develop an aesthetic—or perhaps make specific props. Production design is like a hidden art. We can't be seen to be telling everyone the tricks and must retain the magic. It's also about marketing. If you are selling a pop star, you don't want to push the voice coach.

Many directors have a strong aesthetic, so you need to understand the reference points to correctly set the mood, whether that's an old music video or obscure art film. This process will normally be supported by images but you need to be on the same page regarding the mood and style of the film. Next consider the scale of the environment. How much room do you need to shoot the film? Will there be top shots, panning, or jibbing shots? Or corridor shots? The general shape will assist with the storyboard and filming process—then finally, you are thinking about the detail."

6.23
BTS image of production designer Mark Connell on the set of *Pixelmania* (2013); Terry Hall (director).

Stills photography is about the single or double page output. Filmmakers understand camera moves—a 16 x 9 ratio is more screen real estate to fill. Exactly how much panning and jibbing happens will also affect the budget. Production design is always about working within and pushing against the edges of resources and filmmaking. Everyone involved needs to understand the size of the set and number of props and THEN we can go into detail—the precise color of the wall or specific pieces, the "I love those feathers" moments.

Creating a world—whimsical, fantastical, or visionary—is a creative opportunity to dive into something deep. The more complete the world is, the deeper you go. Working across multiple departments, e.g., director, producer, cinematographer, creates a richer experience but at the very least it's the production designer's responsibility to point the way forward. You need to think about what can be done "in camera" and what can be achieved in post-production. You will ask questions like "Can we build these walls of glitter?" and "How might we create the illusion of raining scissors?"

At a certain point, it will feel as though everything is going wrong but this is part of the process and you must trust the process. If you're creative, that will never go away, but you must be thorough and organized and you must deliver. The camera can turn up to shoot but there must be a background. You shouldn't overreach what you can achieve and it's equally important to manage expectations.

We are now more reliant on post-production and this should be embraced. Technology changes everything. Social media has also changed how we ingest content—specifically Instagram. How is your content played out as an everyday occurrence on a 7 x 7 frame? You would not believe how many hearts and minds can be involved in the simplest of shots.

Summary

- Fashion film starts with research and forms three stages: pre-production, production, and post-production.
- Inspired and methodical research techniques lay the foundation for fashion film and are twofold: concept research drives the core idea while production research supports the film's realization.
- Elements of film development that support the production process include a pitch document, story-board, shot list, and shooting schedule.
- Crews can be scaled up and down according to budget and needs. Low- or no-budget production means those involved will perform more than one role.

Exercises

Plan pre-production and development of a film

Once an idea and narrative have been thought through for a film, produce a storyboard and script (if required). Break down your storyboard into the number of shoots required (it may be a combination of location or studio or at different locations). Then choose one of the key scenes narratively and break it down into a shot list. An idea may evolve over the course of production but this will form the basis of your project.

Studio versus location: compare inner and outer worlds

Closely watch a series of fashion films, some shot on location and some in studios. What are the strengths of each approach? What can be achieved in a studio? What about whole worlds created using Green Screen, Photoshop, or CGI? Draw up a list of the strengths and issues around each approach. Think practically, narratively, and visually. Consider the film you want to make and how the garments and characters might fit into a specific setting. Industrial? Urban? Woodland? Consider what is available, explore those options and make a plan. Start a digital file for collecting potential film locations.

Watch with your ears, listen with your eyes

The soundtrack applied to any film will dramatically alter how we perceive or view what we see on screen so this decision is a key one. Choose a film, maybe one you've made, or found online. Select different soundtracks, from upbeat and contemporary, menacing and suspenseful, industrial soundtracks to those of the natural world. Play them against the film and note how perceptions and meanings of the visuals shift according to different sounds.

Sound and vision: edit your soundtrack

Choose a song you would like in your fashion film. Listen to the track and mark the timing when you feel there is a beat, mood change, or potential for striking an edit (Sound Cloud is useful for this). Using the storyboard, match your shot changes to some of these marks. How does the timing hold up? Is the film too short or the track too long? How can you fix this? Be adventurous and experimental with your cutting.

NO BUDGET

Film or fashion students will often be expected to make short films as part of their courses with no budget, lots of ingenuity, and effective teamwork. This will often mean crew members taking on multiple roles. Provided you can find individuals happy to work for free—only the credit and finished result—it is possible to make a film with no budget.

Production, Management, Logistics

Production Roles

Director – Responsible for the overall visual communication of an idea, directing actors on set, setting up shots with the DoP, and seeing the project through the editing and finishing stages.

Craft, Capture, and Technical

Camera

Director of Photography (DoP) – Head of Camera and Lighting, making key decisions on framing and lighting in partnership with the Director.

Camera Operator – Under direction of the DoP, the Camera Operator is responsible for capturing the scenes. Depending on the production, the DoP may well be the Camera Operator as well.

Sound

Production Sound Mixer – Head of Sound on set and responsible for recording all of the sound. They will decide the microphone setup and use a recording unit to monitor and record the sound in real time.

Art, Styling, and Makeup

Styling / Wardrobe

Costume Designer / Stylist – Responsible for all costume and clothing worn by the cast on screen. If garments are to be made especially for the production, the Costume Designer designs and plans the construction, including style, fabric, color, and patterns.

Hair and Makeup

Hair Lead – Responsible for the look of the hair, this individual should have a good knowledge of style and trends.

Makeup Lead – Responsible for makeup on set. They will have a good knowledge of makeup trends and styles.

Post-Production

Post-Production Roles

Editor (Offline) – This is a creative role. The lead Editor watches all the footage and creates a cut of the film, making constant reference to the script. This is initially done by the Editor. Once a draft of the full film or select scenes is completed, the Editor and Director finesse the cut. This can be a long process and involves watching hours of footage, much which will never be used.

LOW BUDGET

If commissioned to deliver a fashion film by a new designer, you may be given a small budget. This may still involve some duplication of roles, some favors and the producer should still be negotiating for best possible deals and credit exchanges.

Production, Management, Logistics

Production Roles

Director – Responsible for the overall visual communication of an idea, directing actors on set, setting up shots with the DoP and seeing the project through the editing and finishing stages.

Producer – Responsible for budgets and project planning. Depending on budget a Producer will likely delegate tasks to assistants and specialists but will oversee the entire process.

Assistant Roles

1st Assistant Director – Assists the Production Manager and Director to oversee day-to-day management of cast, crew, equipment, script, and the overall set, allowing the Director to focus on the production.

Assistant / Associate Producer – A junior role assisting the Producers with key tasks.

Script

Screenwriter – Responsible for presenting or adapting an initial idea, writing dialogue and detailed screen instructions. This may have been done prior to the Director's or Producer's involvement or may have been a collaboration.

Casting

Key Cast – Some lead members of the cast may have joined a project at its early stages. Not all cast will be above the line talent.

Craft, Capture, and Technical

Camera

Director of Photography (DoP) – Head of Camera and Lighting, making key decisions on framing and lighting in partnership with the Director.

Camera Operator – Under direction of the DoP, the Camera Operator is responsible for capturing the scenes. Depending on the production, the DoP may well be the Camera Operator as well.

1st Assistant Camera / Focus Puller – The 1st Assistant Camera is responsible for pulling focus to ensure that all shots are clear and in focus.

Sound

Production Sound Mixer – Head of Sound on set and responsible for recording all the sound. They decide on microphone setups and use a recording unit to monitor and record the sound in real time.

Boom Operator – Responsible for microphone placement using a boom arm. This allows the operator to position a microphone above or below the shot, keeping the microphone out of frame.

Art, Styling, and Makeup

Art

Production Designer – The Production Designer creates the physical and visual film set, considering setting, costumes, props, and makeup.

Styling / Wardrobe

Costume Designer / Stylist – Responsible for all costume and clothing worn by the cast on screen. If garments are to be made especially for the production, the Costume Designer designs and plans the construction including style, fabric, color, and patterns.

Assistant Costume Designer / Stylist – Assists the Costume Designer or Stylist.

Hair and Makeup

Hair Lead – Responsible for the look of the hair, this individual should have a good knowledge of style and trends.

Makeup Lead – Responsible for makeup on set. They will have a good knowledge of makeup trends and styles.

Key Hair Team – A team of hair stylists that work under the direction of the Hair Lead, budget permitting.

Post-Production

Post-Production Roles

Editor (Offline) – This is a creative role. The lead Editor watches all the footage and creates a cut of the film, making constant reference to the script. This is initially done by the Editor. Once a draft of the full film or select scenes is completed, the Editor and Director finesse the cut. This can be a long process and involves watching hours of footage, much which will never be used.

Assistant Editor – The Assistant Editor is responsible for collecting, organizing, and syncing daily footage. They will also keep track of what footage has been received, making constant reference to an annotated script. The Assistant Editor may also be required to source temporary sound effects and music for the Editor and lay them onto the edit. In some cases, further Assistant Editors are employed to keep track of paperwork and organize script references.

Editor (Online) – A more technical role than the Offline Editor, the Online Editor is responsible for adding in visual effects, color corrected sequences, titles, and credits. They also ensure the project meets the technical delivery specifications.

Sound / Music

Re-Recording Mixer – The Re-Recording Mixer is responsible for bringing the whole sound world together, balancing a mix of sound effects, Foley, sound design, dialogue, and music.

MID–HIGH BUDGET

If you are commissioned by a big brand, you will able to scale up and deploy an army with skillsets and talent that will enable you to think bigger and more ambitiously, potentially collaborating with well-known talents, greater expertise, and seasoned professionals. Bigger budgets can also be reflected in the locations, sets, sound design, SFX, or CGI.

Production, Management, Logistics

Production Roles

Director – Responsible for the overall visual communication of an idea, directing actors on set, setting up shots with the DoP, and seeing the project through the editing and finishing stages.

Producer – Responsible for budgets and project planning. Depending on budget a Producer will likely delegate tasks to assistants and specialists but will oversee the entire process.

Executive Producer – These are usually investors or people who have facilitated key funding for the production.

Line Producer – Typically, the Line Producer manages day-to-day budgeting of a film production. They may also be in charge of production management, depending on the job.

Production Manager – The Production Manager oversees the physical production to ensure filming stays on schedule. They handle crew, technology, scheduling, and budgeting under supervision of the Line Producer.

Production Coordinator – The Production Coordinator is responsible for logistics, hiring crew, equipment rental, and talent booking.

Production Secretary – Provides administration assistance to the production office.

Production Accountant – Oversees production finances, payroll, and expenses.

Assistant Roles

1st Assistant Director – Assists the Production Manager and Director to oversee day-to-day management of cast, crew, equipment, script, and the overall set, allowing the Director to focus on the production.

Assistant / Associate Producer – A junior role assisting the Producers with key tasks.

2nd Assistant Director – The key assistant for the 1st AD, the 2nd AD helps to carry out delegated tasks as well as assisting with the creation of call sheets for cast and crew.

3rd Assistant Director – Assists with the movement of cast and crew under instruction from the 1st and 2nd AD.

Production Assistant / Runner – A trainee position which involves assisting the ADs and on-set staff with general tasks.

Script

Screenwriter – Responsible for presenting or adapting an initial idea, writing dialogue and detailed screen instructions. This may have been done prior to the Director's or Producer's involvement or may have been a collaboration.

Script Editor – Provides a critical overview of the screenwriting process to help the production team and writers identify weak spots. They help develop the story into a stronger, final draft.

Script Coordinator – Produces each draft of the script with annotations for the production team and crew.

Storyboard Artist – Responsible for giving a visual representation of the script shot by shot.

Casting

Key Cast – Some lead members of the cast may have joined a project at its early stages. Not all cast will be above the line talent.

Casting Director – Responsible for finding cast, securing key cast, and organizing auditions.

Locations

Locations Manager – Responsible for finding and securing locations for production. They negotiate permits, costs, and logistics.

Location Assistant – Assists the Locations Manager and is on set to organize access to production crew.

Location Scout – Looks for potential locations prior to production. Location Scouts are briefed with a list of requirements including aesthetics and budget.

Transportation

The transportation department is a key logistical support role. Under the direction of the Transport Lead and Transport Coordinator, they are responsible for ferrying crew and equipment to and from set with a team of drivers.

Catering

The catering team keep the cast and crew well fed and hydrated on set.

Craft, Capture, and Technical

Camera

Director of Photography (DoP) – Head of Camera and Lighting, making key decisions of framing and lighting in partnership with the Director.

Camera Operator – Under direction of the DoP, the Camera Operator is responsible for capturing the scenes. Depending on the production, the DoP may well be the Camera Operator as well.

1st Assistant Camera / Focus Puller – The 1st Assistant Camera is responsible for pulling focus to ensure that all shots are clear and in focus.

2nd Assistant Camera / Clapper Loader – The 2nd Assistant Camera is responsible for the clapper board. This is essential for marking the Production, Scene, and Take numbers so that the footage can be easily synced to the audio in the edit room.

Loader – When shooting on film stock, the Loader is responsible for the transfer of light-sensitive reels to and from the camera, ensuring they are not exposed to light.

Steadicam Operator – Steadicam Operators are specialist Cameramen who use a Steadicam—a type of rig that allows the operator to move freely whilst keeping the shot steady.

Motion Control Technician / Operator – Motion Control Technicians operate robotic camera rigs which can be used to consistently capture the same shot over and over again.

Digital Imaging Technician – Working with the DoP and Camera Operator, the DIT helps to make adjustments to the camera to ensure the best quality of footage. This is a position which was created for digital cinema.

Data Wrangler – Responsible for the transfer of digital files from set to the edit room. Typically, this is a role that may also be done by the DIT. The Data Wrangler may make low resolution (Proxy) files that are easier to edit with. These files are then linked back to the Hi Resolution original footage at a later stage.

Video Split / Assist Operator – Sets up external monitors for use of the Director so that they can see exactly what is being shot in camera.

(Continued)

Art, Styling, and Makeup

Camera

Stills Photographer – Takes still photos of the production for use in promotional and press materials.

Camera Production Assistant – Similar to a runner, they are responsible for general tasks under the direction of more senior camera crew.

Continuity

Script Supervisor – The Script Supervisor is responsible for continuity, constantly monitoring production against the script as well as checking shots to ensure the correct positioning of cast and objects.

Sound

Production Sound Mixer – Head of Sound on set and responsible for recording all the sound. They decide on microphone setups and use a recording unit to monitor and record the sound in real time.

Boom Operator – Responsible for microphone placement using a boom arm. This allows the operator to position a microphone above or below the shot, keeping the microphone out of frame.

Grip

Key Grip – Head of the Grip Department, the Key Grip liaises with the DoP to ensure the correct lighting and blocking setups. They are responsible for the grip and rigging team and work closely with the electrical team.

Best Boy (Grip) – Assistant to the Key Grip, assisting with the setup of lighting and rigging as well as organizing the grip truck. 'Boy' is a historic leftover. The role can be performed by any gender!

Dolly Grip – The Dolly Grip is in charge of the Dolly, a rail-mounted carriage used for tracking shots. The Dolly Grip sets up and operates the Dolly.

Rigging Grips – Rigging Grips are responsible for rigging structures that may hold lighting units or act as camera platforms.

Electrical

Gaffer – Head of the electrical team and responsible for lighting design and setups.

Best Boy (Electrical) – Assistant to the Gaffer.

Lighting Technician – Involved with setting up and controlling lights.

Art

Production Designer – The Production Designer creates the physical and visual film set, considering setting, costumes, props, and makeup.

Art Director – Oversees the production design team.

Construction Coordinator – Coordinates all aspects of construction and carpentry, ordering materials and hiring crew.

Carpenters – Responsible for building sets and large props.

Illustrator – Creates visual representations of sets.

Set Decorator – The Set Decorator is in charge of decorating the set and placing props.

Set Dressers – Set Dressers are generally responsible for furniture, drapery, and carpets— anything you might need in a location to make it seem authentic.

Key Scenic – Responsible for special surface treatments—eg., an aged painted wall.

Greensman – The Greensman is responsible for trees, grass, and flora.

Buyer – The Buyer locates, purchases, or rents props and objects for use on set. They are given a clear list of items to obtain and a budget to do so.

Art Group Assistant – Assistants are assigned general tasks to help out in the Art Group.

Styling / Wardrobe

Costume Designer / Stylist – Responsible for all costume and clothing worn by the cast on screen. If garments are to be made especially for the production, the Costume Designer designs and plans the construction including style, fabric, color, and patterns.

Assistant Costume Designer / Stylist – Assists the Costume Designer or Stylist.

Costume Standby – The Costume Standby works on set to ensure continuity in the clothing between each take. Works alongside the Script Supervisor.

Wardrobe Supervisor – The Wardrobe Supervisor works closely with the Costume Designer to supervise the creation of garments, taking into account budgeting, logistics, and crew.

Art Finisher – Brought in early in production, the Art Finisher advises on clothing wear and tear to ensure clothes look authentic on set. They are employed to create rips, tears, and worn-in effects on clothes.

Costume / Wardrobe

Seamstress / Cutter / Fitter – A skilled technician who fits and tailors clothing to the cast.

Buyer – A buyer may be employed on bigger productions to source and purchase materials as well as specific clothing items.

Hair and Makeup

Hair Lead – Responsible for the look of the hair, this individual should have a good knowledge of style and trends.

Makeup Lead – Responsible for makeup on set. They will have a good knowledge of makeup trends and styles.

Key Hair Team – A team of hair stylists that work under the direction of the Hair Lead.

Special Effects Makeup – A specialist makeup role that involves creating special effects and prosthetics. They are responsible for creating changes to face shape and the size of facial features as well as scars and wounds, for instance, to alter the character's look.

Special Effects

Special Effects

Special Effects Supervisor – The SFX Supervisor plans and supervises all elements of SFX on set. SFX (not to be confused with VFX) are physical effects that are captured in camera such as pyrotechnics, fog, or gunshots.

Special Effects Foreman – The SFX Foreman reports to the SFX Supervisor and assists with the setup and planning of shots. He is responsible for the SFX Technicians.

Special Effects Technicians – The SFX Technicians report to the SFX Foreman, assisting with the setup of SFX requirements on set.

Armorer – The Armorer is responsible for weaponry on set. This will be a licensed and trained professional who has experience and expertise in handling weapons and training cast and crew safely. Live rounds are never used—blanks may be used for effect, or alternatively effects may be added in the VFX stage. Obviously, a very specific requirement!

Pyrotechnics Technician – The Pyrotechnics Technician is responsible for fire and explosion effects. This will be a highly skilled and trained professional with a background in firepower.

Visual Effects

VFX Supervisor – A post-production role that oversees the whole visual effects process. The VFX Supervisor is brought in on set during shooting to consult on VFX setups, such as greenscreen placement and motion capture. They advise the Director, Producer, and camera team on what is possible for the best VFX results.

Stunts

Stunt Coordinator – Responsible for the consultation and planning of stunts. This could involve vehicles, explosions, falls, etc.

Stunt Performers – Stunt performers generally perform dangerous shots in place of the cast. These are trained professionals.

6.24
Diagrams by Edgar Dubrovskiy and Jie Lian.

Post-Production

Post-Production Roles

Post-Production Supervisor – The Post-Production Supervisor oversees the entire post-production process, communicating progress to the Producer and Director. They head a crew that includes the sound team, editors, colorists, and VFX.

Editor (Offline) – This is a creative role. The lead Editor watches all the footage and creates a cut of the film, making constant reference to the script. This is initially done by the Editor. Once a draft of the full film or select scenes is completed, the Editor and Director finesse the cut. This can be a long process and involves watching hours of footage, much which will never be used.

Assistant Editor – The Assistant Editor is responsible for collecting, organizing, and syncing daily footage. They will also keep track of what footage has been received, making constant reference to an annotated script. The Assistant Editor may also be required to source temporary sound effects and music for the editor and lay them onto the edit. In some cases, further Assistant Editors are employed to keep track of paperwork and organize script references.

Editor (Online) – A more technical role than the Offline Editor, the Online Editor is responsible for adding in visual effects, color corrected sequences, titles, and credits. They also ensure the project meets the technical delivery specifications.

Sound / Music

Sound Designer – The Sound Designer is responsible for the post-production sound of a film. This will include generated sound effects that aren't necessarily authentic, but add a depth to the finished project.

Dialogue Editor – The Dialogue Editor is responsible for assembling and editing all of the dialogue in the film. In some cases, dialogue may have to be re-recorded in a process called ADR or Dubbing.

Sound / Music

Foley Artist – The Foley Artist is responsible for recreating natural sounds, such as footsteps, doors opening/closing, etc. These add a layer of authenticity to a film production.

Sound Editor – The Sound Editor assembles and edits all of the sound in the production.

Re-Recording Mixer – The Re-Recording Mixer is responsible for bringing the whole sound world together, balancing a mix of sound effects, Foley, sound design, dialogue, and music.

Music Supervisor – The Music Supervisor is responsible for ensuring that all sound and music meet the necessary licensing and legal requirements. They will work with the composer, sound editing team as well as music agents and distributors to ensure all rights are cleared for the production.

Composer – The Composer creates the score for the film. They work closely with the Director and sound team to get the right feel for the film.

VFX

VFX Supervisor – The VFX Supervisor works on set as a consultant during production. During post-production, they head a team of technical VFX artists to create stunning effects that can't be achieved in camera.

VFX Artists (Animator / Compositor, Roto / Paint Artist, Matte Painter) – Roles within the VFX industry are varied, but include character creation, landscape and background art, removing or adding in visual elements. Larger-scale productions can often have hundreds of VFX Artists involved in the process.

Color Grading

Colorist – The Colorist is responsible for adjusting the color of the film. When footage is shot, it typically looks quite flat. The process of color correction makes certain colors pop and can make a huge difference to look and feel of a film.

Getting Your Fashion Film Seen

Although it would have taken considerable time, energy, and commitment, the completion of a fashion film marks a new cycle of work. The film's communication, dissemination, and audience engagement requires research, organization, and an action plan. Provided the filmmaker is ready and confident the work reflects their abilities and potential, then how and where the film will be presented should be considered. From online portals to film festivals, today's multi-platform media offers many opportunities, but filmmakers need to find the right fit and context.

One question a filmmaker might ask to assist this decision is does the film have a theme or aesthetic that resonates with a specific editorial platform? It might be suitable for numerous platforms, but filmmakers should beware of sending work to concurrent commissioning editors as most demand exclusivity. If the film does not sit easily in a fashion category and verges onto, for example, more art-based or dance territory, platforms that promote these specific areas should be explored as a cross-disciplinary fashion film may be of interest to these crossover audiences. Similarly, non-fashion strands at one of the short film festivals might provide a more suitable context for a not-so-obvious fashion film.

Precious (2011), directed by Monica Menez

7.1
Precious (2011) came about because Monica Menez was unable to tell a particular story through photography so turned to film as the solution. It won the most Creative Concept award at LJIFFF in San Diego. Credits: Monica Menez (director), Kathrin Heck (model).

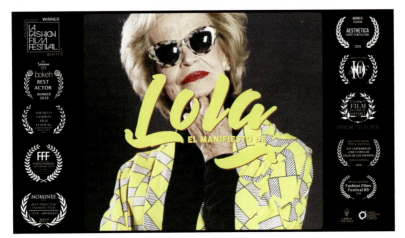

EL MANIFESTO DE LOLA (2018), directed by Gsus López and Cristian Velasco

7.2
Winning specific categories at film festivals—and even being nominated—can support a film's traction and lifespan. A prize or nomination is usually indicated by a laurel and the festival's name and year. This will often be displayed on posters and marketing assets, which will encourage more people to see the film and take note of the director. *EL MANIFESTO DE LOLA* (English: *Lola's Manifesto*) (2018) displays many laurels. Illustration by Alvar Alcalde, film still co-directed by Gsus López and Cristian Velasco, Lola Penate (actress).

IN FOCUS

The marketing pack and website

To market a film—to individuals, distributors, investors, editorial platforms, or festivals—it's necessary to create the right digital assets. These comprise texts, images, and clips that communicate the film story in a clear, engaging way. The marketing pack or press kit should contain a selection of impactful, high-resolution stills, and a short (couple of sentences) and long (a paragraph) synopsis of the film. Both should be succinct and compelling and contain key facts such as length, genre, place, year of production, and credits.

The film should be edited into sharp, engaging ten- or thirty-second clips that can be shared on social media and, hopefully, encourage more shares and create some traction. Film producer Steven Whelan believes that "it's better to promote yourself with one impeccable film than several not fully thought through." When there is enough work in terms of quantity *and* quality, this may merit the creation of a personal website that could include additional content including behind-the-scenes footage or relevant updates for viewers. This website should represent not only the films or outputs but communicate a filmmaker's individual practice and approach. Alongside short clips, handy for social media, a teaser will ideally lead to more views and can be linked to an online biography and/or filmography. A website isn't always necessary, though; viewers can access films on Instagram's IGTV. "If you wanted to use social media as a way to lead people to your website, you would put up the first 60 seconds on your feed, which would enable the viewer to click through and see this in a vertical format," suggests Whelan.

Getting Ready to Present a Film

Once the fashion film genie is out the bottle, it's quite hard to push it back in, so filmmakers must be prepared for this moment of online distribution, whether for mobile dissemination or to broadcast on larger screens, such as festivals. The following checklist items, spanning general technical requirements to mastering, intellectual property, permissions, and music rights, should all be addressed.

Mastering the film

Mastering is the process of making a film technically compatible for screening in a variety of venues. More generally, it refers to the final stages of post-production when the filmmaker works with the crew to polish off all aspects of the film to a professional level of perfection. This phrase generally refers to a few key areas which include the following.

Color correction

Straight out of camera, footage can appear flat. To wake colors up and make them pop on the screen, films go through a process of digital color correction. A colorist has the expertise to infuse or modify certain colors dependent on the film's individual requirements, mood, narrative, and context.

Sound

Finalizing the sound mix of the film is done by the re-recording mixer who balances the ADR, Foley, location sound, music, and sound design. A 5.1 or 7.1 mix may be made in addition to a standard stereo mix.

Title graphics, VFX, and credits

Often a graphic designer is commissioned to work on titles and credits. This might also be done by the editor, online editor, or director, depending on the budget of the production. Similarly, VFX (visual effects) might need to be added. For some productions, a shot list would have been sent after the lockdown of the final edit for the VFX artist to work on.

Online editing

Online editing is the process of taking the edit and matching it to the original hi-resolution footage. The online editor will assemble the final cut to include color-corrected footage, VFX shots, titles, and credits and ensure the final cut meets all the required and correct technical specifications.

7.3
ASVOFF 4 at Centre Pompidou. Credits: Diane Pernet (photographer).

Fashion Film Festivals

As fashion film has established itself a vibrant and dynamic form of filmmaking, fashion film festivals have multiplied: The London Fashion Film Festival, Berlin Commercial, ASVOFF, New York Fashion Film Festival, Miami Fashion Film Festival, Istanbul Fashion Film Festival, Le Jolla in California and Fashion Film Festival Milano, to name but a few. The list constantly changes—a more comprehensive list can be found at the end of this chapter. For emerging and established filmmakers, these events have numerous advantages including the chance to build audiences, make contacts, develop networks, or win awards. Prize-winning fashion films usually incorporate the festival logo on any promotion of the film (posters, websites, and opening frames) to attract more interest, viewers, and potentially commissions. This use of logos can bestow legitimacy, kudos, and status to a production and create more leverage for the film.

It pays to carry out initial film festival research to get a handle on costs and establish which are the most suitable and advantageous festivals for the production. Each have their own approach and perspective with some specifically connected to the fashion industry such as Fashion Film Festival Milano, and others more aligned with the music, advertising, or film industries. Most festivals have a best emerging talent or student section, so it's worth exploring these opportunities. Fashion strategist and promoter Niccolò Montanari asks, "What do you want to get out of a festival? Is it a laurel? a network? the name? Is it about having something to share on social media and show to clients?"

Most film festivals charge a submission fee and international festivals cost more than national ones. Many offer early bird discounts, so being organized will save filmmakers money; the closer to deadline a festival, the more expensive it will be. Genres in larger short film festivals—as opposed to fashion film festivals—will typically include drama, documentary, experimental, fashion, music video, dance, and art and these other categories may also be worth considering, depending on the film's theme, approach, and focus.

Nearly all festivals have a technical specifications breakdown on their submissions page. Websites such as filmfreeway.com often have a technical summary of what different festivals require. Most will commonly request a downloadable link (QuickTime or DCP file, short for digital cinema package) rather than requesting a physical hard drive. This is cost-effective for both the festival and filmmaker and a more sustainable practice. Festivals are increasingly unlikely to request 35 mm reels, HD cams, or Digi Betas, unless for a special screening. It's worth double checking the terms of music permissions to ensure they include festival screenings.

7.4
Aesthetica Short Film Festival 2018. Credits: Photo by Jim Poyner. Courtesy of Aesthetica Short Film Festival.

IN FOCUS

Festival formats checklist by Andy Guy, event and technical coordinator

"There are a number of different formats that might be required for a festival. I would encourage filmmakers to have all these assets ready to go in a Dropbox (or similar folder) ready for delivery.

ProRes file: This will be your highest quality QuickTime file rendered from the original which can now be exported from up-to-date editing packages on windows systems too. It is an industry standard and high-quality option for your film and can be exported from Premiere Pro with ease. To ensure that your film is seen as intended, you should have a version of the film in your original shooting aspect ratio whether that is 1920 x 180 (standard HD), 4:3, Cinema Scope, or any other format. This is the preferred format of most festivals will screen at 1080p (Standard HD) so films shot at other aspect ratios will be letterboxed/pillar boxed inside this frame. Always check with the festival technical team if you are unsure of aspect ratio requirements. This is a heavy file, though, and not ideal for uploading to online platforms such as Vimeo or YouTube.

H.264 file: This is a good quality, low-weight digital file that will be your back-up or online file, ideal for uploading and sharing online. This would look great on a cinema projector but only send to a festival for exhibition if a ProRes version isn't available (or if they ask otherwise). This is a standard mp4 format that produces decent quality results but at low data sizes. Again, Premiere Pro (as well as most editing software) exports these with ease.

DCP file is a specialist file for cinema projection. They are extremely high quality and heavy and cannot be viewed on a computer without specialist software as they're designed to be played solely in venues where DCP projection is available that run off a Linux system. Typically, this will be at a professional cinema venue or dedicated large screen event.

A DCP file is a breakdown of your film into individual image files which are then compiled to a single video mxf file as well as a separate mxf file for your sound. An asset map links these two files together in sync once the DCP package is ingested onto a projection system and played. A basic DCP file can easily be exported from Premiere Pro using Wraptor DCP. Professional DCPs can be used for bigger productions, but they can cost thousands.

5.1 mixes: 5.1 is a surround sound mix. Most cinemas will be 5.1 ready, although for festivals a 5.1 mix is not always necessary. If you have a 5.1 mix of your film, aim to make a ProRes, H.264 *and* DCP version in addition to your stereo delivery assets, just in case they are needed. 5.1 mixes can only be played successfully in venues that have 5.1 surround sound capabilities.

Subtitles/captions: It's a clever idea to prepare a caption file or dialogue list for festivals as well as films that are screening online. A subtitle file can be made to transcribe a film into a language other than English. This can also be important for exhibitors keen to engage with international audiences and the wider community, including those with hearing impairments. Filmmakers should explore the use of English captions and subtitles within

editing software where they can be delivered as a simple timed dialogue list or text file that can assist the translator/subtitle technician. It's also possible lay down a subtitle track in the edit and export as a caption file (.srt or .stl) which can be sent to exhibitors separately.

Content and audiences: Film is an expressive medium and when considering the evolution of filmmaking, breaking societal rules and conventions are part of the journey. However, it's important to acknowledge thresholds in terms of content and that some audiences may find some content offensive or may even experience trauma because of watching a film. Filmmakers should clearly categorize their content by an age rating. UK age ratings are U (Universal), PG (Parental Guidance), 12/12a, 15, 18. The British Board of Film Classification is a useful tool that helps filmmakers gauge the appropriateness of content for specific audiences accurately.

To ensure audiences are informed about forthcoming content, filmmakers should include trigger warnings for any visual or thematic content that could be deemed offensive, upsetting, or trigger an existing condition such as epilepsy or PTSD. Flashing lights, strong language, death or morbid themes, blood, violence/abuse, sexual content, nudity, flashing lights, and strobe effects are all potential trigger warnings."

7.5
Calvin Chinthaka's graduation film shot *Osariya* (2019). Credits: Calvin Chinthaka (director of photography and fashion film production), Kalpanee Gunawardana (model).

Osariya (2019), directed by Calvin Chinthaka

7.6
Continuing with the lecture theater mood and feel, Monica Menez created posters inspired by a university yearbook to promote her film *Odditory* (2013). © Monica Menez (director), Brody Bookings (models).

Social Media and Film Dissemination

A Vimeo or YouTube account is a straightforward way for viewers and audiences to find filmmakers. Vimeo is a social media platform for filmmakers that has a more professional reputation compared with YouTube which is more generalist.

Many online platforms host fashion film that offer both open call and commissioning opportunities. Nowness, Dazed, *Vice*, *i-D* and *Schön!* create content to be viewed exclusively online. As well as presenting film clips on social media or through a personal website, filmmakers have the option to submit work to relevant and appropriate commissioning editors of publications or producers at production houses. This should be combined with a concise introduction that is personalized specifically to the recipient or their organization. Such editors are likely to be deluged with work and introductions to new filmmakers. Acknowledgement is not always guaranteed, and feedback is unlikely, but the act of registering interest and flagging up one's details, name, talent, and abilities is good practice and may lead to a positive outcome.

Turning Passion into a Profession

Far from being a fleeting trend, fashion communication through film has proved far from faddy. It may have started uncertainly, with early practitioners unclear about its purpose or direction but fashion film has evolved into a rich, diverse medium, able to morph to meet changing agendas and modern technologies. While there's plenty of opportunity, it's also highly competitive. So, how might a new filmmaker turn passion into a sustainable practice and career?

Watch Films

Film is magical. It can draw audiences into other worlds and takes our imagination to new places. Filmmakers drawn to this possibility through the fashion lens sometimes make the mistake of predominantly watching fashion films for guidance and inspiration. While there is validity in researching what different portals promote, there is a danger new filmmakers start to imitate the latest attraction. This could tar a filmmaker as one who is a derivative and unimaginative, incapable of generating fresh ideas.

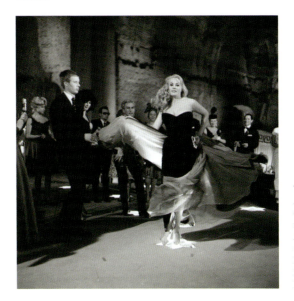

7.7
Anita Ekberg dances to jazz music in *La Dolce Vita* (1960). American International Pictures/Getty Images.

New filmmakers should aim to watch film from as wide a field as possible. The films of the great innovators of the medium included in *The Story of Film: An Odyssey* by Mark Cousins is an excellent introduction and available to stream. Other genres—science fiction, horror, historical drama, documentary, animation—can inform and inspire. Contemporary, cutting-edge films and those from the past can all teach something to new filmmakers. Films from the global canon—Asian, African, and Indian, not just European or Hollywood—have incredibly rich legacies. The opportunity to see films on 35 mm, visit specialist festivals, and luxuriate in the esoteric work will enrich a filmmakers' vocabulary and references, and fuel their imagination.

Practice, Practice, Practice

To develop a practice, filmmakers must make films. Once, this would have required expensive cameras but now an increasing number of the world's population have a high-spec movie camera in their pockets. A smartphone plus a few carefully chosen apps make it possible for anyone to make a film. Geographical location may have once deterred individuals; living in a rural or remote part of the world may have left a filmmaker feeling cut off from the creative industries. But mobile technology and social media mean everyone is a click and swipe away from connecting with influential fashion portals and editorial platforms making it possible to reach out, share, converse, and collaborate. Baloji from West Africa's Democratic Republic of Congo premiered his film on Nowness.

The notion of testing is a familiar one for photography practice. Visual practitioners test to build a portfolio, confidence, and ideas. An opportunity to familiarize oneself with the rudimentaries, and control of, light, space, mood, narrative, and concept, it's also a chance to draw collaborators together and make something happen. New filmmakers should accept that initial forays behind the camera will not deliver the results of revered icons. But developing one's vision, stories, and approach, in a progressively refined and confident way, should be the goal.

When conceiving ideas for films, filmmakers should aim for clarity and simplicity of execution. Many initial attempts at filmmaking are hampered by unrealistic ambitions and overblown fantasies that can expose a new filmmakers lack of experience. A more playful approach brings both the mental and creative space for happy accidents and interesting work to emerge. Caroline Bottomley of Shiny Media, a networking organization that brings together creatives from fashion and music, both digitally and in the physical world, offers a reality check: "Accept your first film probably won't be the one you'll take into the world. But make and test as much as you can. Get used to the technical and practical aspects of film practice and normalize the process. Start to understand how you can get what's in your head out into the world."

Trying ideas out, experimenting with new techniques, and collaborating with teammates is all part of filmmakers' evolving relevant and meaningful work that can eventually be shared with audiences. It's important when testing to communicate clearly with collaborators and respect one another's time and contribution. "You have to honor dates for production and shooting and post-production and feedback," advises Ian Pons Jewell, a film director working in commercials and music videos.

Network and Build Contacts

For the contemporary creative practitioner, social media offers tremendous advantages not available a decade ago. Although it has critics and downsides, the creative industries utilize many facets of social media positively and optimize the potential of Instagram, Vimeo, Facebook, Pinterest, Twitter, and TikTok as not only places to present and share creative outputs but somewhere to actively make contacts and network. At short film festivals, you can meet practitioners across the filmmaking industry, and some will organize specific networking events such as Aesthetica Short Film Festival's Meet the Filmmakers or Meet the Festivals.

For a developing filmmaker, social media provides opportunities through all stages of personal development. When gathering and growing a team, social media can provide fertile ground. Searching appropriate sites and conversing with new talent can help build professional relationships and encourage collaboration. Filmmaker Anna Radchenko finds this aspect of finding and working with new collaborators one of the most rewarding. She dedicates a few days a week to looking for new talent on Instagram to potentially work with. Social media is also home to many specialist groups and forums potentially worth exploring. A search for "filmmaker groups" on Facebook will offer many suggestions and the more refined and specific the search, the more likely it will bear fruit. Illumantrix, for instance, is a collective of female cinematographers. Shooting People and Screen Skills are both useful websites connected to the industry. NoFilmSchool.com is a free and useful resource that offers a wealth of knowledge and know-how.

7.8
Jasmine De Silva feels that as well as giving exposure to film work, festivals have "created opportunities for press coverage, public speaking and the opportunity to foster collaborations." *Time 4 A Wash* (2020) by Jasmine De Silva. Credits: Will Hadley (DoP), Natasha Gravia-Lund, Erika Janavi, Julie Impens (models *left to right*), Ayisha Onuorah (styling), Chris Grimley (hair), Shona Adele White (make-up).

7.9
The Aesthetica Short Film Festival (ASFF) now has a dedicated fashion day within the festival to satisfy the demand and growing audiences. Here, Niccolò Montanari interviews Minnie Carver, video producer for British *Vogue* at the Theatre Royal at ASFF 2018 © Aesthetica Short Film Festival. Photograph by Jim Poyner.

Experience and Knowledge

If the knowledge and skills of a new filmmaker are limited, then opportunities should be sought to develop and expand these through internships or work experience which can work alongside developing personal practice or a filmmaking study program, time permitting. Traditionally, the classic advice to new filmmakers was to consider being a runner and this remains a viable opportunity, although it's by no means the only route. A runner can work on set or in post-production as a go-between for various member of the production team. An on-set runner will need a clean driving license because running can also mean driving. Production companies such as Frame Store and The Mill often have editors in training.

It's also possible through social media and focused research for a new filmmaker to reach out to individual practitioners such as makeup artists, set designers, stylists, etc. and offer their time and energy to the next project or film. Although unlikely to be paid, these opportunities give the chance to learn new skills, see a shoot in action, and gain networking opportunities. This may eventually lead to paid work or recommendations to other creatives or directors. Helping on shoots is an effective way to understand industry etiquette and codes of conduct, to experience different approaches, and start to process how filmmaking interrelates with various parts of the industry from brands, portals, PR, designers, and production houses.

7.10
Just keep practicing. Behind the scenes production shot from Drue Bisley. Credits: Photograph by Drue Bisley.

Abjective (2017),
directed by
Marie-Therese
Hildenbrandt

7.12
Abjective (2017),
directed by
Marie-Therese
Hildenbrandt.
Poster
photography by
Christian Maricic.

Self-Promotion and Proactivity in the Industry

Actively seeking opportunities should become part of a new filmmakers practice. Caroline Bottomley of Shiny Media suggests one way to build a portfolio of work is to seek creative individuals making something that warrants or inspires a film—then make it. For instance, an interesting fashion or jewelry designer making their own collections or a great gigging band yet to be signed may have talent but no digital asset with which to promote themselves. By collaborating with creative contemporaries from fields such as music, design, literature, or dance, the film or video work will be potentially promoted alongside their work sending a filmmaking credit into the public domain and helping build a professional profile for a filmmaker.

With some informed research, it's possible to find most people in the industry online; to ascertain how they might be contacted—whether directly or through representation. Social media such as LinkedIn offers industry profiles. Other social media channels offer possibilities for dialogue and two-way communication.

Understanding that each opportunity can lead to the next thing often requires a joining of dots and overview of the bigger picture. Understanding how to use exposure as a form of leverage, a means by which to introduce filmmaking talents to commissioning editors, producers, or influencers, requires email skills and the ability to write short, precise, properly spelled, engaging messages that make the right impression and encourage others to read until the end, and not delete after two sentences.

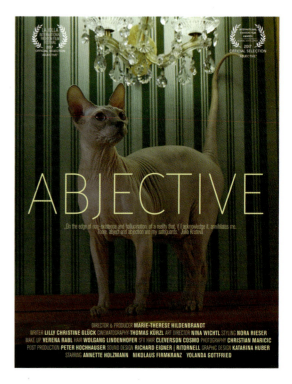

Portfolio Building

A digital portfolio should be a constant work in process and something regularly updated. Every piece contained should be a source of pride and collectively the work should present a filmmaker's individual approach and breadth of filmmaking skills. Digital portfolios are easy to share and view and are more convenient for those who seek talented practitioners for creative projects.

Filmmakers might choose to collaborate with a graphic designer to create a website, or use an existing web design platform such as Squarespace to personalize a web presence from an existing template. A personal website and domain name (which would need to be purchased) can form a single place where a filmmaker's best outputs can be consolidated and presented alongside a supporting commentary or statement. This can link to social media so viewers tantalized by film clips can see the rest of the work. Rather than showing every single project in its entirety, an edited show reel with small clips edited together will intrigue viewers. At this stage, a filmmaker is crossing into the marketplace and effectively presenting as a brand. It's here that aesthetics, an approach, and clear values should be communicated.

"To 'stand for' something is crucial in order to become trusted and defined, and to 'stand out' from the crowd is critically important: to get the attention you want, [...] the career you want."

Thomas and Rosencreutz, *Managing Brand Me, How to Build Your Personal Brand* (Pearson Education, 2002)

IN FOCUS

Getting ahead as a fashion filmmaker

Bunny Kinney, Creative Director, Nowness and Dazed

"Even when Nowness was launched in 2010, short films still mostly existed in their own world. A narrative short film might have gone to a festival and then never be seen again. It was also often used as a stepping stone for directors to attract funding before moving onto longer features. At film school, we were taught you start as a runner but today you don't have to do that. You can make your own short films and be seen. Now, they can exist and be made available for everyone to see.

Some new filmmakers are overly ambitious and if you have a lack of means, then my advice would be to stick to something simple. The simpler the idea is, then the greater the chances are it will work. The danger with attempting a big production is it will come across as amateur and the seams will show. Aim to work collaboratively and get feedback where you can throughout the process, either from industry or your tutors. I would also say, just keep doing stuff. It can go out on your own platforms and we do look at the social media of emerging creatives."

7.13
The opening scene from Marie-Therese Hildenbrandt *Abjective* (2017), her graduation film that screened at seven UK and international festivals. Credits: Marie-Therese Hildenbrandt (director).

Build Your Brand with Integrity

Filmmaking is a form of communication that goes into the wider world. It's also a collaborative practice that involves working with others. Both areas carry responsibilities that directors and filmmakers must be aware of. For instance, if at the beginning of this journey, multiple team members are giving skills to projects for free, be these models, stylists, producers, or assistant directors, then ensuring the creative process is a collaborative and respectful one will lead to a more productive working environment. A professional attitude and conduct, on and off set, is what people remember and will inform their decision in whether to repeat the experience. Professional modes of working should be communicative, caring, polite, and punctual. The emotional care of minors and the cast should always be considered. These on-set codes of conduct will form the basis of your working reputation.

Filmmakers should also consider the types of films to be made and attempt to articulate and maintain a personal ethical framework. For instance, if inclusivity is important, this could be reflected in the selection of the production team as well as the subjects in front of the camera. Strong feminist beliefs may inform how women are represented in a fashion film context, or if the language of film might be employed to challenge conventions and stereotypes. If sustainability is a driver, then how will this be factored into the fashion filmmaking process? If cultural appropriation is a concern, how can this be prevented if shooting abroad for instance? All these things are worth serious thought—and action.

7.14
Designer Katie Eary's first fashion film was funded and shot by Liam S. Gleeson to raise the designer's profile and gain press coverage for her first collection. *Powerless* (2011). © Hidden Agency. Credits: Liam Gleeson (director).

IN THEIR OWN WORDS: STEPHEN WHELAN

Creative director and strategist

Most successful marketing activations generally start by recognizing that brands no longer determine the conversation— that power lies with the audience now.

"Across all the production roles I've held— whether at Blink, Pulse, or YouTube—we would develop a social media strategy alongside the delivery of the film or trailer. Behind the scenes (or BTSs) are great for social media, as are outtakes and unreleased footage that didn't make it to the final edit. For instance, on a project for River Island and Christopher Shannon, we shot lots of film on a GoPro and the purpose of this was for it to look like CCTV footage.

River Island did a social media takeover on Instagram which generated between 80,000 and 100,000 likes and 999,000 readers. There was an installation, a wall of selfies, and a film screening. So, alongside the film that was produced, the client would also receive the full service of digital marketing driven by online and events to galvanize an audience primarily driven by social media. It's important to know who your film is for. Eighteen-year-olds engage differently with media compared to thirty-seven-year olds. The entire life of most eighteen-year-olds is mediated through social media. It's where they hang out, whether that's IG, Snap, or TikTok.

Alongside tentpole fashion and lifestyle brand moments there is now a need for continual communication over a longer period. In much the same way that we think about promotional cycles around music and album releases, marketing content for fashion and lifestyle clients operates across discrete periods— whether that's a month, three months, or a telescoped window to heighten impact and break the internet to get trending on Twitter.

We think about the build-up to a film, then how to follow it up and develop a trail. The question is how we can extract as much engagement as possible from the audience over the longest period within the budget. The best route to achieving this is invariably to start with the audience, the fan group around a brand, and consider how best to offer engaging content to the organic conversation they are already having. Most successful marketing activations generally start by recognizing that brands no longer determine the conversation— that power lies with the audience now. If you want to market a product or a collection these days, it's essential to recognize and operate within this shift of power."

Summary

- Conducting appropriate market research and creating a digital marketing pack will support the process of disseminating a film to audiences once production is complete.
- Online publications and platforms, social media, and specialist festivals all offer opportunities for creating interest in and traction for a film.

- Watching films, practicing, building experience, and developing networks are key to developing as a fashion filmmaker.
- Continually reviewing work and the creation of an online portfolio will help to communicate your approach, aesthetic, and values effectively.

Exercises

Get ready for the close-up

Once the film is complete, collate all the production material and create a marketing pack. Gather a selection of the best, high-resolution still images from the film and beneath the title, write a few sentences that sum up what the film is about together with a longer synopsis that includes key facts such as length, genre, place, year of production, and credits. Behind-the-scenes footage can be edited to create another short promotional film. Ten-second clips or GIFs can be edited for use on social media.

Scope the festival circuit

Chose four or five festivals from the list below. Have a look at their websites online and at previous winners. Explore how much can be saved by submitting early and establish if there is a student or new talent category. Novices should not be deterred by far flung locations of festivals: Filmmakers can still submit even if they cannot attend personally. Filmmakers with specific interests such as documentary or animation might wish to seek out specialist festivals.

Fashion film festival calendar*

Aesthetica Short Film Festival (York, UK)
Launched in: 2011
Month held: November
https://www.asff.co.uk

ASVOFF Film Festival (A Shaded View on Fashion Film) (Paris, France)
Launched in: 2008
Month held: June
https://www.ashadedviewonfashionfilm.com

Berlin Commercial (formerly Fashion Film Festival) (Germany)
Launched in: 2012
Month held: July
https://www.berlincommercial.com

Bokeh South Africa International Lifestyle and Fashion Film Festival (South Africa)
Launched in: 2014
Month held: September
https://www.bokehfestival.co.za

Buenos Aires International Fashion Film Festival (BAIFF) (Argentina)
Launched in: 2015
Month held: April
https://www.baifff.com/indexENG.html

Fashion Film Festival Chicago (USA)
Launched in: 2014
Month held: October/November
http://www.fashionfilmfestivalchicago.com

Fashion Film Festival Istanbul (Istanbul)
Launch date: 2015
Month held: November
https://www.fashionfilmistanbul.com

Fashion Film Festival Milano (Italy)
Launched in: 2013
Month held: November
https://fashionfilmfestivalmilano.com

Fashion in Film Festival London (UK)
Launched in: May 2006
Month held: March/April/May
http://www.fashioninfilm.com

International Film Festival Rotterdam (IFFR) (the Netherlands)
Launched in: 1972
Month held: January/February
https://iffr.com/en

La Jolla International Fashion Film Festival (LJIFFF) (California, USA)
Launched in: 2010
Month held: July
https://www.ljfff.com

London Fashion Film Festival (UK)
Launched in: 2013
Month held: September
https://www.londonfashionfilmfestival.com

London Short Film Festival (UK)
Launched in: 2002
Month held: January
https://shortfilms.org.uk

Madrid Fashion Film Festival (Spain)
Launched in: 2013
Month held: June
https://www.madridcapitaldemoda.com/en/madrid-fashion-film-festival/

Miami Fashion Film Festival (USA)
Launched in: 2013
Month held: January/September
http://www.miafff.org

Fashion Film Festival (Portugal)
Launched in: 2014
Month held: October
http://guimaraesfashionfilmfestival.com/en

*Information accurate at time of going to print

Technology's New Frontiers and the Future of Fashion Film

Digital moving image will be a stalwart of fashion communication but how we compute it may change.

Jonathan Chippindale, Chief Executive and Co-Founder, Holition

From spinning horses to the talkies, technology has been the great shaper of film. It has facilitated huge leaps in the making and consuming of this magical medium and continues to do so. Although film and fashion have been in dialogue since moving pictures began, it was the widespread proliferation of the internet and digital technology that gave rise to what we now know as fashion film.

From Burberry's augmented reality app launched in 2017 to the virtual reality experience of Prada fragrance and the hip brand Atacac, who use augmented reality to create fantastical contexts for their collection with trendily clad bodies flying through the air, experimental technology is de rigeur. Nowfashion brings the 360-degree catwalk experience to viewers, transporting them to front row or backstage, giving a full experience to this once exclusively guarded world. There have been holograms at Givenchy under the auspices of Alexander McQueen and models wearing Google glasses strutting the catwalks of Diane von Furstenberg.

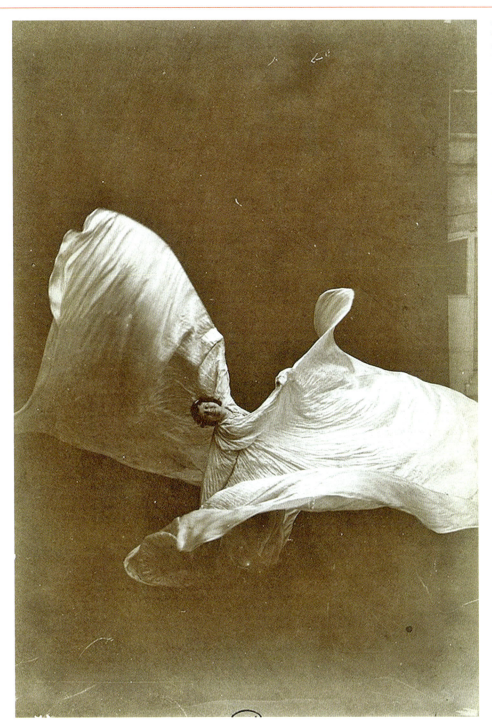

8.1
The various versions of the Victorian butterfly or serpentine dance crystallize the relationship of fashion and film that have existed since the invention of the movie camera. *Serpentine Dance* (1896), directed by Lumière Brothers.

8.2a and 8.2b
This butterfly wonderland is a screen capture from inside a game where the viewer sees a wide, open vista. Here you can feel the heat on your skin and a cool breeze as the view interacts with a flurry of butterflies. The Mill's Corona *Paraiso Secreto* experiential event in Mexico City in August 2018 was a blend of physical theater and a sensory virtual paradise. With the transportative power of VR, viewers could walk through a virtual tropical forest and touch the foliage and rocks as physical entities. Photograph from Adam Grint.

However, in the novelty-loving realm of fashion, we should be wary of "performed" technology. There is something about the "tech spectacle" that can be attractive to fashion producers who will dabble, have some fun, and move on. But what could be the significant and long-term impact of new technologies on future fashion filmmakers?

Fashion's New Realities—and Fantasies

Virtual Reality: Immersion and Other Worlds

In the future, innovative technologies mean time and space will be less bounded and more mutable, so filmmakers will need to consider this in the context of narrative, storytelling, and user experience. The big three "realities" currently influencing fashion communication outputs are virtual reality (VR), augmented reality (AR), and mixed reality (MR). Each offer different cocktails of the physical and digital worlds. Some require specialist hardware and others are more easily accessible via a mobile device or computer screen.

Virtual reality is a computer-generated simulation of a three-dimensional image or environment, which can be interacted with in a seemingly real or physical way. VR uses a headset, sometimes with other peripherals such as sensor-fitted gloves, motion controllers, or sensors attached to the body. Augmented reality superimposes a computer-generated image on a user's view of the real world, thus creating a composite view of the world. Mixed reality is the merging together of real and physical worlds to produce new environments and visualizations where physical and digital objects co-exist and interact in real time.

Virtual reality is a transportative technology that allows participants to experience walking on the moon, swimming at the bottom of the sea, or flying through the air—all without leaving their armchairs. It offers the opportunity to journey into different dimensions and in fashion terms, these might be the dark, contradictory world of Prada fragrance or the ostentatious, luxe world of Swarovski. When Facebook acquired Oculus (a head device through which VR can be accessed) in 2014 and Google created Cardboard (a much cheaper and available means by which to access VR), it was expected that VR would spread rapidly—but this did not happen. Perhaps because VR is ultimately an isolating experience (unless you're participating in group play) and specifically in the fashion industry, where image and personal appearance are key, there's little desire to attach a gadget to one's skull. The ability to capture 360-degree imagery offers filmmakers tremendous potential but what's also required is an expansion of storytelling and filmmaking vocabulary. The crispness and speed of imagery combined with a dynamic range of lighting has raised the bar for conjuring alternate reality experiences. Nirma Madhoo, a fashion image-maker who's worked with virtual reality believes, "real-time VR ultimately offers a new toolkit and platform for envisioning and experiencing new fashion spaces, new ways of being and becoming."

8.3
A project from the Fashion Innovation Agency at London College of Fashion, UAL. Collaborating with technology company Reactive Reality to scan a collection from fashion designer Sabinna. Each garment was captured in 3D in preparation for mixed reality virtual try-on via a Microsoft Hololens headset.

8.4
Azimuth
(2019) features
underwater and
aerial 360 filming,
stunt rigging,
drone-rigged
Lidar scanning,
and a 64-camera
DSLR shoot for
photogrammetry
models. Lorin
Sookool wears
costume
by Jessica
Shuttleworth.
Credits: Nirma
Madhoo (director).

Azimuth (2019),
directed by Nirma
Madhoo

Raf Simons X
Random Studio

Augmented Reality: Participation and Interaction

The advantage augmented reality has over virtual reality is that it can be accessed on existing and ubiquitous digital devices such as mobile phones, tablets, or computer screens. Hipanda, a trendy Japanese boutique in Tokyo, has incorporated AR in the character of a hip panda called … Hipanda. By walking around the store with a mobile phone, 3D representations of the cool creature can be activated and animated within the retail space. Currently, pockets of animation can be delivered at fixed points. AR offers great potential to the fashion filmmaker to create immersive imagery, moments, or experiences. For example, the viewer could start in a closet and step into fashion Narnia with the experiential equivalent of surround sound. Philip Delamore, Creative

Director at The Centre for Making Things Better, develops projects that combine AR with fashion content and gaming technology and believes as we move into a more active, participatory space, gaming will exert greater influence on fashion film and communication. "There are many more people playing computer games than reading *Vogue* or any other type of media. AR offers discovery, narrative, engagement and accessibility. It gives the user the chance to interact with, customize and change things and allows the digital rather than physical consumption of fashion, which is potentially better for the planet."

This opportunity to give more agency to the participant shifts the power dynamic between creator and user into a more co-creative relationship. Such a shift requires directors and filmmakers to loosen their grip of the single narrative arc or conceptual sequence of a fashion film; to allow the viewer to discover story and enjoy the reward of authoring a narrative as they might do in a computer game. Random Studio, who have worked with Raf Simons and Perry Ellis, utilized Google street maps to allow viewers who visited the website to click and scroll through all the cameras and intuitively construct their own version of the Raf Simons Look Book. This more participatory approach aligns more with computer games. Philip Schütte, Creative Director at Random observes, "Everyone arrives with a different interest point and once you enable this, the viewer's fashion journey becomes a more tailored, relevant experience."

"In this non-linear world, the storyteller's job is to create the boundaries of the playground and its' rules. The challenge for the filmmaker in this scenario is to anticipate audience responses and create multiple narratives."

Adam Grint, Creative Director, The Mill

8.5
An early conceptual film *Sweet* (2000) from SHOWstudio presented couture through image-making inspired by sweets and sweet wrappers. Credits: Nick Knight (director), Jane How (stylist).

Mixed Reality: Perception, Illusion, and Magic

Mixed reality is the area many creative technologists believe has the greatest potential for tomorrow's filmmakers. Being able to see a catwalk show or an avatar through a series of animated clips in real scale in one's own environment or front room is a future possibility. Currently technologists are able to tether physical objects into virtual spaces, a concept progressed by gaming companies now being picked up by fashion retail, for example Pokémon Go! and Hipanda. The idea of inviting a group of fashion fans to discover something in a physical environment and collectively make a story has potential. This could radically alter how audiences engage with digital film content. Thomas Makryniotis, a creative technologist, believes, "it could let you into a single moment or allow you to enter an entire world." Interactive, spatial experiences and mixed realities will increasingly form part of future fashion film consumption.

Sweet (2020), directed by Nick Knight experiments with 3D imaging technologies

IN FOCUS

Fashion film and digital futures

Philip Schütte, Creative Director, Random Studio

"Once we can augment how we look at things and make visible the digital layers, computers will eventually disappear, you'll be able toggle the digital layers off and on. In Japan and Korea, some stores already create a preference that points relevant things out to consumers and guides them towards it. We have a situation now where people get support online and are not aware they're not speaking to a person. People are unable to distinguish humans from machines. The future of fashion communication will be interactive and participatory with individualized preferences. We'll be looking at fragmented, bespoke realities, collectively and individually, an extension of the echo chamber evident in social media. Brands will have the potential to shape their audiences and vice versa."

8.6
Random Studio have devised many innovative approaches to film on the catwalk and aim to show something more than the clothes, such as the designer's inspirations or thought processes. This is a multiple image work for Raf Simons Fall 2016. © Random Studio. All rights reserved.

8.7
Still from *Kokosmos* (2019). © Anna Radchenko, courtesy of Anna Radchenko. Credits: Anna Radchenko (director), Roman Yudin (DoP).

Fragmentation of Identity: Reality and Super-reality

We now live in an age where our physical flesh and blood selves co-exist with our digital on-screen selves. Social media offers many platforms and spaces where individuals can curate their own appearances, lifestyles, and choices. Online personalities and lifestyles, both professional and personal, have become as relevant as the human body with digital representations, sometimes living other lives in the cyber sphere. Philip Delamore notes that "Consumers can now buy digital fashion in the way players buy new 'skins' on a game like Fortnight. Comic Con, Cos Play and World of War Craft. These are examples of where people work towards becoming more like their avatar selves." As fantasy selves come to play a greater role in more lives, there is an increasing number of 3D models, gaming engines, and virtual catwalks. By transposing what's happening in the games industry, it's not a far stretch to see how this might influence future fashion film where the viewer becomes part of the story. Instead of running through a space and killing people, a fashion fan of the future could find themselves strutting along a virtual catwalk or nightclub and knockin' 'em dead. But these worlds, scenarios, and opportunities first need to be imagined and created. Consumers already star in their own fashion narratives creating enhanced—or grotesque—alternative online personas in photography driven social media and as this extends into CGI, it's not always possible to differentiate the real from the fake.

Lil Miquela ("real" name, Miquela Sousa) is a digital avatar "from" Downey, California who first appeared in 2016. The following year she released a single and by 2018 had amassed more than a million followers. She has been interviewed for publications, did an Instagram takeover for Prada as part of Milan fashion week in A/W 2018/19, and an animated Calvin Klein ad in 2018. Similarly, Poppy on YouTube, a cute, pink and white avatar, has released singles and has been courted by brands. Lil Miquela and Poppy are virtual stars or "talents" looking for narratives and worlds, waiting to be cast in the right film. In the future, instead of casting for models or performers, filmmakers may be able to create their cast using a mobile phone.

Miquela and Bella Hadid Get Surreal for Calvin Klein, directed by Jonas Lindstroem.

8.8
An image from the Fashion Innovation Agency at London College of Fashion, UAL. Using a photogrammetry rig to capture models in 3D.

The relationship between games design and fashion film

Peter Hill, Lecturer, UAL

"CGI techniques are becoming better and faster with simple storytelling tools that allow filmmakers to create virtual characters. Editing a computer-generated head is now quite straightforward and commonplace in video games. In one or two technology generations, it will be possible to create representations of 'real' people with real voices on our own phones. As the design tools and computer capacity for creativity in 3D worlds improves, so does the consumer's appetite for making content, leading to games such as Minecraft and Dreams on the Sony PS4 console, which focus on highly creative sculpting. In computer games, which are a kind of free-form computer animation, you need visuals combined with storytelling presented in the fastest, most succinct way. Perhaps, this is not so different to fashion film."

Beyond the frame and the infinity factor

Immersive has become a buzzword of communication discourse but arguably cinema has always been immersive. From the opening frame, the characters, story, and music coalesce to draw the viewer into another world. Watching a film on a small but pixel-dense screen phone with surround audio can create a new level of immersion, even while sitting on a crowded commuter train. The use of vertically shot video represents a sea change for photographers who have historically shot in landscape for video. But film could be on the brink of becoming more immersive than ever before. The medium of film has always existed in the confines of a frame with horizontal and vertical borders. We are used to seeing film mediated through a screen whether in the palm of our hand or in a cinema, but in the future, the screen may disappear altogether.

8.9
Poppy – Moshi Moshi (2017), directed by Titanic Sinclair. © Beyond Ideas 2017. All rights reserved.

IN FOCUS

The shifting parameters of fashion film

Andy Lee, Lecturer in Film, UAL

"As we move towards mixed reality environments, the visual storytelling techniques from the last hundred years will need to be adapted and a new language developed. In some ways, augmented and virtual realities take us back to the beginnings of an immersive theater environment as the 'frame' will change. It will no longer be a locked 16 x 9, but a moving window, controlled by the viewer, which means how filmmakers tell stories and edit will change. There will be no more character exits, camera left. Visually, there will be a big empty space to fill. The parameters change so the work will change. In this new world, how do we keep the audiences' attention? Modern technologies pose a similar challenge to what confronted filmmakers with enormous cinema screens last century. We're in the infancy of a post-digital world."

Poppy – Moshi Moshi (2017), directed by Titanic Sinclair

Algorithms, artificial intelligence, and animation

"Eventually, you'll be able to say to your phone or computer 'I want a film of a blonde girl who gets into a red Ferrari in the style of David Lynch'—and it will be there."

Peter Hill, Lecturer, UAL

Algorithms are a finite sequence of computer-implementable instructions to solve a problem or perform a computation. Artificial intelligence describes a computer's mimicking of the cognitive functions associated with the human mind. Both may well play a greater role in future filmmaking. How filmmakers resource and create films in the future could shift massively. Peter Hill explains how this might work:

> You'll be able to describe an image to an AI program and it will Google and deliver it. There will be more and newer representations of people, places, scenes, and transformations. Put the computer-generated dolls with AI and VR in the mix and we move into the territory of interesting truths, and reality. We already have AI-driven computer imagery with Face Swapping and Deep Fake technologies. It's possible to make yourself look eighty or like a child. Now people are playing with this stuff in a photo realistic way.

The tools, processes, and language of games construction and animation also have the potential to exert greater influence over future filmmaking. Animation has traditionally been a time-consuming practice involving time-consuming rendering. It's now possible to interactively change or transform the clothing of a model digitally. Advances in computer-generated cloth simulation combined with photorealistic digital humans suggest a future of interactive product within fashion films or even the possibility of photorealistic avatars modeling collections.

In the future, it will be possible to construct a three-dimensional world with 3D models realized on set in real time who could be activated, animated, and directed. A filmmaker could shoot this in real time or someone else could shoot it. Unity is a form of software that already exists and is used by animators to facilitate real-time rendering and is commonly used in games, advertising, and animation. Cameras with tilt, microphones, and motion sensors will allow for movement or scene construction, characters, sets, and music in the virtual world. Free software and digital content suites already exist for beginner filmmakers, a mini-Pixar studio on a laptop. Hill notes "we currently have independent image-makers who can use these sophisticated tools to bring these ideas into existence; it's where avant-garde digital artists are heading—the complete transformation of the body, the humanoid form and digital grotesque."

Where technology meets biology

In the future, filmmakers might also be looking at is physiological and psychological interaction with biometric data like heart rates and stress levels having a real-time influence on storylines and every film could be as individual as the viewer. Author and director Mark Cousins believes that "VR is an innovation that extends the founding illusion of cinema. I can imagine further innovations if filmmakers and neuroscientists collaborate; cinema as a kind of CAT scan."

The enduring value of the storyteller: the search of authenticity

"The elegance and poetic sensibility often associated with fashion film will always be the preserve of the best storytellers, directors, and photographers. In the future, film will merge increasingly with technology to take on new hybrid forms."

Adam Grint, Creative Director, The Mill

Most artists and practitioners recognize that technology, no matter how impressive, is a tool in the hands of humans. Technology is an enabler and facilitator. It is *story* that will shape these technologies, therefore the medium and experience. Jonathan Chippindale insists, "We will always need storytellers. You can have e-books and Kindles but they are nothing without the stories. The technology itself doesn't give you beauty, creativity or art. Technology is the great enabler but always in service of, not a replacement for, the story or idea." Adam Grint concurs:

> Fashion and new technology share a symbiotic relationship. They have the same lust for the new and a similar fearlessness for imagination and fantasy. Some of the most exciting creative developments that leverage technology are driven by fashion brands bold enough to explore innovative mediums to pioneer new territories. This deeper communication will be the way that consumers will become more engaged with brands. We need to speak with audiences in a way that embraces the broadness of new media and create a more genuinely valuable exchange for their engagement. No one just wants to be sold stuff.

IN FOCUS

The value of the personal touch in a digital world

Jonathan Chippindale, Chief Executive and Co-Founder, Holition

"In a world where it will be harder to spot the truth because of all the fake news, the fight for our soul will be around authenticity, reality, credibility. A bag is a bag is a bag. That is the image but how can we show that the bag is a result of amazing skills passed through generations? The irony is, the more digital we get, the more we seek authenticity. And technology eventually becomes invisible—it just weaves its way into your life.

The more digital our lives become, the more we crave the human touch, the tingle in our spine. With film, you can embed emotion, sound, and cutting. Technologies are blurring. We have a range of human senses, and those senses may evolve with technology: smell, touch, the psychology of emotion, fear, pain, perception, the sense of being in a space. Its like we're back in the early days of 3D cinema where burning spears would be pointed at the audience and they would scream. There is a fantastic Wim Wenders 3D film about cave diving where the screen is completely black except for these tiny glimmers of light. You are there. We might be heading for a future of more personal takes and experiences."

IN THEIR OWN WORDS: ANNA RADCHENKO

Director

CGI ... allows us to recreate our wildest dreams and fantasies.

"*Kokosmos* was released on Cosmonautics Day, the day dedicated to the celebration of the first man in space. It's a purely visual, experimental piece inspired by space and our fascination with the unknown. The video is a collaboration with model Yana Dobroliubova. Hairless from birth, she was the ideal choice thanks to her otherworldly, striking, and ethereal looks that broke away from traditional beauty standards. The choice of clothing and makeup was also meant to fit with the post-Soviet space theme, featuring only Russian fashion designers.

Kokosmos was a huge learning experience for me. I'm interested in 3D design and new technologies, so this video was my opportunity to experiment. It's just over three minutes, but took one and half years to complete, the

post-production alone took over a year, the amount of time it takes to do a feature! But it was worth it, as it was published in media outlets such as *Vogue Italia*, selected as a Vimeo Staff Pick and screened at festivals such as Underwire.

I'm stimulated by digital fashion including digital models and collections. Virtual reality is an exciting medium that gives so much freedom and is less about the physical product and more the meaning or viewing experience. Computer-generated imagery, CGI, is about enhancement and allows us to recreate our wildest dreams and fantasies. In *Kokosmos*, everything apart from the model and the snail is CGI. We worked with prosthetic makeup too but then we ended up animating the eyes. I define what I do as imagination-tickling. I like to leave the viewer thinking, 'My god, what is this sensation?' I want to leave people feeling curious, surprised, inspired; wondering about worlds and dimensions they never knew existed."

Kokosmos (2019), directed by Anna Radchenko

8.11
Everything in this shot from *Kokosmos* was animated in 3D; no live shooting took place. Still from *Kokosmos* (2019). © Anna Radchenko. Credits: Anna Radchenko (director), Roman Yudin (DoP).

IN THEIR OWN WORDS: NIRMA MADHOO

Filmmaker and researcher, working with new technologies

I want to create an experience apart from the predictable genres of fashion film.

"I decided to become a fashion image-maker in the face of fashion photography that I couldn't relate to as a woman of color who did not identify with the sexualized, objectified images of women in mainstream media. My films perform a post humanity that question normative constructs of fashion identities and norms of beauty in some textual terms but I would say they are accessible and not overtly political.

Visually and conceptually, I'm influenced by the culture of technology and how it's changed fashion. Digitality, as a phenomenon, is a source of inspiration and my work often explores a digital aesthetic. It is interesting to merge this with more established stylistic genres such as Film Noir. Film directors such as Tarsem Singh in his collaborations with costume designer Eiko Isioka—and the fantastical locations—have been an influence; also Floria Sigismondi's early music videos.

I want to create an experience apart from the predictable genres of fashion film that capture mainstream, 'mood' images of models posing for the camera. My approach is non-narrative and impressionistic. I produce imagery that transports the viewer to imagined and synthetic other worlds that tap into the technologically sublime.

I've been outputting one project a year and the number of people involved depends on the number of sequences shot and location specifics, etc. The last project involved about thirty people in various stages of pre-and post-production: From concept (mood board for art/fashion/creative direction and references for camera work) to tests with DP (which might include new equipment, rigs, technology/gear such as 360, and techniques such as drone/aerial; open-ended storyboards and then the shooting; tests with post (keying/photogrammetry/animation); output of sequences for compositing; video editing/cutting to audio towards a soft lock and test exports then final audio to final cut for final exports. It's a complex, time-consuming process.

If VR is only used to view fashion imagery which may as well exist on a rectangular screen, then its audience is less likely to adopt it after the novelty of wearing the HMD has worn off. I think where VR (or maybe XR, which encompasses VR, AR and MR) will influence future fashion film is when producers are able to explore, innovate, and entrench digital methodologies into their productions, it will lead to greater viewer engagement and immersion, but this territory is still to be charted."

Future Body (2015), directed by Nirma Madhoo

8.12
In *Future Body* (2015), Alice Hurel wears dress by Leanne Broadway. Credits: Nirma Madhoo (director).

Summary

- Technology has been a significant founding and shaping influence on film and this will continue.
- Virtual reality, augmented reality, and mixed reality offer different combinations of the physical and digital worlds, and each will play a greater role in future fashion filmmaking.
- CGI techniques and the use of avatars may become more prevalent in the films of tomorrow.
- The frame or screen of traditional film mediation and access may become eliminated in the more immersive world of the future.
- Although no one can be completely sure how technology will unfold, film will always need storytellers.

Exercises

Storyboard the fashion film of your dreams … or nightmares

Future technologies that allow greater experimentation with reality and fantasy mean that the realms of possibility will be far greater in future fashion films. Create the fashion film of your dreams or nightmares (!) and consider how you might achieve this, using what technologies. Dream first and plan later. How might you realize this vision?

Game on: fashion film and gaming technology

In the future, viewers may become active participants in fashion film. Imagine a favorite computer game and consider how this world might be transposed into a fashion space and the characters adapted or recreated accordingly. Aim to develop an alternative overarching story, alongside numerous potential outlines, challenges, and outcomes for each character.

In Conclusion

"Throughout the history of technology, the 'shock of the new' has followed its own trajectory. The thrill of the ghost story has evolved from Chinese shadow play, the magic lantern to Eame's multi-screen architecture to VR."

Tom Gunning, Professor Emeritus in the Department of Cinema and Media at the University of Chicago

And so it is we start and finish with technology. But at the beginning, middle, and end of this narrative is the filmmaker as storyteller, individuals who will translate the language of fashion into new experiences and alternative realities. It is the creativity and imagination of the storyteller that will forge new paths for technology and shape the future of fashion film—not the other way around.

Acknowledgements

A big thanks to Georgia Kennedy, Rosie Best, Colette Meacher, Miriam Davey, Hannah Marston, and Faith Marsland at Bloomsbury for all of their support throughout the making of this book. Roy Peach, former Dean at the London College of Fashion, UAL, first recognized the importance of film within fashion disciplines which I was able to develop in my capacity as Course Leader, Programme Director, and Creative Director. A special mention to Jie Lian, Liying Zhang, and Rie Zhou who worked long and hard on the organization and picture research needed to make this book the visual and informative publication it is and to Tiffany Radmore at the London College of Fashion who facilitated this introduction via the Collaborative Unit. We have … Action!

Thanks also to:

Katie Baron http://www.katiebaron.com

Ivana Bobic www.ivanabobic.com

Alexandra Bondi de Antoni https://www.vogue.de/die-redaktion/alexandra-bondi-de-antoni

Drue Bisley https://druebisley.com

Caroline Bottomley https://www.shiny.network

Lynden Campbell https://www.spatialsound.co.uk; https://www.linkedin.com/in/lyndencampbell

Calvin Chinthaka https://www.chinthaka.co.uk

Jonathan Chippindale https://holition.com

Mark Connell https://markconnell.tv

Sally Cooper https://the-quarry.co.uk/editor/sally-cooper/

Mark Cousins https://www.bfi.org.uk/people/mark-cousins; Twitter @markcousinsfilm

Philip Delamore linkedin.com/in/Philip-delamore-88a0382

Jasmine De Silva www.jasminedesilva.com

Edgar Dubrovskiy https://www.edgardop.com

Cherie Federico https://aestheticamagazine.com

Kathryn Ferguson http://www.kathrynferguson.co.uk/films/

Liam S. Gleeson https://www.hidden-agency.com

Adam Grint http://archive.themill.com/portfolio/filter/collection/89/adam-grint

Andy Guy http://www.andyguycreates.wordpress.com

Declan Higgins https://i-d.vice.com/en_uk/topic/declan-higgins

Marie-Therese Hildenbrandt https://www.marie-theresehildenbrandt.com

Peter Acott Hill Twitter @glowingslab

Ruth Hogben http://ruthhogben.com

David Holah www.davidholah.com

Ian Pons Jewell http://www.ianponsjewell.com

Quentin Jones https://www.quentinjones.info

Isaac Julien CBE, RA https://www.isaacjulien.com

Raoul Keil https://schonmagazine.com/tag/raoul-keil/

Bunny Kinney Instagram @bunnykinney

Nick Knight OBE https://www.nickknight.com

Demetra Kolakis https://www.arts.ac.uk/subjects/ fashion-business/undergraduate/ba-hons-fashion-visual-merchandising-and-branding-lcf #teaching-staff

Andy Lee www.andyl.ee

Nirma Madhoo https://anatomythestudio.com

Thomas Makryniotis https://www.linkedin.com/in/ thomas-makryniotis/?originalSubdomain=nl

Penny Martin https://thegentlewoman.co.uk

John Maybury Instagram @johnfmaybury

Sarah McCullough Instagram @sarah.mccullough.studio

Sam McKnight Instagram @sammcknight1

Clare Melia https://www.themill.com

Monica Menez http://www.monicamenez.de

Faith Millin https://faithmillincolour.com/

Niccolò Montanari https://niccolomontanari.com

Benn Northover www.notesandmessages.com; http://bennnorthover.com

Diane Pernet https://ashadedviewonfashion.com

Anna Radchenko http://annaradchenko.com

Mikel Rosen http://mikelrosen.com

Lernert & Sander http://lernertandsander.com

Philip Schütte https://www.philipschuette.com

Marie Schuller https://www.marieschuller.com

Stevie Stewart Instagram @steviestewartbodymap

Ahmad Swaid Instagram @ahmadaswaid

Alex Turvey http://alexturvey.com

Marketa Uhlirova https://www.arts.ac.uk/UAL/ Research/UALstaffresearchers/MarketaUhlirova; http://fashioninfilm.com; Instagram @fashioninfilmfestival

Iain R. Webb https://hopeandglitter.wordpress.com

Stephen Whelan https://www.linkedin.com/in.com/ in/stephen-whelan

Ryan White https://i-d.vice.com/en_uk/contributor/ ryan-white; Instagram @ryandgwhite

Helen Woltering www.wildwomenstudios.com

Yulia Yurchenko Instagram @yulyayurchenko_

Anna-Nicole Ziesche www.anna-nicoleziesche.com

Bibliography

Berra, J. 2012. "Lady Blue Shanghai: The Strange Case of David Lynch and Dior," *Film, Fashion & Consumption*, 1 (3): 233–50.

Baron, K. 2016. *Fashion + Music: Fashion Creatives Shaping Pop Culture*. London: Laurence King.

Bartlett, D, Cole, S., and Rocamora, A. 2013. *Fashion Media Past and Present*. London: Bloomsbury.

Bresson, R. 1975. *Notes on the Cinematographer*. Paris: Editions Gallimard.

Carter, M. 2003. "Sartor Resartus by Thomas Carlyle." In *Fashion Classics from Carlyle to Barthes*. London: Berg/Bloomsbury, 1–18.

Casadio, M. 2010. "New Kenneth Anger Film for Missoni." *Arthur Magazine*. Online: https://arthurmag.com/2010/07/27/wowowowwowwowowowowowowowowow/ (accessed October 19, 2015).

Cook, P. 1990. *The Cinema Book*. London: BFI Publishing.

Cope, J. and Maloney, D. 2016. *Fashion Promotion in Practice*. London: Fairchild Books (imprint of Bloomsbury).

Cousins, M. 2004. *The Story of Film*. London: Pavilion.

Craik, J. 2009. *Fashion: The Key Concepts*. Oxford: Berg.

Davis, F. 1994. *Fashion, Culture, and Identity*. London and Chicago: University of Chicago Press.

Dixon, W. W. and Foster, G. A. 2002. *Experimental Cinema, The Film Reader*. London and New York: Routledge.

Engelmeier, R., Engelmeier, P. W., and Einzig, B. 1990. *Fashion in Film*. Munich: Prestel Publishing.

Graham, G. 1999. *The Internet://A Philosophical Inquiry*. London. Routledge.

Keen, A. 2012. *#Digital Vertigo. How Today's Online Revolution is Dividing, Diminishing and Disorienting Us*. New York and London: Constable & Robinson.

Kismaric, S. and Respini, E. 2004. *Fashioning Fiction in Photography since 1990*. New York: The Museum of Modern Art.

Macdonald, K. and Cousins, M. 1996. *Imagining Reality: The Faber Book of Documentary*. London and Boston: Faber & Faber.

Mathijs, E. and Mendik, X. 2008. *The Cult Film Reader*. New York: Open University Press.

McDonald, T. J. 2010. *Hollywood Catwalk: Exploring Catwalk and Transformation in American Film*. New York: I.B. Tauris.

McNeil, P., Cole, C., and Karaminas, V. 2009. *Fashion in Fiction: Text and Clothing in Literature, Film & Television*. London: Bloomsbury.

Menkes, S. 2010. "Is a runway show really necessary?" *The New York Times*, September 10, 2010.

Powell, D. 2009. *Studying British Cinema: The 1960s*. Leighton Buzzard: Auteur Publishing.

Rees-Roberts, N. 2018. *Fashion Film, Art and Advertising in the Digital Age*. London: Bloomsbury Visual Arts.

Ryan, J. 2010. *A History of the Internet and the Digital Future*. London: Reaktion Books.

Shirky, C. 2008. *Here Comes Everybody: How Change Happens when People Come Together*. New York: Penguin.

Stark, G. 2018. *The Fashion Show: History, Theory and Practice*. London: Bloomsbury Visual Arts.

Thomas, G. and Rosencreutz, A. 2002. *Managing Brand Me: How to Build Your Personal Brand*. Edinburgh: Pearson Education.

Uhlirova, M. 2013. *Birds of Paradise: Costume as Cinematic Spectacle*. London: Koenig Books.

Werner, T. 2018. *The Fashion Image: Planning and Producing Fashion Photographs and Films*. London: Bloomsbury Visual Arts.

Wilson, E. 1985. *Adorned in Dreams*. London: Virago.

Winston, B. 1995. *Claiming the Real: The Documentary Film Revisited*. London: BFI Publishing.

Wood, G. 2007. *The Surreal Body, Fetish and Fashion*. London: V&A Publications.

Exhibitions and specialist publications

Berlin Fashion Film Festival, Berlin, June 8–9, 2017.

Digital Revolution, An immersive exhibition of art, design, film, music and videogames, July 3–September 14, 2014, London, Barbican.

Dressing the Screen, London Fashion Week, September 13–17, 2013.

Fashion, Film & Transmedia – An Anthology of Knowledge & Practice, VIA University College.

Fashion Popcorn, Meet the Filmmakers in FP#6: Hackney Picture House, 2010.

Frame by Frame, Dissecting the Fashion Moving Image Now, The 5th Fashion in Film Festival London curated by Hywel Davies and Marketa Uhlirova, March 17–24, 2015.

How to Get Ahead in Fashion Film, ASFF17, curated by Nilgin Yusuf, Aesthetica Short Film Festival, 2017.

London Short Film Festival, Convention and Transgression in the Fashion Film, curated by Nilgin Yusuf, ICA, January 10, 2015.

London Short Film Festival, Fashion Adventures in a Sonic Landscape, curated by Nilgin Yusuf, January 15, 2017.

London Short Film Festival, Life is Great, Fashion on Film, January 17, 2015, ICA.

MA_11, The Fashion Film: Art or Commerce? UAL: London College of Fashion, curated by Nilgin Yusuf, January 31, 2011.

MA_12, Graduates: Visioning Gender, Fashion in the Frame, Interrogating the Image, Perspectives in Fashion and Film from London College of Fashion, February 6, 2012.

MA_13, Fashion Film Screening, UAL: London College of Fashion, curated by Nilgin Yusuf, February 14, 2013.

MA_14, Fashion Film Screening, UAL: London College of Fashion, curated by Nilgin Yusuf, 2014.

MA_15, Fashion Media Production and MA Fashion Photography, Film Screening, UAL: London College of Fashion, Victoria House, curated by Nilgin Yusuf, 2015.

MA_16, Fashion Media Production and MA Fashion Photography, Film Screening, UAL: London College of Fashion, Victoria House, curated by Nilgin Yusuf, 2016.

New Medium, Diverse Messages; convention and transgression in the fashion film, UAL: London College of Fashion, curated by Nilgin Yusuf and Pamela Church Gibson, July 1, 2014.

Screen School, VR Lab, VR Discussions, London College of Communication at Aesthetica Short Film Festival, 2018.

Shooting Style: Fashion on Screen Study Day, The Costume Society, UAL: London College of Fashion, October 19, 2013.

SHOWstudio, Fashion Revolution, Somerset House, December 2009.

VIA Film and Transmedia Research & Development Centre, Denmark, 2017.

Further Reading

Barnard, M. (2007) *Fashion Theory: A Reader*, London: Routledge.

Breward, C. (1995) *The Culture of Fashion: A New History of Fashionable Dress*, Manchester: Manchester University Press.

Breward, C. (2003) *Fashion*, Oxford: Oxford University Press.

Cavallaro, D. and Warwick, A. (1998) *Fashioning the Frame: Boundaries, Dress and the Body*, Oxford: Berg.

Church Gibson, P. (2006) "Analysing Fashion," in T. Jackson and D. T. and D. Shaw (eds.), *The Fashion Handbook*, London: Routledge, 20–8.

Corrigan, P. (2008) *The Dressed Society: Clothing, the Body and Some Meanings of the World*, Oxford: SAGE.

Craik, J. (2009) *Fashion: Key Concepts*, Oxford: Berg.

Davis, K. (1995) *Reshaping the Female Body*, London: Routledge.

Eicher, J. B. (1995) *Dress and Ethnicity: Change across Space and Time*, Oxford: Berg.

English, B. (2013) *A Cultural History of Fashion in the 20th and 21st Centuries: From the Catwalk to the Sidewalk*, 2nd edn., Oxford: Berg.

Entwistle, J. (2015) *The Fashioned Body: Fashion, Dress and Modern Social Theory*, 2nd edn., Oxford: John Wiley & Sons.

Evans, C. (2003; 2007) *Fashion at the Edge*, New Haven: Yale University Press, 111–36.

Hollander, A. (1993) *Seeing through Clothes*, Berkeley: University of California Press.

Kawamura, Y. (2004) *Fashion-ology: An Introduction to Fashion Studies*, Oxford: Berg.

Mendes, V. and de la Haye, A. (1999) *20th Century Fashion*, London: Thames & Hudson.

Negrin, L. (2008) "Feminism and Fashion," in L. Negrin, *Appearance and Identity: Fashioning the Body in Postmodernity*, Basingstoke: Palgrave Macmillan 33–52.

Polhemus, T. (2011) *Fashion & Anti-fashion*, London: Thames & Hudson.

Reilly, A. (2014) *Key Concepts for the Fashion Industry*, London: Bloomsbury.

Rocamora, A. and Smelik, A. (2015) *Thinking through Fashion: A Guide to Key Theorists*, London: I.B. Tauris.

Steele, V. (1999) *China Chic: East Meets West*, New Haven and London: Yale University Press.

Vincent, S. (2009) *The Anatomy of Fashion: Dressing the Body from the Renaissance to Today*, Oxford: Berg.

Wilson, E. (2011, repr.) *Adorned in Dreams*, London: I.B. Tauris.

Yurchisin, J. and Johnson, K. K. P. (2010) "What is Fashion Consumption?" in J. Yurchisin and K. K. P. Johnson, *Fashion and the Consumer*, Oxford: Berg, 13–21.

Useful Resources

1.4
A self-funded project launched in January 2012, this platform is curated by former *Shots* editor Lyndy Stout and aims to feature the very best directing talent in short form filmmaking.
https://www.onepointfour.co

Artsadmin
They said their team supports UK-based artists working in contemporary performance, at all career stages, and offer the following: free advice and information; development and training opportunities; awards to support research and experimentation; a program for graduate artists.
https://www.artsadmin.co.uk

Arts Council
Arts Council was set up in 1946, by Royal Charter, to champion and develop art and culture across the country. There are National Lottery project grants and opportunities for the funding of artists' films.
https://www.artscouncil.org.uk

BAFTA (The British Academy of Film and Television Arts)
BAFTA is the leading UK charity that supports, promotes, and develops talent in film, games, and television.
http://www.bafta.org

BFI Flare (London LGBT Film Festival)
London LGBTIQ+ Film Festival showcases the best new queer cinema, celebrating the diversity of LGBTIQ+ culture from around the globe.
https://whatson.bfi.org.uk/flare/Online/default.asp

BFI Network
BFI Network collaborates with film organizations and leading cultural venues across the UK to provide short film and early feature development funding, industry-backed professional development, and networking support to producers, writers, and directors of all ages.
https://network.bfi.org.uk/

Birds Eye View Film Festival
Founded as a short film event in 2002 and registered as a charity in 2004, this annual festival celebrates films by women and is also a network with year-round activity for those who make, release, view, and show them.
https://www.birds-eye-view.co.uk

Boiler Room 4.3
4:3 by Boiler Room is a platform for underground film with a rich program and annual festival. Exploring themes of performance, identity, youth culture, and anti-establishment, its global mix is an inspirational destination.
https://fourthree.boilerroom.tv

Boooooooom in Canada
Canada's highest-traffic online arts publication has a dedicated film section. An authoritative voice in the new contemporary arts scene, it promotes emerging talent and has helped launch the careers of many young artists internationally.
https://www.booooooom.com

British Urban Film Festival – UK
Also known as BUFF (not to be confused with Sweden's film festival) and launched in 2005, this festival showcases urban independent cinema across all genres and is the leading film festival for all diversity on screen in the UK.
https://www.britishurbanfilmfestival.co.uk

dazeddigital.com
Dazed's online platform is where pop culture meets the underground and reaches an ever-growing and loyal community of global tastemakers. Founded by Jefferson Hack in 1991, its films reflect global youth cultures and a new generation of talent.
https://www.dazeddigital.com

Digital District in Paris
Digital District is an internationally acclaimed and award-winning VFX post-production company specialized in feature films, digital art, and new technologies.
https://www.digital-district.fr

Directors Notes

Scouring the globe for the best of independent cinema, Directors Notes share the production stories of its talented creators.
https://directorsnotes.com Find today's most cutting-edge drama, documentary, music video, animation, fashion and experimental cinema being made today on the Directors Notes vimeo channel. https://vimeo.com/channels/wearedn)

Film Crux

A free online blog that creates and shares everything filmmakers need to take their filmmaking to the next level, from tutorials and free resources, to video essays, interviews, and more.
https://www.filmcrux.com

FilmFreeway

FilmFreeway is a website for filmmakers to submit their films to hundreds of film festivals globally.
https://filmfreeway.com

Filmmakers Academy

A camera-based blog founded by cinematographer Shane Hurlbut, which is also a free go-to resource featuring the latest technology and proven techniques. The blog covers basic camera equipment to high-end professional gear and production tips.
https://www.hurlbutacademy.com

Film Riot

Ryan Connolly's video tutorials include how to make a music video, how to use CGI, and how to use autofocus and exposure effectively.
https://www.filmriot.com

FLAMIN Productions

Offers funding for artists. Last year it closed its ninth round of applications. http://flamin.filmlondon.org.uk/flamin_productions

Framestore

A three-time Oscar-winning creative agency, Framestore is a British animation, visual effects company, and creative studio based on Chancery Lane in London.
https://www.framestore.com

i-D

Originally launched in 1980 as a niche, British sub-cultural print publication by Terry Jones, i-D is now a global platform for emerging talent owned by Vice, i-D's online channel, launched in 2013, celebrates fashion, culture, individuality, and youth.
i-d.vice.com/en

IndieWire

Focusing on film industry news and advice, it also features useful posts on production, distribution, exhibition, and festival strategy information for independent filmmakers alongside reviews and blogs.
http://indiewire.com

London Film Academy

A UK film school situated in Fulham, London and founded in 2001 as a non-profit making trust, the London Film Academy provides practical courses on a variety of filmmaking skills.
https://www.londonfilmacademy.com

Look

An expansive creative studio that combines dynamic visual content with a journalistic sensibility to effectively tell stories for a broad range of international clients utilizing a strategic, multidisciplinary approach to advertising and branding.
https://look.inc/

No Film School

A global community of filmmakers, video producers, and independent creatives with a wealth of free online resources for any individual at any level of their filmmaking journey. The latest tutorials, interviews, short films, and equipment reviews help to make all filmmakers better ones.
https://nofilmschool.com

Nowness

Originally launched in 2010 by Jefferson Hack, this global digital video channel celebrates storytelling through film. Screening the best in culture across a broad remit, spanning art and design, fashion and beauty, music, culture, food, and travel, it won a Webby for the Best Cultural Website in 2017.
https://www.nowness.com

Philip Bloom

The digital cinematographer Philip Bloom has been using DSLRs and high-end digital cameras to successfully create short films, adverts, and documentaries. His website offers valuable insights into cinematography and the video-making industry along with equipment reviews, workshops, and webinars.
https://philipbloom.net

Promonews

Presenting the latest, best, and most inspiring music videos every day alongside interviews with music video directors, and much more, this is a place to consider submitting music videos as well as watching them.
https://www.promonews.tv

Raindance Academy

An independent film festival and film school, Raindance has been operating as a professional film school since 1992, and their alumni feature several A-list filmmakers including Chris Nolan, Edgar Wright, and Guy Ritchie.
https://www.raindance.org

Shiny Network

This not-for-profit limited company supports the best emerging talent with screenings, networking events, and annual awards. Headed up by Caroline Bottomley, formerly of *Radar*, it aims to connect up-and-coming directors with worldwide commissioners of branded content, music video, and other short film forms.
https://www.shiny.network

ShootingPeople

A community of independent filmmakers, writers, actors and industry professionals, Shooting People facilitates creativity in film. One of the UK's largest collaborative networks of creative, independent filmmakers, it helps members to connect and have their films made and seen.
https://shootingpeople.org

Shots Studios

Shots Studios is a next-generation media company which has become a creative studio to musicians and internet creators. The company creates original content for YouTube, Netflix, Instagram, Instagram, Facebook, Snapchat, and other streaming platforms.
https://shots.com

SHOWstudio

Founded by the visionary pioneer Nick Knight, this award-winning fashion website has championed fashion film since 2000 and is recognized as a leading force behind this medium, offering a unique platform to nurture and encourage fashion to engage with moving image in the digital age.
https://www.showstudio.com

The Dots

A professional network for people finding dream jobs, upskilling at events, getting advice and finding collaborators and connecting with like-minded peers, clients, and mentors.
https://the-dots.com

The Mill

A VFX and Creative Content studio headquartered in London, The Mill is a global creative partner for agencies, production companies, and brands. Projects include the creation of digital products and virtual experiences, as well as world-class film content.
https://www.themill.com

Vice Film School

An award-winning international network of digital content, the Vice Film School, launched in 2018, is completely free and shares its wisdom with viewers and learners. Based on a decade of documentary filmmaking, "there's only so much you can learn in a classroom."
https://www.vice.com

Vimeo

A video hosting, sharing, and services platform, Vimeo was founded in 2004. A rich source of inspiration and potential collaboration, Vimeo Staff Picks is a selection of videos from Vimeo curated by its own staff.
https://vimeo.com/channels/staffpicks

WFTV (Women in Film & Television UK)

The leading membership organization for women working in creative media, WFTV runs a comprehensive program of events across the UK and at European festivals including workshops, panel discussions, and screenings.
https://wftv.org.uk

Useful glossaries and tutorials

5 important tips to help you make great storyboards

https://nofilmschool.com/storyboarding-tips

25 basic camera terms all beginner filmmakers should know

https://nofilmschool.com/2018/06/25-basic-camera-terms-all-filmmakers-should-know

A glossary of music licensing terms from Domino:

https://docs.google.com/document/d/1LdEg-V75FsNSvpcEMINcY5xip49N3yBt6T4RhH3nvVyg/edit

A guide to on-set filmmaking lingo [w/ visual dictionary]
https://nofilmschool.com/Visual-Film-Lingo-Dictionary

Download free storyboard software and visualize your story now
https://nofilmschool.com/download-storyboard-software-free

Film terms glossary – index (alphabetical and illustrated)
https://www.filmsite.org/filmterms2.html

How to make a shooting schedule
5 things you should think about when planning your shooting schedule
https://nofilmschool.com/2017/09/5-things-you-should-think-about-when-planning-your-shooting-schedule

How to make a shot list
The essential 10 step guide to shot lists (free shot list template & examples)
https://fivedayfilm.com/free-shot-list-template/

How to make a storyboard for video
https://photography.tutsplus.com/tutorials/how-to-make-a-storyboard-for-video--cms-26374

How to write a shot list in 5 easy steps
https://blog.stareable.com/how-to-write-a-shot-list-in-5-easy-steps-bd1095a9c00e

Intro to lighting: terms, techniques, and concepts you need to know
https://nofilmschool.com/2016/07/intro-lighting-terms-techniques-and-concepts-you-need-know

Shot lists and script lining: preparing your screenplay for your shoot
https://nofilmschool.com/2018/02/shot-lists-and-script-lining-how-prepare-your-screenplay-shoot

These storyboard templates were made by filmmakers for filmmakers
https://nofilmschool.com/storyboard-templates-tropic-colour

Online Resources

Below are the full URLs for the online resources linked to via QR code in each chapter.

Chapter 1
http://ruthhogben.com/blog/2019/03/19/gareth-pugh/
https://vimeo.com/52236734
www.kathrynferguson.co.uk/films/?project=3
https://youtu.be/YeF0Bw_7ZTk
https://vimeo.com/55977152

Chapter 2
https://www.youtube.com/watch?v=v9AErtn21VA
https://www.youtube.com/watch?v=cPpPpnVwRgY
https://www.youtube.com/watch?time_continue=20&v=Ur3f3uEIpwE&feature=emb_logo
https://showstudio.com/projects/torus-fredrik-tjaerandsen/fashion_film?autoplay=1
https://www.youtube.com/watch?v=OMbRxqrAHdI
https://www.imdb.com/video/vi198221337?playlistId=tt0110907&ref_=tt_pr_ov_vi
https://www.youtube.com/watch?v=JWsRz3TJDEY
https://www.isaacjulien.com/projects/this-is-not-an-aids-advertisement/

Chapter 3
https://www.showstudio.com/projects/moving_fashion/peter_lindbergh
https://www.youtube.com/watch?v=f5r5PXBiwR0
https://www.youtube.com/watch?v=PEANC3ipyws&t=7s
https://youtu.be/_n0Ps1KWVU0
https://dicekayek.com/stories/dice-kayek-fashion-films-by-marie-schuller
https://vimeo.com/37764709
https://www.youtube.com/watch?v=EDwb9jOVRtU
https://www.youtube.com/watch?v=TJAfLE39ZZ8
https://www.youtube.com/watch?v=qrO4YZeyl0I
https://vimeo.com/62797737

Chapter 4
https://youtu.be/GCac_bRSqzg
https://www.youtube.com/watch?v=b87B7zyucgI
https://www.miumiu.com/us/en/miumiu-club/womens-tales/womens-tales-6.html

https://www.loewe.com/int/en/stories/runway/ss20-women/campaign

https://www.youtube.com/watch?v=-gl-kaGumng

https://www.nowness.com/series/fashion-disciples/black-isaac-lock

https://vimeo.com/58933055

http://lernertandsander.com/the-sound-of-cos/

https://www.nowness.com/series/model-muse/quentin-jones-naked-with-paint

https://www.youtube.com/watch?v=JYfJfCeQ8As

https://www.maff.tv/watch/river-island-x-georgia-hardinge

https://www.nowness.com/story/isosceles-amy-gwatkin-the-male-gaze

Chapter 5

https://www.youtube.com/watch?v=2mejMl2bWPs

https://www.youtube.com/watch?v=11txU4kDMiw

http://www.kathrynferguson.co.uk/films/?project=4

https://youtu.be/pJuZ7qhcKho

https://vimeo.com/282491349

http://www.kathrynferguson.co.uk/films/?project=13

https://www.showstudio.com/project/barbara_casasola_menswear_for_women

Chapter 6

https://vimeo.com/317267283

https://vimeopro.com/monicamenez/moving-images-by-monica-menez/video/110763016

http://amp.nowness.com/story/detour

https://vimeo.com/221336840

https://vimeo.com/111357606

http://ivanabobic.com/MULBERRY-SS15-DANCE-FILM

https://vimeo.com/66731102

https://vimeo.com/263110770

https://vimeopro.com/monicamenez/moving-images-by-monica-menez/video/68168785

https://vimeopro.com/monicamenez/moving-images-by-monica-menez

Chapter 7

http://gsuslopez.com/portfolio/el-manifiesto-de-lola-lolas-manifesto

https://www.chinthaka.co.uk/fashion-and-storytelling

https://vimeopro.com/monicamenez/moving-images-by-monica-menez/video/22647358

https://vimeo.com/282491349#at=10

http://www.marietheresehildenbrandt.com/abjective

Chapter 8

https://anatomythestudio.com/azimuth-3600-vr-fashion-film

https://random.studio/projects/rafsimons

https://www.showstudio.com/projects/sweet/film?autoplay=1

https://www.youtube.com/watch?v=JuTowFf6B9I

https://www.youtube.com/watch?v=x0dNpGO1pCk

https://vimeo.com/306497056

https://anatomythestudio.com/future-body-fashion-film

Picture Credits

1.1 Ruth Hogben

1.2 Ruth Hogben

1.3 Stan Meagher/*Daily Express*/Hulton Archive (via Getty Images)

1.4 Stan Meagher/*Express* (via Getty Images)

1.5 Declan Higgins

1.6 *Blade Runner*, Ridley Scott, 1982

1.7 Anna-Nicole Ziesche (director)

1.8 Dazed Digital 2014; All rights reserved; screenshot from YouTube @Daze

1.9 Screenshot from Vimeo @Fashion Film Festival Milano

1.10 Eadweard Muybridge, *Attitudes of Animals in Motion*, 1879

1.11 Kathryn Ferguson

1.12 Hidden Agency

1.13 OBSESSION campaign Screenshot from Vimeo @ Shaka Agina

1.14 Raiden Quinn

1.15 *Lady Blue Shanghai*, David Lynch, 2010

6.1 Creativity Factory The Blink Fish for Camera Nazionale della Moda Italiana

6.2 Lernert & Sander (director), Lernert & Sander X Jop van Bennekom & Gert Jonkers (Creative Direction)

6.3 Giacomo Boeri and Matteo Grimaldi (director); Stefano Usberghi (DoP)

6.4 Bennie Julian Gay for *Vogue* Germany

6.5 Sasa Zivkovic

6.6 Courtesy of Anna Radchenko

6.7 Courtesy of Anna Radchenko

6.8 Director: JMP; co-director: Francesco Cuizza; DoP: JMP

6.9 Courtesy of Anna Radchenko

6.10 Courtesy of Anna Radchenko

6.11 Marie-Therese Hildenbrandt; photography by Christian Maricic

6.12 Photography by Ivana Bobic

6.13 Courtesy of Anna Radchenko

6.14 Photographer/director: Jasmine De Silva; model: Natasha Gravia-Lund; makeup artist: Natasha Lawes; hairstylist: Judit Florenciano; styling: Sian O'Donnell; set design: Amy Exton

6.15 Giulia Achenza

6.16 SHOWstudio Fashion Film "1418 NOW," 2016

6.17 Riff Raff Films

6.18 Marie Schuller, Dice Kayek Fashion Film, 2014

6.19 Editor: Sally Cooper

6.20 Mafalda Millies

6.21 Monica Menez

6.22 Courtesy of Anna Radchenko

6.23 Mark Connell

6.24 Edgar Dubrovskiy and Jie Lian

7.1 Monica Menez; Model: Kathrin Heck

7.2 Gsus López

7.3 Diane Pernet

7.4 Photo by Jim Poyner; courtesy of Aesthetica Short Film Festival

7.5 Calvin Chinthaka

7.6 Monica Menez; models: Brodybookings

7.7 John Kobal Foundation (via Getty Images)

7.8 Photographer/director: Jasmine De Silva; DoP: Will Hadley; models (left to right second image): Julie Impens, Erika Janavi, Natasha Gravia-Lund; styling: Ayisha Onuorah; hair: Chris Grimley; makeup: Shona Adele

7.9 Photo by Jim Poyner; courtesy of Aesthetica Short Film Festival

7.10 Photo by Drue Bisley

7.11 Marie-Therese Hildenbrandt; photography: Felix Vratny

7.12 Marie-Therese Hildenbrandt; photography: Christian Maricic

7.13 Marie-Therese Hildenbrandt

7.14 Hidden Agency

8.1 Isaiah West Taber

8.2 a and b Adam Grint, The Mill

8.3 London College of Fashion

8.4 Nirma Madhoo

8.5 Nick Knight

8.6 Fall 16, Raf Simons/Random Studio, 2016

8.7 Courtesy of Anna Radchenko

8.8 London College of Fashion

8.9 *Moshi Moshi*, Titanic Sinclair, 2017

8.10 *Speak Up*, Elliot Sellers, 2020

8.11 Courtesy of Anna Radchenko

8.12 Nirma Madhoo

Index